CHAUCER
AND
GENDER

PETER LANG
New York • Washington, D.C./Baltimore • Bern
Frankfurt am Main • Berlin • Brussels • Vienna • Oxford

Michael Masi

CHAUCER AND GENDER

PETER LANG
New York • Washington, D.C./Baltimore • Bern
Frankfurt am Main • Berlin • Brussels • Vienna • Oxford

Library of Congress Cataloging-in-Publication Data
Masi, Michael.
Chaucer and gender / Michael Masi.
p. cm.
Includes bibliographical references (p.) and index.
1. Chaucer, Geoffrey, d. 1400–Characters–Women. 2. Chaucer,
Geoffrey, d. 1400–Political and social views. 3. Women and
literature–England–History–To 1500. 4. Sex role
in literature. 5. Women in literature. I. Title.
PR1928.W64M375 821'.1–dc22 2003025887
ISBN 0-8204-6946-7

Bibliographic information published by **Die Deutsche Bibliothek**.
Die Deutsche Bibliothek lists this publication in the "Deutsche
Nationalbibliografie"; detailed bibliographic data is available
on the Internet at http://dnb.ddb.de/.

Cover design by Kevin Masi

The paper in this book meets the guidelines for permanence and durability
of the Committee on Production Guidelines for Book Longevity
of the Council of Library Resources.

© 2005 Peter Lang Publishing, Inc., New York
275 Seventh Avenue, 28th Floor, New York, NY 10001
www.peterlangusa.com

All rights reserved.
Reprint or reproduction, even partially, in all forms such as microfilm,
xerography, microfiche, microcard, and offset strictly prohibited.

Printed in Germany

For Gigi

与众不同

Table of Contents

Preface	ix
1. Gender Theory in the Middle Ages	1
2. Chaucer and Christine de Pizan	31
3. Chaucer's Women and Their Logical Discourse	55
4. Money, Sex and Gender	77
5. The "Marriage Group" Revisited–Again	103
6. Boethius and the Wife of Bath	127
7. Chaucer and the Incubus	145
Index	163

Preface

This book is the product of my teaching Chaucer at Loyola University, Chicago, for thirty-five years. In the course of that time I have seen the development of Chaucerian critical approaches across a broad spectrum, from structuralism and new criticism to feminism and queer studies through several stages between. As graduate students at Northwestern University during the late 1960's we never heard mention of "gender studies." My venerable elderly professor, retired already from another institution, lectured learnedly and interestingly on philological fine points in the Chaucerian text. Much of my research during that time was in source studies. Since those years of graduate study, I have kept up with some interest my reading in literary theory and particularly as theories impacted on medieval literary studies. It seems that recent theories originated more commonly in contemporary literature and trickled gradually to medieval literature. All through those years, I felt that I was able to profit from the whole gamut of medieval critical approaches, as they developed, including the shift in interest to the non-canonical works.

As teachers of graduate students, of course, we kept abreast of changes in critical approaches and I noted with interest varieties and changes in the work of young faculty who came to us for interviews as we filled junior positions. One of the characteristics of critical theory in the 1980's and 1990's was, it seemed to me, a proliferation of new terminologies. Some of the terminology has remained, some of it has evaporated. Among these younger scholars, however, I could still sense the traditional solidity of scholarship as I knew it in graduate school. Some of the critical benefits I derived during the period of three decades of literary studies were first the feminist studies and, as I listened to and read those critics I began to comprehend a whole range of what are now referred to as gender studies. The importance of gender and of gender relations in the literature of the Middle Ages not only struck me as extremely useful and inherently interesting but also elicited considerable response from students.

My interaction with hundreds of students in my Chaucer classes has been an important stimulant for the advancement of my Chaucer studies and to those students I owe a debt of gratitude. In my teaching I have avoided as much as possible a proliferation of critical terminology. Consequently, in the writing of this book on Chaucer, I have not used terms of recent critical theories and have endeavored as much as possible to follow the more "traditional" methods in my critical analysis. Nonetheless, recent gender studies, particularly as they are cited throughout this book, had an enormous impact on my thinking and on my teaching. As a profoundly gendered species, I felt, we humans could see in the literature of our past both a greater awareness—as well as, at times, a lesser

awareness—of gender relations in the works of writers of the medieval period. It is an awareness that I felt should be passed on to students regardless of a desire or need for undertaking a championship for causes (though such causes may have been the origins of this critical awareness).

In my several decades of reading about and teaching Chaucer, I have delivered dozens of papers at conferences and visited several libraries regularly for my research. Since my first paper on the Wife of Bath at the University of Wisconsin in 1971, when I was a research fellow in the Humanities Institute, helpful comments from listeners and readers have stimulated and helped me. I wish to thank Michael Lieb, Barbara Rosenwein, Tom Kaminski, Barbara Newman and Karma Lochrie, all of them close and valued friends, for their comments and patience in responding to my ideas over the years. My own institution, Loyola University, deserves gratitude for supporting my research and for use of a library rich in the Latin texts of the Middle Ages. The Newberry Library and Northwestern University Library were also available with their extensive resources and their easy access for me here in Chicago. I would be remiss not to mention the Renaissance Seminar of the University of Chicago where a regular exchange with local scholars as well as with visiting scholars who were drawn regularly to meetings at that distinguished institution enabled me to profit from both casual conversation and from responses to papers I have presented there. Finally, I doubt if any American medievalist is able to avoid an expression of gratitude to that popular and ever useful forum of medieval studies, the Medieval Institute at the University of Western Michigan and its annual Conference in Kalamazoo, Michigan. I have delivered many papers at those conferences and wish to thank its current director, Paul Szarmach, for continuing the work of that remarkable institution. Paul was kind in helping me schedule a session on the works of Christine de Pizan. I will always remember Jeff Richards, Charity Willard and Nancy from that meeting. Several chapters of this book have profited from my exchanges with many other scholars at Kalamazoo.

This work is dedicated with particular gratitude to Gigi, "who is without equal among all I know," and to my five grandchildren who, though innocent of Chaucer, have provided incalculable emotional support.

Loyola University, Chicago

1

Gender Theory in the Middle Ages

Chaucer's views on gender, though significant in terms of his own individuality as a poet and thinker, are certainly better understood against the background of gender discussions and pronouncements that we find in Europe before and up to his own time. As we here enter on a general survey of those views, however, it is well to make clear we understand that by modern standards the commonly accepted medieval theories on the differences between male and female would be repugnant to most educated moderns. Although built largely on abstract theological and metaphysical bases (in contrast to modern theories frequently constructed around political and social issues) the medieval attitudes on gender are significant for their variety and for the logical consistency with which they fit into the larger scheme of medieval philosophy.

In order to begin such a survey of 14th century gender ideas some working notions of what Gender Theory means in this discussion would be appropriate. A descriptive definition of Gender Theory should try to speak to some of the following assorted questions:

—From a theological and spiritual perspective, what is God's purpose in the institution of the two gender system?
—For what practical earthly reason is the human race divided into two genders?
—What are the major characteristics which differentiate the genders, physical and psychological?

—How are the two genders to relate to each other?
—Is one inferior, the other superior?
—What tasks, special privileges, particular duties are due to each?
—How do the two genders originate at the time of conception?

There has been developing an immense literature devoted to the topic of Gender Theory and writers usually choose or work on the assumption of a definition of gender which serves their individual purposes. In literature about social issues, among modern thinkers, Gender Theory deals with the history of empowerment, the advantages which one gender (male) has over the other. Judith Lorber, for example, discusses gender as a social institution. Donna J. Haraway, following gender theorist Gayle Rubin, approaches the issues of gender differences as part of a political discussion. Another significant aspect of gender studies and gender discussion in both modern and medieval periods is its connection to linguistic and grammatical gender. On this topic, for example, we can look at Monique Wittig's, *The Straight Mind*. In Robert Sturges we see a definition of gender particularly in terms of homosexuality and Chaucer's Pardoner with the purpose of explaining how sexual preferences in gender relationships may be understood. Whatever may have been Chaucer's own sexuality, and whatever may have been the complex views towards homosexuality in the Middle Ages, Sturges and others pose the question of how we are to interpret various terms used by Chaucer to describe the Pardoner, terms which to the modern ear trigger many significant concepts important in "queer studies," a distinctly modern mode of inquiry.

These are not the avenues that my discussion on Chaucer will take. Instead, I would focus on what theological and philosophical thinkers offered as explanations for a question that in modern biological terms takes an entirely different course. For many writers of the last one hundred years in modern scientific approaches to gender topics, the questions posed above are most satisfactorily explained in Darwinian terms, terms that involve a process which has developed through a variety of almost entirely random possible means for

preserving and extending the propagation of the species; among these other minor processes of limited success, we may include mitosis and the dissemination of spoors. But the most successful in evolutionary time has proven to be the two gender system. This is the system of reproduction which serves best the most biologically advanced living creatures. Social dynamics and personal relations are then consequent on that evolutionary process.

For the medieval thinkers, one must look to the scriptures or the speculations of the ancients for logical explanations of this biological condition. Some scholars have combed the medical works of the medieval writers for help in deriving a coherent statement of how genders differ and how personality variations are linked to and explained by physical make-up. We should, after evaluating these assumptions drawn from medical treatises, look as well at literary works whose evidence is some times at variance with that of the medical and scientific works.

In the discussion of the prevailing medieval gender theories, certainly the Biblical account of Adam and Eve plays an important part. In the story of *Genesis*, these details emerge as significant:

1. Man (the male) is created perfect in himself;
2. He is made in the image of God;
3. Woman is made for the service of her male companion;
4. Woman is morally and physically weaker.

Only after God had created all living things and fashioned the Garden of Eden did He put man there and finally, with His last act of creation, He fashioned woman as the helpmate to man. Scripture scholars have distinguished what are clearly two stories of the creation of man and placed one after the other in the *Book of Genesis*. These two differ in their implications but one dominates over the other in the medieval tradition of man's origins. In the first, man and woman are created at the same time and equally:

And God made the beasts of the earth according to their species and the beasts of

burden and all the crawling things of the earth according to their kinds and God saw that this was good. And He said, let Us make man in Our image and like Us and He put him over the fish of the sea and the flying things of the heavens and the beasts of all the earth and of every crawling thing which moves on the earth. And God created man to His image and to the image of God He created him; masculine and feminine created them. And God blessed them and said: increase and multiply and fill the earth and rule over it and rule over the fish of the sea and the flying things of the heavens and all the living things which move on the earth. (*Genesis* 1:25–28)

(I use my own translations of Biblical passages in order that the Latin may be seen as literally as possible, though there are many reliable modern English translations available. In the citation of relevant medieval texts, it seems most reasonable to use language in which Chaucer and his contemporaries encountered these texts. Thus, though the scriptures were written in Hebrew or Greek, they were read in 14th century Europe almost exclusively in Latin.)

Et fecit Deus bestias terrae iuxta species suas et iumenta et omne reptile terrae in genere suo et vidit Deus quod esset bonum.Et ait faciamus hominem ad imaginem et similitudinem nostram et praesit piscibus maris et volatilibus caeli et bestiis universaeque terrae omnique reptili quod movetur in terra. Et creavit Deus hominem ad imaginem suam ad imaginem Dei creavit illum masculum et feminam creavit eos. Benedixitque illis Deus et ait crescite et multiplicamini et replete terram et subicite eam et dominamini piscibus maris et volatilibus caeli et universis animantibus quae moventur super terram.

Such is the first account of the creation of the first human beings. The grammarian will be aware of the switch from singular to plural (creavit illum masculum et feminum creavit eos). The second account is different and more detailed.

Therefore the Lord God made man from the slime of the earth and breathed in his face the breath of life and man was made into a living soul and God planted a Paradise of Pleasure from the beginning in which He placed man whom He had formed and the Lord God brought forth from the soil every plant beautiful to see and every plant delicious for eating and he also put in the midst of the Paradise the tree of good and evil knowledge.

Therefore the Lord God took man and put him in the Paradise of Pleasure so he might

care for it and keep it and gave him a command saying that from every tree of Paradise "Eat. But from the tree of the knowledge of good and evil do not eat and on the day when you eat from it you will die the death." And the Lord God said it is not good that man be alone; let Us make for him a helper similar to him in form and therefore the Lord God took from the soil for all the living things of the earth and all the flying things of the heavens and gave them to Adam so that he see what he might call them and Adam called every living thing by its name.

Adam called all the living things by their names and of all the flying things of the heavens and all the beasts of the earth, Adam truly did not find a helper who was like him. God then put Adam into a sleep and when he slept, He took from Adam one of his ribs and filled it with flesh and God constructed that rib which he took from Adam and built it into a woman and gave her to Adam. And Adam said, this is bone from my bones and flesh from my flesh and she shall be called woman because she comes from man [vir– virago]. For this a man should leave his father and mother and cling to his wife and the two shall be one flesh. They were both naked, Adam and his wife, and they were not ashamed. (*Genesis* 2:7–9; 15–5)

Formavit igitur Dominus Deus hominem de limo terrae et inspiravit in faciem eius spiraculum vitae et factus est homo in animam viventem. Plantaverat autem Dominus Deus paradisumvoluptatis a principio in quo posuit hominem quem formaverat. Produxitque Dominus Deus de humo omne lignum pulchrum visu et ad vescendum suave lignum etiam vitae in medio paradisi lignumque scientiae boni et mali. Tulit ergo Dominus Deus hominem et posuit eum in paradiso voluptatis ut operaretur et custodiret illum. Praecepitque ei dicens ex omni ligno paradisi comede de ligno autem scientiae boni et mali ne comedas in quocumque enim die comederis ex eo morte morieris. Dixit quoque Dominus Deus non est bonum esse hominem solum; faciamus ei adiutorium similem sui formatis. Igitur Dominus Deus de humo cunctis animantibus terrae et universis volatilibus caeli adduxit ea ad Adam ut videret quid vocaret ea omne enim quod vocavit Adam animae viventis ipsum est nomen eius. Appellavitque Adam nominibus suis cuncta animantia et universa volatilia caeli et omnes bestias terrae; Adam vero non inveniebatur adiutor similis eius. Inmisit ergo Dominus Deus soporem in Adam cumque obdormisset tulit unam de costis eius etreplevit carnem pro ea. Aedificavit Dominus Deus costam quam tulerat de Adam in mulierem et adduxit eam ad Adam. Dixitque Adam hoc nunc os ex ossibus meis et caro de carne mea haec vocabitur virago quoniam de viro sumpta est. Quam ob rem relinquet homo patrem suum et matrem et adherebit uxori suae et erunt duo in carne una. Erant autem uterque nudi Adam scilicet et uxor eius et non erubescebant.

The most striking difference between the two versions is that in the second, a version more often followed in non Biblical medieval texts, in the arts and in

drama, is that man is made first and the woman is created afterwards as a helper and companion. With this creation, as well, the institution of marriage is created, according to medieval Catholic theology.

In the *New Testament*, it is particularly the epistles of St. Paul which have provided material for those who wish to relegate women to a secondary role in society, and one may point out a singular and well known passage of the third chapter in Paul's "Epistle to the Colossians," verses 18–22:

> Women, be subject to your husbands, as is fitting in the Lord; men, love your wives and do not be unpleasant with them; children obey your parents in all things because this is pleasing to the lord; fathers, do not provoke your children to indignation so that they be not weak in spirit; servants obey your fleshly masters in all things.

> Mulieres subditae estote viris sicut oportet in Domino; viri diligite uxores et nolite amari esse ad illas; filii oboedite parentibus per omnia hoc enim placitum est in Domino; patres nolite ad indignationem provocare filios vestros ut non pusillo animo fiant; servi obedite per omnia dominis carnalibus.

On the other hand, there are many passages in the *Old* and *New Testament* which demonstrate a sensitivity and a respect for women, the spirit of which is at variance with the readings based on the selections above. The books of *Judith* and of *Esther* present to modern readers examples of women which many feminists have chosen as ideal models of womanhood. The iconographic representations of Judith and Esther are particularly striking in idealized representations during the Middle Ages and as such would be comfortably in accord with much modern thought on these topics. In the *New Testament*, Christ Himself was especially sensitive toward the women during the three years he spent preaching and gathering his disciples, women such as Mary Magdalene, the sisters Mary and Martha, the Samaritan Woman at the well and, particularly, his own mother. With the exception of the veneration which grew up around the Mother of Christ, medieval attitudes toward women seem to have taken little heed of Christ's example in matters of gender. Several modern feminist critics, such as Elizabeth Smith, Luise Schottroff, David Rutledge and others have brought these examples to the attention of modern Biblical students.

When Barbara Newman deals with the problem of how to explain the deleterious representation of Eve in the *Book of Genesis*, in her chapter "The Woman and the Serpent," she selects from the immense literature on the topic and recommends works by George Tavard and Rosemary Ruether. Newman points out that even medieval women had trouble freeing themselves from the tradition of commentary on Eve:

> Hildegard's treatment of Eve, then, is predictably fraught with tensions. On the one hand, the paradigmatic woman must embody all the sapiential values that inhere in the feminine per se. But, on the other hand, Hildegard could not escape the influence of the Augustinian tradition, which linked original sin with concupiscence or desire, and the related monastic tradition with its esteem for virginity. These traditions, formed and perpetuated as they were by male celibates, are notorious for their tendency to identify sex in general with the female sex in particular and thus to condemn Eve and her daughters as the abiding source of temptation. (Newman 89–90)

The account of *Genesis* emphasizes the superiority of the male, the subservience, almost as an afterthought, of the female. After she succumbs to the temptations of Satan, Eve is also seen as weak and vulnerable. But *Genesis* also stresses the importance of the union and the cooperation between the genders. Nonetheless, one of the most significant characteristics of medieval Gender Theory is the extreme bipolarization of gender identities. This tendency to polarize male and female functions and behaviors has been pointed out in recent gender discussions, as in the work of Camille Paglia. One may take particular note of her published dissertation, *Sexual Personae*. There is in the literature of the Middle Ages a tension between the official theological and bipolarization of the genders and the obvious evidence to acknowledge the reality of the complex identity of individuals who may be, to a greater or lesser extent, composed of some characteristics which are found in the opposite gender. For a clear explanation of how cross over characteristics occur in each gender (from a modern perspective), one may see Nancy J. Chodorow, *Feminism and Psychoanalytic Theory*, especially the section "Gender, Self and Social Theory" pp. 97–162.

Recent writers on Gender Theory and particularly those who write on

homosexuality in the Middle Ages, have brought to light literary evidence in some writers that a certain amount of gender ambiguity was recognized and acknowledged by some medieval thinkers. In many medieval authors, such as Dante and Chaucer, this recognition is combined with disapproval. Courtly love, in its purely theoretic form, almost entirely excludes any cross gendering. Courtly love, it could be argued, is probably the singular most important factor in the polarization of genders. Most of the discussions of homosexuality, seen as one kind of gender crossover, and called sodomy, are condemnatory in their approach (see Sturges 51ff).

Opportunities for serious and extensive discussion of gender among ancient authors must begin with Plato. Although Plato's *Symposium* was virtually unknown in the Middle Ages and therefore without any direct influence on medieval Gender Theory, there is an important discussion in that work which provides an unusual view of how gender may be conceived, at least for purposes of considering its functions. This is certainly a theory without a foothold in Plato's other work, but is significant because it speaks to the equality of the genders and the importance of their interdependence. Socrates and his companions are depicted as engaged in a discussion about the power of love, and Aristophanes, in order to illustrate the power of love, proposes a theory about the origins of gender differences which he claims is a story about "the real nature of man, and the change which it has undergone—for in the beginning we were nothing like we are now" (189d). And so in sections 189–193, he tells of a creature that in the beginning consisted of four legs, two faces on one head and with four arms. This creature had great power and, though seemingly an ungainly individual with so many appendages, was very fast in running and very clever in intellectual abilities as well as ambitious in his desires. His abilities were so great that he threatened the status of the gods themselves who, having already destroyed the race of giants for their ambitious move against the deities, were perplexed as how to curb this creature and yet preserve him for the sacrifices he could yet offer to the gods. Zeus proposed and then proceeded to implement a drastic plan: divide the creatures into two parts,

each having but two legs and two arms. These individuals would be so consumed with desire to be reunited that they would become entirely distracted from other pursuits, and so the supremacy of the gods would remain secure from competition. The story was not taken seriously by the listeners of Aristophanes and served only to illustrate the power of heterosexual love for it can distract from all other pursuits those individuals entrapped in its power. Also the story is significant because it contrasts sharply with Plato's conception of Gender Theory as seen in other writings as well as with the Judeo-Christian account of gender origins given in the *Book of Genesis*. In this account the genders are not only equal but desire to be united in order to form a more powerful combination than either would be singly. The story would also imply that neither is sufficient alone but considers itself only half of a complete being. In the account which dominated from the *Genesis* story, the male gender is quite sufficient and complete alone, though he does profit from the divinely given help of his mate and companion. Although the *Symposium* accounting for the relationship between the genders is not found in the medieval period, it does give expression to a common notion about the union and important relationship between male and female. It is a concept voiced, among other ways, in the common expression of referring to one's spouse as "my better half."

In other writings, Plato presents further comments on the role and function of sexuality; though he is not always clear and entirely consistent, it is obvious he has doubts about the equality of the two genders. He is, furthermore, somewhat uneasy about the power of attraction between them. The Athenian in *Laws* VI.782e says that sexual attraction must be controlled and regulated and checked, like desire for food, with the benefit of using the three supreme sanctities: fear, law and true discretion. This would seem to leave out the validity of lesbian or homosexual sex. That passage has no reference to homosexuality but he comments through 784 in detail on the relationship of bride and groom.

The Athenian and Clinias continue their conversation to *Laws* B VI.800 where they talk about competitive sports. Then the Athenian goes on to ask how

should sexual attraction between the young of both genders be controlled? He eventually comes to postulate the control of homosexuality which Clinias considers wrong. In the old days, this practice was considered unnatural but in his day it is not. His conclusion is that nonetheless it must be censured. It is further condemned by the Athenian as reprehensible as relations between brother and sister. In VIII 841 the Athenian concludes:

> One [law] would be that no free born citizen should dare to touch any but his own wedded wife, and that there should be no sowing of unhallowed and base seed with concubines, and no sterile and unnatural intercourse with males. (trans. A.E. Taylor 1406)

The mating of male and female must be controlled in order to produce the best quality of offspring. Stipulations for the education of men and women is the same in *Republic* V, 456. The best possible men and women would be best for the state. In book V of the *Republic* there is a great deal of emphasis on the equality of the genders. Mating would not be in common but instead marriages would be carefully arranged. In *Republic* V 451 he suggests that women are trained differently from men. It is here that Socrates and Glaucon both seem to agree that women exercising nude would be a ridiculous sight and should therefore be excluded from public sports activity.

As with most issues when the evolution of Western thought is considered, one compares the ideas of Plato with the developments brought to them by his student Aristotle. As a general statement of attitude toward gender among the learned in the medieval period, one is required to look to the works of Aristotle rather than to Plato. Some of Aristotle's works were recovered through the Arab versions and were generally in wide circulation in Latin during the 14th century. As repugnant as some of Aristotle's ideas may seem to some now, they must be approached with a sense of their range and complexity. Aristotle is doubtless one of the authors whom Christine de Pizan read in the 14th century with mixed fascination in general and some distress in particular regarding his comments on the nature of women. Though she begins her discussion with Matheolus, one who for her was most disturbing, she goes on:

But more generally, judging from the treatises of all philosophers and poets and from all the orators—it would take too long to mention their names—it seems that they all speak from one and the same mouth. They all concur in one conclusion: that the behavior of women is inclined to and full of every vice. Thinking deeply about these matters, I began to examine my character and my conduct as a natural woman and, similarly, I discussed this with other women whose company I frequently kept, princesses, great ladies, women of the middle and lower classes in great numbers, who graciously told me of their private experiences and intimate thoughts, in order to know in fact—judging in good conscience and without favor—whether the testimony of so many famous men could be true. To the best of my knowledge, no matter how long I confronted or discussed the problem, I could not see or realize how their claims could be true when compared to the natural behavior and character of women. (p. 4)

Mais generaument auques en tous traictiez, philosophes, poetes, tous orateurs desquieulx les noms dire seroit longue chose, semble que tous parlent par une mesmes bouche et tous accordent une semblable conclusion, determinant les meurs femenins enclins et plains de tous les vices. Ces choses pensant a par moy tres parfondement, je pris a examiner moy mesmes et mes meurs comme femme naturelle et semblablement discutoye des autres femmes que j'ay hantees, tant princesses, grandes dames, moyennes et petites a grant foison, qui de leur grace m'ont dit de leurs privetez et estroictes pensees, savoir mon a jugier en conscience et sanz faveur se ce peut estre vray ce que tant de nottables hommes, et uns et autres, en tesmoignent. Mais nonobstant que pour chose que je y peusse congnoistre tant longuement y sceusse viser et esplucher, je ne apperceusse ne congneusse tieulx jugemens estre vrraye encontre les natureulz meurs et condicions femmenines. (*La Città delle Dame*, ed. Richards 42)

Some modern writers are still expressing their baffled reaction about Aristotle, a philosopher who could be so wise on other matters, so extensive in his influence and studied so seriously for two millennia and yet so wrong about the nature of woman. Whether he is considered right or wrong on issues, however, his opinion still must be come to terms with. His attitude on gender has been particularly troublesome, however. As Nancy Tuana puzzles:

It seems to fly in the face of reason to say that man, who neither gestates, bears, nor lactates, possesses reproductive capacities superior to those of woman. Yet this is exactly what Aristotle did. In his embryological theories, Aristotle ascribed generative superiority to man. For Aristotle, the male is the true parent. Furthermore, he argued that woman's role in reproduction—her station, labors, and lactations—are the cause of her intellectual inferiority to man. (p. 189)

There is more such anti-Aristotelian criticism in her essay "Aristotle and the Politics of Reproduction." Unlike the modern commentaries on Aristotle's writing in other areas, such as physics, cosmology, chemistry or biology—to name a few where he is still seriously read and discussed—modern gender discourse on Aristotle almost always begins with an emphatic refutation, as does Christine Senach in the opening of her essay "Aristotle on the Woman's Soul":

> There is no doubt that Aristotle's theories on women are wrong. As his views are presented in what follows here, all one needs is general knowledge in areas such as biology, sociology and psychology to offer evidence against and successfully refute Aristotle's ideas about what sort of creatures women are. (p. 223)

However, to some careful readers of his works it would seem that Aristotle's assessment of women's intellectual abilities is not a simple one. As is usual in complex matters of assessing a writer's attitude which may shift from time to time and from work to work, a clear and definitive statement on such a difficult issue as gender is not easy to find. We are, of course, in a better position in the 21st century to comb through his works, compare passages from different texts and draw inferences from discussions not directly focused on that topic. So we are better able to approach a topic from a variety of angles and see how it appeared to him at different times in different terms. This is not to overlook the fact that a simplified version of his ideas became standard received wisdom in the Middle Ages. Rather we should judge cautiously and recognize that thinking persons who are not by intellectual habit inclined to accept standard thinking on any complex topic may not be entirely decided in their opinion. This is especially true of those thinkers who have not benefited from extensive intellectual movements which produce copious discourse on every angle of a topic—as have feminist writers on Gender Theory in recent decades. All of this is true with respect to Aristotle and even more significant in the case of Chaucer's writing where the complexity of developing ideas is mixed with the interplay of irony, satire and deliberate ambiguity.

A discriminating researcher will therefore be gratified to read Debrah Modrak's even handed examination of Aristotle in her essay "Aristotle: Women, Deliberation and Nature."

> Turning to Aristotle's biological writings, one soon discovers that the support to be found there for a negative assessment of the rational capacity of women is slight at best. With respect to internal physical structures, the differences between male and female anatomy are solely due to differences in sexual organs. Insofar as human rationality is dependant on the body, more specifically on the perceptual system, there would appear to be no obvious difference between the sexes. (p. 209)

There is, however, no denying that Aristotle looked upon the reproductive act, either in humans or in non-rational animals, as designed ideally to produce a male offspring. With regard to reproduction,

> In the best case, Aristotle believes, the male parent generates another male resembling himself in the material supplied by the mother. If, however, the motions in the male's sperm are weak, they may be overpowered by the motions in the catamenia [καταμένια – the residue in the uterus of the female]; in this case, a female offspring is produced. (Modrak 209; see also Aristotle's *Generation of Animals* 766a17–30)

Women, simply put, are seen as defective, even though Aristotle makes it clear elsewhere (*Meta.* 1058a29–63 and *Gen. An.* 723a27–630) that "gender differentiation is not a proper part of the essence or form of a living creature" (Modrak 209). Later thinkers, however, did not make such subtle distinctions. Aristotle may still be seen to have doubts about women's abilities to make morally responsible decisions; it seems he was more influenced in this attitude by current Athenian thinking rather than by the logic of his own analysis.

> Aristotle assumed that there are people in his society whose moral intuitions are trustworthy and hence that to appeal to the intuitions of well educated and experienced Athenians is morally sound. This means that the value system of the upper classes in fourth century Athens provides the context in which Aristotle examines ethical positions and develops his own ethical and political analysis. (Modrak 218)

We must agree with Professor Modrak that:

> The uncomfortable fact remains, however, that from a modern perspective, Aristotle's views on women and natural slaves are morally repugnant. (p. 218)

When the commonly received Aristotelian views are combined with the Judeo-Christian Biblical accounts of male-female relationships, an almost insuperable amalgam of ideas develops in the Middle Ages which may even be termed a "theology of antifeminism."

Joan Cadden in her book *The Meaning of Sex Differences in the Middle Ages* (1993) makes an important, perhaps an indispensable contribution to the discussion of gender in medieval Europe. Its value lies chiefly in the survey of scientific literatures which are examined as the official scholarly statements about male-female differences and the implications of these differences in the social order. With careful documentation and citations of passages, including corresponding passages in the original languages, Professor Cadden demonstrates what we already would have known are the standard received medieval attitudes: that women are born as deficient males whose physical and psychological make-up illustrates the individual's inability to become a complete and fully developed male. The large majority of those texts comes from the scriptoria of male authors such as Constantinus Africanus, William of Conches, Avicenna, Peter of Spain, Albertus Magnus, Dimo del Garbo, Bernardus de Gordino, Thaddeus Florentinus, as well as the more familiar authorities from ancient times, particularly Aristotle.

A survey of medieval Gender Theory must inevitably begin with Aristotle and perhaps include some discussion of Plato's attitude toward gender. Most profitably for this survey of Chaucer's attitudes toward gender, one moves then to texts which Chaucer mentions and which would appear that he had read and consulted. There is one author, however, whom Chaucer did not know but whose name should enter into any discussion of medieval Gender Theory, and that is Hildegard of Bingen. She is of particular interest and relevance to modern readers for several reasons, but in this context, her *Book of Compound Medicine* is given special attention in Cadden's survey of medieval sexuality. Its interest is enhanced because of the great ascendancy of Hildegard's

reputation in several areas of modern feminist studies. She is widely celebrated now for her music and her mysticism as well as for her medical compendia. It is thought that added importance accrues to her medical work since as a woman Hildegard might bring to gender studies some insight of her own in the definition of female sexuality. In fact, Hildegard's book contains a wide ranging discussion on a number of scientific topics yet none of them reveals a particularly "feminist" point of view on gender issues. Hildegard, unlike Christine de Pizan, a visionary and mystic, wrote in her monastic cloister from books that surrounded her. She was not a medical researcher but rather a reader and a compiler of texts.

Though she was in essential agreement with Aristotle and some other established authorities, Hildegard did try to bend and shape her terms and theory a bit to provide a few concessions to the female gender. In her text, she posits, as does William of Conches, that both Adam and Eve were made of clay (ignoring the account of Eve as coming from Adam's rib). She concedes that Adam was made of finer clay than Eve and as a result he is stronger and firmer.

> We are fortunate that Eve transgressed first, because, Adam being stronger, his fault would have been irremediable. (Cadden 75)

Among other traditional attitudes, she believes that it is the strength of the man's semen that determines the sex of the child but while she concedes the male strength, she softens her terms to express the woman's lack of strength.

> Although she frequently called man "strong" (fortis), she did not usually describe the woman simply as "weak" (debilis), as Aristotelians were to do, but rather chose words that have less negative connotation, for example "soft" (mollis) and "fragile" (fragilis). (Cadden 82)

Hildegard's works (mid 12th century), though of interest to modern feminists, had little influence in the Middle Ages. It is among writers whose work Chaucer refers to explicitly who become more important for our survey in this examination of Chaucer and gender. From Aristotle one may look to writers more immediate to Chaucer for further description of some system of

Gender Theory. In addition to Aristotle's theories as the basis for thinking about human nature that pervaded the works of the late Middle Ages, we may consult a list that Chaucer conveniently supplies for us in his description of the physician in his General Prologue to the *Canterbury Tales*:

> Wel knew he the olde Esculapius,
> And Deyscorides, and eek Rufus,
> Olde Ypocras, Haly, and Galyen,
> Serapion, Razis and Avycen,
> Averrois, Damascien, and Constantyn,
> Bernard, and Gatesden and Gilbertyn. (A 429–434)

Three important names from this list of writers of medieval medical treatises which touch on Gender Theory and sexuality are Constantinus Africanus, John of Gaddesden and Gilbertus Anglicus. Walter Clyde Curry and others have devoted considerable commentary to Constantinus Africanus and, perhaps somewhat less, to John of Gaddesden. Except for a passing note from Cadden, however, no scholar seems to have explored the relationship between Chaucer and Gilbetus Anglicus. Chaucer may also have drawn on gender ideas from Thomas Aquinas who wrote on and was influential in a wide range of many other philosophical and medical topics as well.

To begin with the most important of these three names which are connected with texts on Gender Theory in the Middle Ages, we note that the name of Constantinus is mentioned twice in the *Canterbury Tales*. Since there is no reference in Chaucer to him or the contents of his works before the mid 1380's, we may see in that observation on his chronology an indication that Chaucer read the works of Constantinus late in his writing career. Constantinus was widely known in the European Middle Ages and manuscript copies of his works cover a wide variety of medieval scientific issues. Of the remarkable array of medical works by Constantinus, the *De Coitu*, cited in the "Merchant's Tale," suggests that Chaucer may have drawn on that particular work which was responsible for the transmission of Greek and Arabic texts specifically for some of his ideas on gender.

Discussions of coitus before Constantinus may be found in a number of

ancient authors, though most would not have been available in 14th century England. In addition to those explicitly mentioned in the *De Coitu* by Constantinus (Hippocrates, Galen and Rufus of Ephesus) are:

Aretealus of Cappadocia (2nd–3rd centuries)
Paul of Aegina (625–690)
Albrecasis (935–1013)
Costa Ben Luca (10th century)
Haly Abbas (d. 994)
Razes (860–932)
Isaac (d. 932 or 941)
Avicenna (980–1037).
(Bassan 134. See for a more complete list Lucien Leclerc, *Histoire de la médecine arabe*, 2vols. [N. Y. N.d. originally published 1876] I, pp. 478, 529, II, p. 62.)

Constantinus does not discuss the nature of the divine origin of the sexes; however, as a writier of a merely medical treatise, he does speculate on the reasons for sexual differentiation at birth. While a fully developed Gender Theory should deal with the reasons why there are two genders, Constantinus seems satisfied on the matter of the origins and purposes of gender to state simply that its purpose is propagation. In trying to flush out further facts about Chaucer's knowledge of Constantinus we may note that copies of his work were to be found in England in the 14th century. Bassan notes:

In 1375 there appeared at Merton, [College Oxford] from the library of William Durand, Aristotle's *De animalibus* which included a now lost *Liber de Cohitu*, probably the one by Constantinus Africanus. (Bassan 140)

For another copy one may consult F. M. Powicke, p. 159.

All the historians of medieval medical treatises have commented on the importance and reputation of Constantinus in the Europe of the Middle Ages.

His life spans most of the 11th century (from 1015–1087). Constantinus is a major conduit of ancient medical lore and as a North African Arabic scholar who converted to Christianity, he sat in his study at Monte Casino in the late 11th century and translated a great number of Arabic and Greek medical works into Latin.

The importance of Constantinus is due to the variety of significant works which he transferred from their originals into Latin and thus made the traditional Arabic medical wisdom available to Western European readers. In general, much of the transfer of Arabic philosophical and medical works into Latin took place in Spain, but apparently there was also considerable translation activity in Italy as well. Some scholars have complained of his garbled turgid Latin prose, as noted by Michael McVaugh in his entry for the *Dictionary of Scientific Biography*, but the transmission of difficult material, for much of which there was no vocabulary in Latin, was an important if imperfect part in the development of medical learning. Constantinus may have reasonably stressed the necessity of proper rest and diet, but in some instances his medical remedies were questionable. Significantly, it must be said that he brought attention to issues which eventually did become properly addressed later in the West. We single out here his treatise *De Coitu*, which constitutes a discussion of male sexual health. That medical scholars of the East and particularly of Arabic culture recognized a need for such a discussion is significant since it was an issue probably talked about frequently in all cultures and at all times but significantly not taken up in Europe by the medical scholars until the (presumably) celibate monk at Monte Casino determined to search the works of Greek and Arabic materials to compile his treatise on male sexual health. One may read this work in a fairly lucid translation by Paul Delany in the *Chaucer Review*. Constantinus' sources have not yet been fully determined but he does make explicit reference to Galen, Hippocrates and Ruffus of Ephesus (fl. 100 AD). Doubtless he also uses the work of several unnamed Arabic writers.

Chaucer's appellation of Constantinus as the "cursed monk" is often cited and frequently misinterpreted. Constantinus' reputation was wide spread in the

West, and on reading his treatise *De Coitu* one can readily see that it is a serious work, hardly a lurid pornographic document that Chaucer's context might suggest:

> Soone after that, this hastif Januarie
> Wolde go to bedde; he wolde no lenger tarye.
> He drynketh ypocras, clarree, and vernage
> Of spices hoote t'encreessen his corage;
> And many a letuarie hath he ful fyn
> Swiche as the cursed monk, daun Constantyn,
> Hath writen in his book *De Coitu;*
> To eten hem alle he nas no thyng eschu. (E 180–12)

The serious medical discussion by this 11th century monk must be seen, in the far ranging ambiguity and allusion of Chaucer's writing, as one more ironic reference (such as the blessing of the marriage bed) which condemns more the behavior of January rather than curse the work of this monk.

An interesting and entirely coincidental comment cited by Maurice Bassan may, in the absence of other documentation about the reputation of Constantine in the time Chaucer, throw light on what could have been orally transmitted comments which Chaucer encountered and which would have been recognized by his contemporary readers. According to Bassan, (p. 139), an Italian medical writer, Taddeo Alderatti (c. 1223–1303), whose work Chaucer could hardly have known referred to Constantinus as "ille insanus monachus" a phrase sometimes translated as "that crazy monk" or better yet, I would suggest, one that could be rendered instead as "not healthy" (*in* + *sanus*) and would refer to the doubtful trustworthiness of his medical advice which Thaddeo judged was full of inaccuracies. "Nam ille insanus monachus in transferendo peccavit quantitate et qualitate" (p. 139). *Insanus monachus* ("that cursed monk") could be a phrase assocaited with Constantinus among those who knew his work and one circulated in common parlance.

In his treatise, Constantinus attributes his information chiefly to Galen, Hippocrates and Rufus of Ephesus. There is no doubt that he used Arabic sources as well and one may speculate on why he omitted mention of

them—perhaps from a sense that medical authorities at Casino and Salerno, where he seems to have had some influence that Arabs were disliked and distrusted (see Moritz Steinschneider). It should not go unnoticed that several verbal echoes in Chaucer's text suggest that Chaucer not only knew Constantinus' work by reputation but also was familiar with its contents. There are in Chaucer's text passages strongly reminiscent of the *De Coitu*, as when the Wife of Bath argues that sexual activity is not reprehensible and in fact the existence of sexual organs indicate God's intent that they be used for procreation. See lines 115 to 134 of her Prologue:

> Telle me also, to what conclusion
> Were membres maad of generacion,
> And of so parfit wys a wright ywroght?
> Trusteth right wel, they were nat maad for noght.
> Glose whoso wole, and seye bothe up and doun
> That they were maked for purgacioun
> Of uryne, and oure bothe thynges smale
> Were eek to knowe a femele from a male,
> And for noon oother cause, – say ye no?
> The experience woot wel it is noght so.
> So that the clerkes be nat with me wrothe,
> I sey this: that they maked ben for bothe;
> That is to seye, for office, and for ese
> Of engendrure, ther we nat God displese.
> Why sholde men elles in hir bookes sette
> That man shal yelde to his wyf hire dette?
> Now wherwith sholde he make his paiement,
> If he ne used his sely instrument?
> Thanne were they maad upon a creature
> To purge uryne, and eek for engendrure.
> ("Wife of Bath Prologue," D 115–134)

Chaucer's Wife seems to acknowledge a sour glance from the Clerk in this discourse ("So that clerkes be not with me wrothe"), as well as allude to annotated texts of medical books (possibly of Constantinus) but most significantly, this passage seems to echo the opening lines of the *De Coitu* where Constantinus clarifies the reason why God endowed humans with

members of generation. In the translation of Paul Delany, beginning with "Creator volens animalium genus firmiter ac stabiliter..."

> The Creator who wanted the race of animals to continue firmly and stably, planned for it to be renewed by intercourse and generation, so that by this complete renewal the race would not perish. He therefore gave animals suitable natural members for this specific function: and he put in them such an admirable virtue and sweet pleasure that all animals are overcome with delight in intercourse for if they disliked it, their race would surely perish. Animals have such a strong instinct for intercourse that if they get a chance of enjoying it after having been restrained for a long they will perform the act regardless of almost any other consideration. (Delany 56)

One may note that as well as the verbal echo the sentiment of the passage informs much of what the Wife tells us about her sexuality in her Prologue.

At the end of his treatise, Constantinus outlines a number of recipes for heightening desire and increasing potency in men. In the "Merchant's Tale," January explicitly follows Constantinus' recipies and Constantinus' text is cited by its title:

> And many a letuarie hath he ful fyn,
> Swiche as the cursed monk dawn Constantyn,
> Hath writen in his book *De Coitu*. (E 180–11)

Chaucer must have derived a variety of notions about gender from other mainstream sources such as Aristotle, Augustine and Aquinas, as well as from literary sources such as works by Ovid and the *Roman de la Rose*. Constantinus is especially valuable because he provides us a compact and specific enunciation of some central notions about human, especially male, sexuality. Chaucer was certainly familiar with Consantine's ideas and they very likely infused his thought as his characters who were defined by their gender specific behavior drew on Gender Theory for their assumptions. The Pardoner for example since he is gelded, displays none of the secondary sex characteristics usually associated with the male sex:

> A voys he hadde as smal as hath a goot.
> No berd hadde he, ne nevere sholde have;

As smothe it was as it were late shave
I trowe he were a geldyng or a mare. (A 688–691)

We may compare those lines with a passage from Constantinus:

> The secretion prepared for the body by the testicles is also a virtue; for this reason a man who has been castrated is beardless, lacks body hair and has veins like a woman's, and has lustful desires. (Delany 58)

Constantinus also cites the factors which can result in the birth of a male or female child, though those details about gender determination are not explicitly found in Chaucer. Still, reading Constantinus on the determination of gender differences must bring to mind the Wife's comment about the purpose of human genitalia in D 11-123. We note that that Constantinus' influence does not seem to appear in Chaucer's earlier works and his ideas surface only in the *Canterbury Tales*. It could be that Chaucer had not encountered Constantinus' writings until later in his own career, but more likely, Chaucer's early writing was not as involved in gender issues. It is obvious that in the 1380's the topic became important for him and his interest in gender and sexuality may have led him to read Constantinus, a name he would have known by reputation as relevant and useful for the matter.

Though Constantinus is mostly concerned with male sexuality he did acknowledge in another work, *De Genitalibus Membris*, that women also have sexual desires, a factor determined by the size of a woman's sexual parts, which he calls *vulva* (Cadden 64). In yet another of his works on gender, the *Pantegni*, Constantinus asserts that women enjoy the greater pleasure in acts of sex:

> Pleasure in intercourse is greater in women than in males, since males derive pleasure only from the expulsion of a superfluity. Women experience twofold pleasure: both by expelling their own sperm and by receiving the male sperm, from the desire of their fervent vulva.
>
> Delectatio in coitu maior est in mulieribus quam in masculis, quia masculi delectantur tantum in expulsione superfluitatis. Mulieres dupliciter delectantur, et in suo spermate expellendo et masculi recipiendo ex vulve ardentis desiderio. (Cadden 65)

It is a safe assumption that Chaucer read Constantinus Africanus since we find verbal echoes of the opening sentence of the *De Coitu* spoken by the Wife of Bath. It seems that the ingredients for January's aphrodisiacs also come from Constantinus. Constantinus, though far removed from Chaucer in years and distance, derives his importance from a wide-spread reputation among medical writers and as such seems to have been recognized by Chaucer.

Gilbert the Englishman (Gilbertus Anglicus) and John of Gaddesden are mentioned by Chaucer and both are included in Cadden's survey of medieval sexuality. The importance for us of Gilbert the Englishman and John of Gaddesden are derived from the fact that they are Chaucer's countrymen and near contemporaries. It is entirely likely that they were also known to him by word of mouth, but my survey of Chaucer publications has revealed no scholarship detailing Chaucer's use of their texts.

In his *Compendium Medicinae,* Gilbertus Anglicus comments on why nature has provided such great pleasure in the sex act (see Bk. VII, ch. I). He speculates that without the pleasure, creatures would find intercourse disgusting and would not perform reproductive functions, to the detriment of the species. Gilbert also discusses the difference between animals and humans regarding the contrary forces of the draw of pleasure and the restraint of shame that humans feel in the sex act. But he insists that all men, all animals and both genders alike feel this pleasure (see Cadden 137). Gilbert goes into particulars of how sexual pleasure is developed and transmitted in the male (Cadden 138).

John of Gaddesden (Cadden 228–9) in the early 14th century wrote a popular treatise, the *Rosa Anglica* which, since he is cited in the General Prologue, we can assume was known to Chaucer. The particular significance of this work in the discussion of medieval Gender Theory is its treatment of the question of sterility. Since Biblical times, sterility or the failure to produce offspring, had been a continued topic of concern in societies with high infant mortality rates and in which, consequently, the procreation of a large progeny was very important. Traditionally, the failure to produce offspring was blamed on the woman and husbands who were frustrated in their desire for sons would sometimes look for another partner. This practice some times had enormous

political or economical consequences. One may cite the egregious case in the following period of English History when Henry VIII made this desire the basis of catastrophic change in English society. John of Gaddesdon, known also by his Latinized name Johannes Anglicus, enters upon a topic of considerable importance when he undertakes a study of the causes of infertility. He thus generates some discussion on a topic which according to Cadden was becoming more important and much disputed in the 14th and 15th centuries. But particularly notable in John's discussion is that he shifts the discussion of sterility from the traditional focus on the female and includes both male and female in his discussion.

> Although the classical sense of the word *sterilitas* referred predominantly to barren women or female animals, secondarily to plants, and occasionally to males (usually castrated males), the medieval medical position was persistent and unambiguous in its inclusiveness. ...in spite of the parallels established between infertility in men and women, John's introduction reveals a significant distinction between the natures of male and female failure. (Cadden 229)

Cadden goes on to emphasize that the problem of sterility was considered serious and there were many infertile couples who were willing to pay considerable sums to suppliers of remedies for sterility which were, unfortunately, often fake. According to Johannes Anglicus, the purpose of sex which he based on the Biblical account that woman be a helpmate to man required that the two cooperate in the work of reproduction. This is an idea which is further enunciated in Aquinas' *Summa*, Be. I, q. 92, art 1. John of Gaddesden, moreover, stresses the importance of pleasure for both the man and the woman. In his emphasis on pleasure for the women, John's work would have been agreeable to the Wife of Bath who had much to say on the topic. He also suggests remedies for women's slowness (Cadden 248) and retardants for men who ejaculate too soon. The consonance of male and female pleasure ultimately produced better children. The main purpose of his work, however, is to cure sterility rather than study the enhancement of pleasure.

As a final note on John of Gaddesden we can see citations in his work from the works of Constantinus Africanus. This cross-referentiality among

Constantinus, Gaddesden and Chaucer would indicate a certain general commonality in the knowledge of these texts on the topics of sex and gender. Chaucer was doubtless immersed in an active intellectual milieu in which these ideas were frequently exchanged. It may have been knowledge which was exchanged informally in conversation or heard in lectures. The work of Constantinus is also alluded to in the *Roman de la Rose:*

> He has them in his power. Doctors themselves
> We never see escaping from Death's grasp.
> Hippocrates and Galen, though both skilled,
> Rhazes, Avicenna, Constantine,
> All had to leave their skins; (lines 15,927–32)
>
> Et les fisiciens meïsmes,
> onc nul escaper n'an veïsmes,
> pas Ypocras ne Galian,
> tant fussent bon fisician;
> Rasi, Constantin, Avicenne
> li ront lessiee la couenne;

Since Chaucer was very familiar with that work from his translation into English and since the *Roman de la Rose* covers similar topics which touch on gender, we may see how the interest in this issue moves from medical treatises to literary works. In addition, Chaucer mentions two of his own countrymen who are known to have written scientific works on gender, Gaddesden and Gilbertus Anglicus, two writers whose works appeared after the *Roman* was written and were therefore unknown to Jean de Meun. Chaucer's concern with gender owes much to the *Roman de la Rose*, a great interest of his earlier years, but clearly his concern was expanded to include more readings in his later period of writing.

It seems to me that modern critics would err in seeking a medieval theory of gender difference from medical or philosophical texts alone; it is important, rather, to look to other texts, such as literature, as well as personal accounts and biographies of actual living persons, to construct an adequately complex and nuanced framework from which we may understand how the medieval mind

derived its gender concepts. At times it seems that the evidence of literary works, such as the *Roman de la Rose* or the narratives of Chrétien de Troyes, contradict the requirements of official gender rules and we see women who frequently dominate their male companions, in contradiction to established theory. In fact, it would seem that the entire structure of the Courtly Love system is in contradiction to the "facts" of the Aristotelian tradition. Even more striking is the historical record in which women from every social stratum, including those who acquire positions of leadership or those who produce works of literature, are frequently at odds with the received theories. This is precisely the point, of course, that Christine de Pizan is making in the construction of the City of Ladies as described in her book of that title (*La cité des dames*).

The hagiographic literature contains accounts of courageous women clearly stronger than their male persecutors. Some of these may be historically doubtful but they nonetheless represent an ideal and one which must be incorporated into our outline of Gender Theory of the times. Some women whose political influence as well as their personal reputation for sanctity, such as St. Catherine of Siena, must certainly have challenged the way many churchmen, men steeped in the traditional doctrines of proper male-female relationships, thought about women. Of course these women, such as Trotula, Catherine of Siena, Marie de France, Eleanor of Aquitaine and Joan of Arc, to mention some of the better known, were thought of as exceptions, but to the thinking individual, certainly the contrast between the lived experience of women and the theories read in the traditional texts must have encouraged these thinkers to disregard the gender strictures attributed to Aristotle. This also must certainly have been the case with creative writers, such as Chaucer and the authors of the Lancelot stories, that reality would supersede the theories they had studied.

There were always those writers who clung to the traditional attitudes and on them the reality of remarkable women had no effect. However much one may try to explain it away, the negative attitude of the author of *Sir Gawain and the Green Knight* seems in no way to allow a balanced view of female personality to enter into his traditional picture of woman as temptress, the direct

descendant of Eve:

> And þur3 wyles of wymmen be wonen to sor3 e,
> For so watz Adam in erde with one bygyled,
> And Salamon with fele sere, and Samson eftsonez—
> Dalyda dalt hym hys wyrde Dauyth þerafter
> Watz blended with Barsabe, þat—and much bale þoled.
> Now þese were wrathed wyth her wyles, hit were a wynne huge
> To luf hom wel, and leue hem not, a leude þat couþe.
> For þes were forne þe freest, þat fol3 ed alle þe sele
> Excellently of allew þyse oþer, vnder heuenryche
> > þat mused;
> > And alle þay were biwyled
> > With wymmen þat þay vsed.
> > þa3 I be now bigyled,
> > Me þink me burde be excused.
> > (Lines 241–2428; ed. Norman Davis)

In spite of attempts to excuse the Gawain poet, these lines must be seen as clearly in the center of the traditional medieval antifeminist tradition. In the case of Chaucer's works, however, we see a more nuanced and complex picture of gender issues, one which clearly understands the tradition and in doing so is able to depart from it and level satirical criticism toward it.

Bibliography

Bassan, Maurice. "Chaucer's 'Cursed Monk,' Constantinus Africanus," *Medieval Studies* 24 (1962): 127–40.

Bat-Ami Bar On, ed. *Engendering Origins: Critical Feminist Readings in Plato and Aristotle.* Albany, New York: State University of New York, 1994.

Brenner, Athalya. ed. *A Feminist Companion to Reading the Bible: Approaches, Methods and Strategies.* Sheffield, England: Sheffield Academic Press, 1997.

Cadden, Joan. *Meanings of Sex Difference in the Middle Ages.* Cambridge, England: Cambridge University Press, 1993.

Chodorow, Nancy J. *Feminism and Psychoanalytic Theory.* New Haven: Yale University Press 1989.

Christine de Pizan. *The Book of the City of Ladies*, trans. Earl Jeffrey Richards. New York: Persea Books, 1998.

———. *La città delle dame*, Bilingual Italian/Medieval French edition with the Medieval French text edited with introduction and variants by Early Jeffrey Richards; introduction, Italian translation and notes by Patrizia Caraffi. Milan: Luni Editrice, 1997.

Davis, Norman, ed. *Sir Gawain and the Green Knight.* Oxford: Oxford University Press, 1967.

Delany, Paul. "Constantinus Africanus' *De Coitu*: a Translation,"*Chaucer Review* 4 (1969–70): 5–65.

Flandrin, Jean-Louis. "Contraception, mariage et relations amoureuses dans l'occident chrétien," *Annales: Economies, sociétés, civilisations* 24 (1969): 137–90.

———."Sex in Married Life in the Early Middle Ages: The Church's Teaching and Behavioural Reality," in *Western Sexuality: Practice and Precept in past and Present Times,* edited by Philippe Ariès and André Béjin; translated by Anthony Forster. Oxford: Basil Blackwell, 1985, pp. 114–29.

Freeland, Cynthia A. "Nourishing Speculation: A Feminist Reading of Aristotelian Science," in *Engendering Origins,* ed. Bat-Ami Bar On, pp. 145–187.

Gilbertus Anglicus. *Compendium Medicinae.* Lyon: Jacobus Saccon, 1510. Giovanni Boccaccio. *Famous Women (De Mulieribus Illustris)*, ed. and trans. Virginia Brown. Cambridge, Mass: Harvard University Press, 2001.

Guillaume de Lorris and Jean de Meun. *Le Roman de la rose,* ed. Ernest Langlois. Paris: Firmin-Didot, SATF, 1913–24.

———. *The Romance of the Rose,* trans. Harry W. Robbins. New York: E. P. Dutton, 1962.

Haraway, Donna J. *Simians, Cyborgs and Women: The Reinvention of Nature.* New York: Routledge, 1991.

Hildegard of Bingen. *Causae et curae [Liber Compositae Medicinae],* ed. Paul Kaiser. Bibliotheca Scriptorum Graecorum et Romanorum Teubneriana. Leipzig: B. G. Teubner, 1903.

Johannes Anglicus. *Rosa Anglica Practica Medicine.* Venice: Bonetus Locatellus, 1516.

Leclerc, Lucien. *Histoire de la médecine arabe.* 2 vols. New York. N.D. (originally published 1876).

Lorber, Judith. *Paradoxes of Gender.* New Haven: Yale University Press, 1944.

McVaugh, Michael. "Constantine the African" in Charles Coulston Gillespie, ed. *The Dictionary*

of Scientific Biography. New York: Scribner, 1970–80, pp. 393–5.

Modrak, Debrah. "Aristotle: Women, Deliberation and Nature," in Bat-Ami Bar On, ed. *Engendering Origins*, pp. 207–222.

Newman, Barbara. *Sister of Wisdom: St. Hildegard's Theology of the Feminine.* Berkeley: University of California Press, 1987; 1997.

Paglia, Camille. *Sexual Personae.* New York: Vintage Books, 1991.

Plato. *The Collected Dialogues.* In English, translated by various translators, ed. Edith Hamilton and Huntington Cairns. New York: Pantheon Books, 1966; 2000.

Powicke, F. M. The Medieval Books of Merton College. Oxford, England, Oxford University Press, 1931.

Rubin, Gayle. "The Traffic in Women: Notes on the Political Economy of Sex," in *Toward an Anthropology of Women*, ed. Rayna R. Reiter. New York: Monthly Review Press, 1975, pp. 157–210.

Ruether, Rosemary, ed. *Religion and Sexism: Images of Woman in the Jewish and Christian Traditions.* New York: Simon and Schuster, 1974.

Rutledge, David. *Reading Marginally: Feminism, Deconstruction, and the Bible.* Leiden and New York: E. J. Brill, 1996.

Schottroff, Luise. *Feminist Interpretation: The Bible in Women's Perspective.* Minneapolis: Fortress Press, 1998.

Schüssler Fiorenza, Elisabeth. *Wisdom Ways: Introducing Feminist Biblical Interpretation.* Maryknoll, New York: Orbis Books, 2001.

Senach, Christine. "Aristotle on the Woman's Soul," in Bat-Ami Bar On, ed. *Engendering Origins*, pp. 223–237.

Smith, Elizabeth J. *Bearing Fruit in due Season: Feminist Hermeneutics Hermeneutics and the Bible in Worship.* Collegeville, Minnesota: Liturgical Press, 1999.

Steinschneider, Moritz. "Constantinus Africanus und seine arabischen quellen," *Virchow's Archiv für Pathologische Anatomie und Physiologie* 37 (1866): 351–410.

Sturges, Robert. *Chaucer's Pardoner and Gender Theory.* New York: St. Martin's Press, 2000.

Tolkien, J. R. R. and E. V.Gordon, ed. *Sir Gawain and the Green Knight.* 2nd edition. Norman Davis ed. Oxford: Clarendon Press, 1972.

Tavard, George. *Woman in Christian Tradition.* Notre Dame Press, Notre Dame, Indiana, 1973.

Tuana, Nancy, "Aristotle and the Politics of Reproduction" in Bat-Ami Bar On ed. *Engendering Origins*, pp. 189–206.

Washington, Harold C. and Susan Lochrie Graham, ed. *Escaping Eden: New Feminist Perspectives on the Bible.* New York: New York University Press, 1999.

Wittig, Monique. *The Straight Mind and Other Essays.* Boston: Beacon Press, 1992.

2

Chaucer and Christine de Pizan

Some scholars of medieval literature, particularly those interested in feminist issues, have speculated how satisfying it would be if research could establish a connection between Chaucer and his near contemporary, Christine de Pizan. She was twenty-four years younger and lived to be four years older. Their dates are Chaucer: 1340–1400 and Christine 1364–1429. Some feminist critics such as Shiela Delany, Maureen Quilligan, and Jill Mann have noted similarities between their works and have made comparisons without being concerned about an actual connection. This much is certain: no trace of Christine's work is known to be clearly cited in Chaucer. By the time that she began to publish, in the middle and late 1390's, Chaucer was no longer reading French authors as intensely as he had at the beginning of his intellectual career. His interest had been in an earlier generation of French writers, Machaut, Froissart, Deschamps and, before that, particularly, De Lorris and De Meun. As for Christine, she did not read English and there is no sign she knew Chaucer's works.

Christine did, however, develop close ties with the court of England. In the last years of the century, Christine sent her son Jean for to London for several years where he doubtless learned the English language and given both the English poet's prominence in that social class as well as the fact that his mother was a serious writer, the boy almost certainly made contact with Chaucer's work or his reputation. In the fall of 1398 Christine met the Earl of Salisbury in Paris, with whom she probably spoke in French, and who showed his appreciation for her writing. Her reputation in England grew in the following

century and many manuscript copies of her writing in French and in English translation dating from that time can be found in English libraries. She probably felt that her son would receive a good career start at the court of Richard II where Salisbury enjoyed special favors. Jean was recalled summarily two years later by his politically sensitive and cautious mother when Henry IV came to the throne under somewhat frightening circumstances. Salisbury was executed as a traitor and Christine hastened to bring her son home, having lost her most trustworthy English patron. (Willard, *Christine de Pizan: Her Life and Works,* 42–43.) Modern readers of Christine's work, both of the prose and poetry, see that it is suffused with intellectual material drawn from the classics, Virgil, Ovid, Boethius, and Italian writers such as Dante, Boccaccio, and Petrarch as well writers in her adopted country the French authors, de Lorris, de Meun, Machaut, Froissart and Deschamps. In the roll call of favorite authors for Chaucer, one is immediately struck by some similarities with Christine's regular reading. There is the interest in classical authors, Italian poets and the recent most popular French writers. This similarity should compel both Chaucerians and readers of Christine's work to look more closely at the two. I have done so and found several notable points of interest, some of which have been cited by other writers, some of which have been overlooked.

In his book *Chaucer and his French Contemporaries,* James Wimsatt has little to say about Christine, perhaps because he is not looking for an opportunity to forge a link between them. His discussion of Eustache Deschamps is significant because, in the interests of my discussion here Deschamps may be the connection, if one can be found, between Chaucer and Christine. Chaucer and Deschamps have many similarities and in his earlier works, Chaucer is as much French as English (though later he shifts his interests very heavily to Dante and Petrarch). Deschamps has been cited as a major influence in Chaucer's composition of the Prologue to the *Legend of Good Women*. The precise nature of this influence has been disputed and John Livingston Lowes published, in 1904, a lengthy comparison of Deschamps and Chaucer. Although Lowes' argument on the relationship between Deschamps

and Chaucer has been seriously and convincingly challenged by Marian Lossing in 1942, yet the presence of Deschamps must still be acknowledged and perhaps there is more of Deschamps in the Prologue than just some resemblances between certain passages cited here and there from his works. The prologue does exhibit some close parallels to lines in Deschamps' *Lay de franchise,* as most current commentators still feel convinced (Wimsatt, p. 263). Both poets alleviate their sadness in love by contemplating a sweet flower (Chaucer's daisy, a flower not named in Deschamps). Deschamps' narrator catches sight of a company of nobles dressed in green, just as Chaucer's persona sees a woman in green. Interestingly, when Deschamps' poem comes to its ending it engages in a moralistic attack on the indecency of extravagant meals on the part of the nobility while Chaucer's narrator is chastised for his writing which has been offensive to women.

In her book *The Naked Text,* Shiela Delany undertakes an extensive comparison between Chaucer's *Legend* and Christine's *Livre de la cité* and points out the many and very notable similarities between them, though she is never trying to draw a direct connection between the two which were composed approximately twenty years apart (c. 1385 for the *Legend* and 1405 for the *Livre de la cité*). Delany comes close to establishing a connection between the two and certainly her comparison demonstrates great similarity, one that would justify a book length study of the two authors. "There is no evidence that the two writers met" she says "but they probably knew of each other," she adds, but without proof (p. 94). In her comparison, it seems to be Delany's purpose to show that the feminist mentality of Christine treats authors differently on the issue of how an author-narrator confronts literary misogyny. In this analysis, Delany sees a failure in Chaucer's account of how to deal with a misogynistic tradition.

> Both works purport to rewrite that tradition in order to present a new image of woman, that of the good woman. That Christine actually does this, while Chaucer does not, strikes me as an interesting opportunity for speculation within the problematic of gender-linked literary production. (p. 95)

Delany is perhaps too harsh on Chaucer. The fact that he takes on this gender issue at all is certainly a notable event. Also, that success should be claimed for Christine is problematic. Though in her later publications Delany sees Christine as somewhat backwards in her political thinking in terms of gender issues, even labeling her as the "'Rosemary Woods' and the 'Phyllis Schlafly'" of her day (Reno 171). By her later assertion of Christine's conservative attitudes, Delany is in fact moving the two closer together. Delany might note that the two writers approach the topic as completely gendered personalities—Chaucer as a male accused of writing in the misogynist tradition, Christine as the female who must confront that tradition as it affects her assessment of her own intellectual life. In a dream vision both are confronted by a female figure, a personification which for both authors comes obviously from the apparition of Lady Philosophy in the *Consolatio* of Boethius. It is reasonable to expect, as Delany observes, that in Chaucer's case, the

> female figure is not represented as an aspect of the poet's self. Instead, she is distanced remaining woman-as-object: critic of the poet's work and object of his devotion, Other. Christine's female figure on the other hand, is Lady Reason, explicitly portrayed as an aspect of the narrator's self: her own capacity for reason, as well as the personification of human reason generally. (p. 96)

Delany does not comment on how the female figure which personifies Philosophy functions in the Boethian *Consolatio*. In Boethius, she hardly has a gender role, so perhaps she is seen simply as "the personification of human reason generally" and of Boethius' own philosophical awareness. She is, in the *Consolatio*, an extension of the author's own self with no concern about his gender. Delany does Chaucer readers a great service in delivering this insightful distinction that Chaucer cannot get beyond his male identity in this instance. It is difficult for me to see Delany's conclusion, however: "His intellectual posture can scarcely generate a frontal assault on tradition, for it is a posture of receptivity rather than of reconstruction" (p. 97). It was never Chaucer's expressed hope to stage a "frontal assault" as we can read was Christine's stated intent. In Chaucer it is not a matter of reconstruction nor receptivity but of a

recognition, an event already of considerable import in England of the late 1300's.

Christine's involvement in the gender issue is profound and personal. Chaucer's involvement seems to be on the intellectual level, perhaps on the moral level, but it does not seem to be a personal issue. Chaucer's interest in gender would appear to develop from his intense involvement with a purely literary character analysis and the creation of personality types such as are illustrated in the General Prologue to the *Canterbury Tales*. The historical context of courtly love, a topic which thoroughly imbued the poetry of French and Italian writers that Chaucer was reading at the time, must inevitably have led him to consider the matter of gender differences, the implications of these differences and how they have been treated by the main stream writers he knew. In Boethius the matter of gender hardly appears at all and in Dante and Petrarch in highly idealistic form, but in the *Roman de la Rose,* one of the first works Chaucer studied with great intensity, the issue became at first fascinating and then problematic for him. This was an intellectual interest, perhaps a moral one, yet not a deeply felt personal one, at least not as it was to Christine.

For Christine, whose approach to traditional literature is just as serious, though not as much concerned with the study of character and the creation of literary personality, the gender issue becomes more immediate when she is confronted with the traditional texts. We can be sure that she was bothered by misogynist passages in Aristotle and Plato and by comments from works by contemporary writers even perhaps in the work of her friend Deschamps. But it is Matheolus whom she singles out for the occasion to force the issue to its crisis.

> The next morning, again seated in my study as was my habit, I remembered wanting to examine this book by Matheolus. I started to read it and went on for a little while. Because the subject seemed to me not very pleasant for people who do not enjoy lies, and of no use in developing virtue or manners, given its lack of integrity in diction and theme, and after browsing here and there and reading the end, I put it down in order to turn my attention to more elevated and useful study. (p. 3, Richards trans.)
>
> Le matin ensuivant rassise en mon estude si que j'ay de coustume, n'oubliay pas mettre

> a effect le vouloir qui m'estoit venu de visiter ycellui livre de Matheole. Adonc pris a lire et proceday un pou avant, mais comme la matiere ne me semblast moult plaisant a gens qui ne se delittent en mesdit, ne aussi de mal prouffit a aucune edifice de vertu et de meurs, veu ancore les paroles et matieres deshonnestes de quoy il touche, visitant un pou ça et la et veue sa fin, le laissay pour entendre a plus hault estude et de plus grant utilité. (pp. 40,42)

Lori Walters, in an article from the collection of essays by Zimmerman and De Rentiis, shows how Christine and Chaucer read many of the same Italian poets. Though she does not mention Petrarch by name, it is obvious that Christine read his works and was influenced by his writing. Like Chaucer, Christine is very interested in Ovid, if much disturbed by his antifeminism. Walters notes:

> Although she mentions the name of Ovid three times in the *Cent Balades* and makes several other allusions to the Ovidian *Metamorphoses,* she would go on to attack him bitterly for his antifeminism in the *Epistre au Dieu d'Amours* and in the *Cité des Dames.* (p. 56)

Brownlee also comments extensively on Christine's use of Ovid, and remarks on the French widow poet's dislike of the Roman poet's ideas, though she is much impressed by his verse. Chaucer's attitude toward Ovid is much simpler, seeing him as a rich source for classical stories and certainly admiring him, rightly, for his poetic style.

As Monica Green indicates, one major difference between Chaucer and Christine in the use of Ovid is her tendency to deeroticize her heroines "to suppress or omit any negative associations with adultery or sexual promiscuity they may have had" (Green 169). Hicks (*Debat* 138) cites Christine on Ovid's ideas as "la poerverse doctrine, et le venim engoisseux" (perverse, poisonous doctrine).

In contrast, Deschamps, almost in defiance of his friend Christine's feeling about Ovid, praises Chaucer as "Great Ovid" (Ovid grans en ta poëterie) (Kellog 149) and even more remarkably describing Christine (again, seemingly unaware of her sensitivities) says that Christine is above Ovid:

Noble poete et faiseur renomme
Plus qu'Ovide vray remede d'amours
Qui m'a nourry et fait maintes doucous
(from Wimsatt. 247–48)

Noble poet and famous writer, more than Ovid, the remedy of love, who has nourished me and created much beauty.

Here and elsewhere, there is the strange conflict of the strong and mutual personal esteem between Deschamps and Christine which contrasts with their different estimates of ancient Roman and medieval Italian writers.

Familiarity with Christine's body of work must make one admit its astonishing breadth of scholarly interest. As an intellectual she had greatly impressed her contemporaries, notably scholars such as Jean Gerson, chancellor of the University of Paris. She is partial to the authors of her native Italy, a group of authors who were also of major interest to Chaucer as a consequence of his several visits to Italy. One must remark also that Christine's reading and her interests are far broader than Chaucer's. In shear volume of written work, she was more productive. Her high productivity is understandable since she was a full time scholar (an enterprise in which, against all odds, she enjoyed moderate financial and professional success) and depended on her writing for sustenance while Chaucer had other duties to perform. As a civil servant, he had regular job duties to undertake variously as customs inspector, administrator of payroll and, among other time consuming responsibilities, his diplomatic journeys. His study and writing were done during odd hours and in the evening, time stolen from his employment. It must also be pointed out that the spirit and temper of their writing differs considerably. Christine is polemic, politically concerned, a crusader for women's rights and very much morally preoccupied. Chaucer is more witty, less political, not at all interested in causes and usually given to exploring moral ambiguities.

It is not the purpose of this chapter to make a full scale comparison of these two writers but rather to examine a possible link between the two. The two are tied, certainly, in their interest in the then immensely popular *Roman de la Rose*.

It was a work that Christine knew intimately, at first as a scribe when she may have made copies of it, and then as a polemicist when she initiated and won partisans on her side for a general denunciation of the work's anti-feminist passages, particularly in the second part written by Jean de Meun. For my discussion of the debate over the problem of the *Roman de la Rose* and Christine's relationship with Jean Gerson, Jean de Montreuil, Gontier and Pierre Col, among others, my indispensable reference has been Eric Hicks, *Le débat sur le Roman de la Rose*. For a briefer statement in English where Christine forcefully condemns the *Roman de la Rose,* one may see Hicks' translation of her "Lesser Treatise" in Charity Cannon Willard, *The Writings of Christine de Pizan,* 152–161.

Christine is most recognized in recent decades for her deeply felt reaction to passages against women that she read in the works of authors whom she otherwise respected and loved. In a particularly moving section of her *Livre de la cité de dames*, she tells of her depression in coming to terms with the accusations leveled by both classical and modern writers against the inadequate, deficient and even vile nature of women. The mention of Matheolus in the opening chapters of Christine's testimony about her personal intellectual crisis has not been significantly noted with any particular link to Chaucer. Thanks largely to the work of Zacharias Thundy, we now have a better sense of where Matheolus fits in the rich, complex and intricate intellectual web in which Chaucer, Christine and Deschamps as well as some minor French writers such as Jean Le Fèvre shape significant patterns. Christine cites the name of Matheolus as one of the anti-feminist writers who most offended her and precipitated her anxiety and self examination that, among other remarkable results, evoked from her a wish that she had rather have been born a man.

Matheolus, the Latinized name of a French priest called Mathieu or Mahieu, abandoned his priestly calling to marry a widow, Petronilla (Perette), then lived to regret the decision. The young and attractive widow seemed more important than his vocation for the priest who looked for passion; but unfortunately for Mathieu the marriage turned out very sour and, according to his description,

Petronilla was transformed from an alluring love who seduced him out of religion to a life of married misery; she became a shrew who gave him no peace in the home and no satisfaction in bed. The arrival of children only made matters worse for Mahieu and, as it would seem, the priestly training of the man did not prepare him for the demands of parenthood with nagging financial obligations and the disruptive household of noisy children which interrupted his bookish and literary peace of mind. The suffering ex-priest turned his unhappiness into a diatribe against all women and all marriages; he vented his complaint in a lengthy Latin poem, the *Lamentationes*. In it he complains specifically about his wife and then goes on to criticize women in general. He continues to do so for thousands of lines in Books I and II. In Book III Mathieu attempts like a good stoic philosopher to reconcile himself to his fate—in the manner of the Boethius *Consolatio*—and imagines a dream in which God assures him that in heaven all will be well and in just over one thousand more lines, the now repentant ex-priest attempts to bring his thoughts about marriage—in the abstract at least—into line with traditional Church doctrine on the matter.

This lengthy Latin poem which by any account and certainly by the reaction it evoked from Christine de Pizan, must be called misogynistic, was translated into French by Jean Le Fèvre, in Paris, about 1371 or 1372, some one hundred years after it was originally composed. Two years later, the same Le Fèvre, interestingly and perhaps instructively, write a sequel on the topic of women and marriage. In this second work, *Le Livre de leësce*, Le Fèvre made an attack on the Matheolus poem which he had so recently and so faithfully translated into French. The new work represented a complete reversal of Le Fèvre's thinking of two years previous, assuming that the translation some how represented his "real thinking" on the topic at the time. The new work seems to argue that, in the words of Professor Thundy: "women are more chaste, more honest, more virtuous and more trustworthy than men" (p. 25).

Thundy has read closely the text of Matheolus and, though Chaucer never explicitly mentions the name or work of Matheolus, he argues that Chaucer made much use of the *Lamentationes* (probably in the French translation by Le Fèvre)

and, particularly, that many passages in the Wife of Bath's Prologue appear to be drawn from that work. The numerous passages which Thundy aligns on pp. 28–33 of his article seem to indicate more than mere coincidence and perhaps Matheolus' book was indeed in Chaucer's study for some time in the late 1300's as indeed we know it was in the study of Christine de Pizan (no doubt in a different copy) shortly after. Christine's reaction to the work is easily understood. Chaucer's treatment is characteristically complex, ambiguous and not as easily interpreted. As I indicate in another chapter of this book, Chaucer's Wife of Bath eagerly takes on many of the attributes assigned to unpleasant and shrewish women and to women in general. I believe she does so to undercut and refute these misogynistic accusations by making them a part of her glorious feminine identity. In short, I believe the Wife of Bath's absorption of antifeminist and misogynistic texts from St. Paul and St. Jerome as well as from Matheolus constitute a refutation of them, one which renders them by ironic wit as meaningless (a point not made by Professor Thundy).

A further role played by Matheolus' poem may be seen in the works of Eustache Deschamps, another important actor in this drama who must be allowed an appearance in any comparison of Chaucer and Christine. Disregarding questions of who influenced whom, whether Chaucer derived his Matheolus from Deschamps or whether Deschamps and Chaucer both drew directly from Matheolus, I cannot doubt that Deschamps drank deep draughts from the springs of Matheolus' misogyny. Renate Blumenfeld-Kosinski in her article "Jean Le Fèvre, Livre de Leesce: Praise or Blame of Women," has shown that Le Fèvre's work was frequently in the hands of the intellectual French writers from the 13th to the 15th centuries. Her lengthy and greatly nuanced article ranges widely to cover the many complexities of Matheolus' work and Le Fèvre's refutation of it. She says of the part where Matheolus attempts to reconcile himself to the sacred purpose of marriage: "book 3 of the Lamentations is extremely funny—whether intentionally or not is hard to say" (p. 711). This is a comment which is as effectively dismissive as any made by the Wife of Bath.

It seems that Le Fèvre may have been compelled by some (for us) unknown responses to his French Matheolus. Chaucer seems to have encountered some similar criticism for his English translation of the *Roman de la Rose*, if we are to judge by his Prologue to the *Legend*. In Le Fèvre we read:

> Ladies, I ask, your pardon. I want to excuse myself before you for the fact that I have spoken of the great discord and torments of marriage without your permission. I slandered you by this outrage, I can well say, without trying to curry your favor. That I have done nothing but translate what I found in the Latin. I implore you to forgive me for this, for I am all ready, to compose a book in my excuse.

> Mes dames, je requier mercy.
> A vous me vueil excuser cy
> De ce que sans vostre licence
> J'ai parlé de la grant dissence
> Et des tourments de mariage.
> Se j'ay misdit par mon aultrage,
> Je puis bien dire sans flater (1–7)

> Je suppli qu'il ne soit remis
> Et Pardonné par vostre grace.
> Car je suy tout prest que je face
> Un livre pour moy excuser (lines 14–19)
> (Cited, with some adjustment, from Blumenfeld-Kosinski, pp. 711–712.)

It seems that a sense of repentant misogyny was in the air during the late 1300's since we see in Chaucer's prologue to the *Legend of Good Women* almost a decade later that he asks for mercy and claims ignorance for his defense:

> I ros, and doun I sette me on my kne,
> And seyde thus, "Madame, the God above
> Foryelde yow that ye the god of Love
> Han maked me his wrathe to foryive,
> And yeve me grace so longe for to live
> That I may knowe sothly what ye be
> That han me holpen and put in swich degre.
> But trewely I wende, as in this cas,
> Naught have agilt, ne don to love traspas.
> For-why a trewe man, withoute drede,

Hath nat to parte with a theves dede;
Ne a trewe lovere oghte me nat to blame
Thogh that I speke a fals lovere som shame.
They oughte rathere with me for to holde
For that I of Criseyde wrot or tolde,
Or of the Rose; what so myn auctour mente,
Algate, God wot, it was myn entente
To forthere trouthe in love and it cheryce,
And to be war fro falsnesse and fro vice
By swich ensaumple; this was my menynge." (445–464)

The experience which Christine described in the opening pages of her *Livre de la cité* was the culmination of a profoundly moving and regenerative time for her which had probably been developing over a period of years. As she describes the experience, Christine finally resolves that she need not accept these accusations about the evil nature and inferior minds of women and sets about writing an outline of an ideal city of ladies peopled by women who were examples of good moral behavior and high intellectual abilities; she thus challenges the accusations of generations of male writers. Before, however, she ever undertook this *Livre de la cité*, she had been publicly critical against that already established classic of French literature, the *Roman de la Rose*.

Christine was born in Venice about 1364 and as an infant went with her father to Paris where she married young and had three children. It was largely due to her father, the court astrologer, that she developed her intellectual interests and was encouraged to read widely in the sciences, philosophy and poetry. In 1389, when she was only 25 years of age, she lost her husband to the plague. She then applied herself to an unmarried life of scholarship and writing. By 1401 she achieved some recognition, even some notoriety among her contemporaries in the debate over the *Roman de la Rose*. She had created both opponents and allies among the distinguished intellectuals of her time by her attack on Jean de la Montreuil, provost of the city of Lille (who was joined by the brothers Pierre and Gontier Col); her most distinguished ally was Jean Gerson, chancellor of the University of Paris. Christine collected the letters and texts of this debate and presented them to the queen, Isabeau of Bavaria. By this

time, it was 1401 and Chaucer had probably already died. Christine was 37 years of age.

Christine's dismay over the status of women and her feelings as defender of women's dignity had doubtless been some years in the developing and was certainly well formed while she was still in her twenties. Among her friends, if not her ally in the debate over the *Roman de la Rose,* was another distinguished French intellectual and important poet, Eustache Deschamps. Eustache Deschamps, also known as Eustache Morel, was a writer of Chaucer's generation, a Frenchman who in fact, became a friend and acquaintance of Chaucer from the early 1360's when they met during one of the youthful Chaucer's travels in France. They became correspondents and life-long friends. Deschamps was also friend to Christine and there are extant poems that he has written to both Chaucer and Christine. In his "Ballade" to Christine, Deschamps renders her high praise indeed and, justifiably, says to her "I know of no one like you today, who could equal you in learning." The close intellectual relationship of the two is touchingly confirmed in her letter of Feb. 10, 1404 to Deschamps in which Christine calls him "dear master and friend." (Willard, *Writings*, xiv and 27. Christine's letter to Deschamps with his ballade to her, both translated into English in *The Selected Writings,* ed . Blumenfeld-Kosinski, 109–113.)

Deschamps, however, did not participate in the debate which we now call the *Querelle de la Rose* and his name does not occur in Hicks' modern edition of the collected documents about the debate. It has been established by Charity Willard and others that Christine was influenced by Deschamps as early as 1390 and he doubtless was aware of the debate over the *Roman de la Rose.* The closeness of these two French intellectuals, Christine and Eustache, is indisputable. Eighteen years her senior, Deschamps must have known Christine personally since both spent some of the same years together at the court of Orléans during the late 1300's. He may even have had a romantic interest in her.

One cannot overlook the fact that on the very face of it, Deschamps's record on feminist issues is not favorable, though he and Christine remained friends. His *Miroir de la mariage* contains many passages satirizing marriage and

women; we have no explicit statement from Christine that she was offended by the *Miroir*, though much of that work goes against her convictions of an ideal marriage. As Lori Walters points out in an essay on Deschamps and Christine, Deschamps wrote and behaved in a way that suggested his feelings on the matter of women were ambiguous at best. Nonetheless, she remained an admirer and imitator of his works until the end of his life (about 1407).

In a ballade which Deschamps wrote probably about 1390 (according to a carefully and convincingly argued dating by Murray L. Brown) we see a poem of profuse praise addressed to Chaucer. A survey of the exiting scholarship on this "Ballade" raises more questions than can be answered from the existing medieval documents. There are numerous discussions of Deschamps and Chaucer, but the most notable may be found in articles by David Lampe, Murray L. Brown, and James Wimsatt. These lines of Deschamps' "Ballade" comprise an important text well known to Chaucerians and it is on these forty three lines of French verse I would like to concentrate the remainder of this chapter. At the end of the chapter I have inserted the text of the "Ballade" in French with my translation, based on Wimsatt, pp. 249–250.

The praise accorded Chaucer by Deschamps is notable for a number of reasons; several sections of these four stanzas deserve some close attention. In the first stanza, Deschamps praises the English poet with comparisons to the classical poets of Greek and Roman antiquity: "O Socrates full of philosophy, a Seneca in morals, an Aulus Gellius in practice, great Ovid in your poetry, brief in speech, learned in rhetoric." This praise is all the more remarkable because Deschamps could not yet have read what we consider the best of Chaucer's poetry as we know it in the *Canterbury Tales*, a work that was largely the product of the 1390's and yet to be written. In the second stanza of the ballade, Deschamps comes to his main point, which is praise of Chaucer as translator of the *Roman de la Rose*. The phrase *Grand translateur* is repeated at the end of each stanza as Deschamps' recurring motif in the "Ballade"; it is therefore the main point of the poem and, very likely, refers to the several issues connected with the *Rose*. It seems that this particular achievement of translation especially

impressed the French poet because it brought to England an important document of French literature. As he begins his horticultural imagery, Deschamps praises Chaucer for transplanting the *Book of the Rose* from France to England. This transplanting is an image that—not coincidentally—parallels the image Christine uses, when writing later, as she says that the *Roman* was a tree that never should have been planted in France.

In his third stanza Deschamps asks for Chaucer to send more—ideas or poems—to slake the Frenchman's thirst. He also alludes to Sir Lewis Clifford, the carrier of his message to Chaucer. "For this reason I would ask from you, from the fountain of Hippocrene, an authentic drink whose due is entirely in your bailiwick in order to hold back with it my moral thirst, I who in Gaul will be paralyzed until you give me to drink." (On Clifford, see the article by Reisner.) It is in the final stanza, passages with ambiguities that have elicited numerous differing interpretations, that I wish to concentrate on Deschamps' request of Chaucer. "Consider what I have said to you earlier, about your noble plant, your sweet melody." *Ton noble plant, ta douce melody.* "But that I may know, I pray you to write back about this," *Mais pour sçavoir, de la rescripre te prie.* Brown translates this final clause interestingly as: "Nevertheless, that I may not be left in doubt, I beg thee to return me an opinion." *Mais pour sçavoir, de la rescripre te prie.* When Deschamps refers to what he describes above, after calling Chaucer *"Grant Translateur"* and devoting an entire stanza specifically to the *Roman*, can Deschamps be referring to anything other than an opinion on the *Roman*? Among the several commentators on this "Ballade," it has been speculated that the "Ballade" was accompanied by a letter which was more explicit in its comments to the English poet, but no one has yet commented on the obvious possibility that Deschamps wanted Chaucer's opinion on the question of the *Roman*, a debate which was probably already simmering in Paris and would eventually emerge in a collection of written exchanges edited by Christine. Though the completed document she assembled is dated to 1401, its development must have taken some years, perhaps as much as a decade. Beginning with discussions and spoken debate which eventually were put into

written form, the issue may have been emerging in Paris as early as 1390. Already, no doubt, Christine was making her opinion known whether in Paris or Orléans. It is possible that Deschamps was at this point also attempting transplant to England some sprigs of the debate over the *Roman* (to use his own horticultural image).

There is no extant clear and explicit reply from Chaucer to Deschamps' earnest request in the final stanza of the ballade, *de la rescripre te prie*. At about this time, however, Chaucer began to write the Prologue to the *Legend of Good Women*. It is not clearly a reply to the request by Deschamps, but the Prologue is thoroughly imbued with the influence of the French poet. John Livingston Lowes demonstrated that much of the material in the prologue comes from Deschamps' *Lai de la franchise* written in 1385 the text of which Lowes feels that Chaucer may have received with this ballade at the hand of their go between, Sir Lewis Clifford, an earlier date than is generally now accepted. The passages in the Prologue, however, which depict Chaucer under accusation of anti-feminism do not come from Deschamps and appear to be Chaucer's original composition.

The *Legend of Good Women*, and particularly the Prologue, mark a significant event in Chaucer's life and he indicates those several new directions in which his writing will turn. At the outset we note that there are two versions of the Prologue and regardless of which may be dated earlier (as Seymour argues, the question is still open) the existence of two versions is in itself significant. Although Chaucer doubtless revised and rewrote many of his poems, we must take note that two versions of this prologue have come down to us and no other poem has undergone a similar textual experience among all his works. It is a composition of great introspection and self examination that provoked Chaucer's continued and renewed concentration over a period of several years. In a manner which we see several times in the *Tales,* Chaucer presents us with an extended self satirizing and self deprecatory scene which ultimately we must take seriously. One must deal here as well with a major development in English prosody. For the first time in English poetry the rhymed five foot line, the

pentameter couplet, is being used in an extended narrative, and here was established for Chaucer the verse form of choice; he thenceforth used the iambic pentameter couplet almost throughout the *Canterbury Tales* which he spent the following decade of his career writing (though without completing it). The significance of this shift from the French tetrameter line to the Italian pentameter has been noted as early as 1758 by Thomas Tyrwhitt in *"The Canterbury Tales" of Chaucer*; Eleanor Prescott Hammond particularly developed the idea that Chaucer based his late metrics on Italian verse (*Chaucer: A Bibliographical Manual*, p. 486). The discussion is carried further in P. M. Kean "Chaucer An Englishman Elusively Italianate." The entire matter of Chaucer's versification and the debate over how "Italianate" it really was, aside from its five foot line, may be found with considerable bibliographic reference in Steven R. Guthrie, "Prosody and the study of Chaucer: A Generative Reply to Halle-Keyser." The importance of this development in Chaucer's verse alone would draw his intense concentration and preoccupation in the composition of the Prologue. The pentameter line did not come from Deschamps or Christine or any other French writer. Chaucer had been imitating his French models and his earlier poems, such as *The Book of the Duchess,* and *the Hous of Fame*, were written in tetrameter lines. *Anelida and Arcite* as well as the *Parlement of Fowls* were written in pentameters, but arranged in stanzas, the noted Chaucerian stanza of his middle period. But here for the first time emerges the pentameter couplet, the long narrative verse form which became so consistently tied with his own writing and with the long narrative poems of many subsequent writers. Chaucer was understandably introspective and preoccupied. He was developing a significant form, one certainly more significant than he realized. Furthermore, in the prologue Chaucer represents himself as under accusation; he undergoes a review of his writing career, a career in which Chaucer, a poet at about the age of 40, has not yet written his greatest work. He is under accusation of antifeminist writing by the God of Love who, in terms reminiscent of Deschamps' horticultural imagery, accuses Chaucer of being a worm whom he would prevent from coming closer to his flower (in this case a daisy, not a rose).

The accusations against Chaucer are severe:

> Thou maist yt nat denye,
> For in pleyn text, withouten nede of glose,
> Thou has translated the Romaunce of the rose,
> That is an heresye ayeins my lawe,
> And makest wise folk fro me withdrawe;
> And of Creseyde thou has seyd as the lyste,
> That maket men to wommen lasse triste,
> That ben as trewe as ever was any steel.
> Of thyn answere avise the ryght weel. (F, 327–335)

The accusations go on, but this should suffice. Chaucer is enjoined to write well of women and to compile this book of Good Women.

Derek Pearsall in his recent biography of Chaucer states clearly what is now generally recognized, that Chaucer was universally sensitive toward and concerned about women (see pp. 138–143). Pearsall cites Gavin Douglas on Chaucer's sympathy for women expressed in the fifteenth century (p. 138). As he assembles his summary judgement about women, however, Pearsall neglects to note an evolution in Chaucer's ideas. In the formation of his view of Chaucer and women, he cites early, middle and late works as though Chaucer's ideas had been constant throughout the thirty years of writing poetry. Chaucer's ideas on gender, as on versification, must be seen to evolve together while more complex ideas entered his sphere of reading. (This matter from Pearsall is pp. 191–192.) Derek Pearsall and others have claimed a model for the poet accused of insulting women then given a penalty to write well about them may have influenced Chaucer in his "self portrait" as we find it in the Prologue. This model Chaucer supposedly found in Machaut's *Le Jugement dou roy de Navarre*. The comparison between Chaucer and Machaut was first developed by G. L. Kittredge in 1910. Though there is a similarity, and though Chaucer almost certainly was acquainted with Machaut's work, this similarity should not discourage us from believing that Chaucer adopted that description in the *Jugement* to suit his own intentions, that is, to write a collection of stories that investigate gender issues by way of accounts about wronged female lovers.

Such then, to conclude, is the broad outline of my conjecture. After finishing his *Troilus and Criseyde,* and perhaps already under some accusation from critical women readers, Chaucer receives a message from his friend in France, Eustache Deschamps. That message, partly in form of a ballade, in conjunction with other poetry of Deschamps, inspired Chaucer to depict a scene in which he represents himself, sincerely, in a profound bout of self analysis. He consequently under takes a book which is written in recognition of Good Women. It is an inspiration which, given Deschamps' closeness to the active feminist sensibilities of Christine de Pizan, could very likely have come to Chaucer from her.

Appendix

O Socrates plains de philosophie,
Seneque en meurs et Auglux en pratique,
Ovides grans en ta poëterie,
Briés en parler, saiges en rethorique,
Aigles treshaulz, qui par ta theorique
Enlumines le regne d'Eneas,
L'Isle aux Geans—ceuls de Bruth—et qu'i as
Semé les fleurs et planté le rosier,
Aux ignorans de la langue pandras,
Grant translateur, noble Geoffrey Chaucier.

Tu es d'Amours mondains Dieux en Albie:
Et de la *Rose,* en la terre Angelique,
Qui d'Angela Saxonne, est puis flourie
Angleterre d'elle ce nom s'applique
Le derrenier en l'ethimologique—
En bon anglès le livre translatas;
Et un vergier où du plant demandas
De ceuls qui font pour eulx auctorisier,
A ja long temps que tu edifias
Grand translateur, noble Geffroy Chaucier.

A toy pour ce de la fontaine Helye
Requier avoir un buvraige autentique,
Dont la doys est du tout en ta baillie,
Pour rafrener d'elle ma soif ethique,
Qui en Gaule seray paralitique
Jusques a ce que tu m'abuveras.
Eustaces sui, qui de mon plant aras:
Mais pran en gré les euvres d'escolier
Que par Clifford de moy avoir pourras,
Grand translateur, noble Gieffroy Chaucier.

L'ENVOY

Poete hault, loënge d'escuirie,
En ton jardin ne seroie qu'ortie:

Consideré ce que j'ay dit premier,
Ton noble plant, ta douce melodie;
Mais, pour sçavoir, de rescripre te prie,
Grant translateur, noble Geffroy Chaucier.

1. O Socrates full of philosophy, a Seneca in morals, an Aulus Gellius in practice, great Ovid in your poetry, brief in speech, learned in rhetoric; a lofty eagle who by thy theory illuminates the kingdom of Aeneas, the Island of the Giants, those of Brutus. And you who have sown the flowers and planted the rose garden for those ignorant of the Greek language, you Great Translator, noble Geoffrey Chaucer.

2. You are the worldly God of Love in Albion, and you the *[Roman] de la Rose* in the angelic land, which from Anglo-Saxon has subsequently flourished as England, and to her this name is now applied, the final development in its etymology. Into good English you have translated that book; and in a garden there you have sought for plants from those who can show (poetic) authority for themselves, and now for a long time have you been at work, O Great Translator, noble Geoffrey Chaucer.

3. For this reason I would ask from you from the fountain of Hippocrene an authentic drink whose due is entirely in your bailiwick in order to hold back with it my moral thirst, I who in Gaul will be paralyzed until you give me to drink. I am Eustaces from whom you shall have some plants; but look gently on the works of a school boy which you may receive from me through Clifford, you Great Translator, noble Geoffrey Chaucer.

THE ENVOY

4. O high poet, the praise of squirehood, in your garden I am but a nettle; consider what I have said to you earlier, about your noble plant, your sweet melodie. But that I may know, I pray you to write back, you Great Translator, noble Geoffrey Chaucer.

Bibliography

Blumenfeld-Kosinski, Renate. "Jean Le Fèvre, Livre de Leesce: Praise or Blame of Women" *Speculum* 69 (1994): 705–25.

———. "Christine de Pizan and the Misogynistic Tradition" *Romania Review* 81 (1990): 279–92.

Brown, Murray L. "The order of the Passion of Jesus Christ: A Reconsideration of Eugene Deschamps's 'Ballade to Chaucer,'" *Mediaevalia* 11 (1989 for 1985): 219–44.

Brownlee, Kevin. "Ovide et le moi poetique" in Cazelles and Mela, ed. *Modernité au Moyen Age*. Geneva: Droz, 1990, pp. 153–173.

Chance, Jane. "Christine de Pizan as Literary Mother: Women's Authority and Subjectivity in 'The Floure and the Leefe' and 'The Assembly of Ladies,'" in The City of Scholars: New Approaches to Christine de Pizan. ed. Margarete Zimmerman and Dina De Rentiis. Berlin: W. De Gruyter, 1994, pp. 245–259.

Chaucer, Geoffrey. *The Riverside Chaucer*, Larry Benson, gen. ed., 3rd ed. Boston: Houghton Mifflin, 1987. Christine de Pizan. *The Writings of Christine de Pizan,* selected and edited by Charity Cannon Willard. New York: Persea Books, 1993.

———. *The Book of the City of Ladies*, trans. By Earl Jeffrey Richards, revised edition. New York: Persea Books, 1998.

———. *La Città Delle Dame*, an edition of *Livre de la cité des dames* by Earl Jeffrey Richards, with Italian translation by Patrizia Caraffi. Milano: Luni Editrice, 1997.

———. *The Selected Writings of Christine de Pizan,* ed. by Renate Blumenfeld-Kosinski, (New York, 1997), 109–113.

Delany, Sheila. *The Naked Text: Chaucer's "Legend of Good Women."* Berkeley, California: Berkeley University Press, 1994.

Eustache Deschamps, ed. Le Marquis de Saint-Hilaire. *Oeuvres Complètes de Eustache Deschamps*. Paris: Société des anciens textes francais, Firmin Didot, cie, 1880.

Green, Monica. "Traittie de tout de mensconrtes" in Marilynn Desmond, ed. Christine de Pizan and the Categories of Difference. Minneapolis, Minnesota, University of Minnesota Press, 1998, pp. 146–178.

Guthrie, Steven R. "Prosody and the Study of Chaucer: A Generative Reply to Halle-Keyser," *Chaucer Review* 23, no. 1 (1988): 30–49.

Hammond, Eleanor Prescott. *Chaucer: A Bibliographical Manual*. New York: Macmillan, 1908.

Hicks, Eric. *Le Débat sur le Roman de la Rose: Edition critique, introduction, traductions, notes*. Paris: H. Champion, 1977.

———. trans. "Christine's 'Lesser Treatise'" in Charity Cannon Willard, ed. *The Writings of Christine de Pizan*. New York: Persea Books, 1994, pp. 152–161.

Kean, P. M. "Chaucer an Englishman Elusively Italianate," *RES* n.s. 34 (1983): 388–94.

Kellogg, Judith L. "Transforming Ovid: The Metamorphosis of Female authority," in Marilynn Desmond, ed. *Christine de Pizan and the Categories of Difference*. Minneapolis, Minnesota: Univesity of Minnesota Press, 1998: pp. 181–194.

Kittredge, George L. "Chauceriana," *MP* 7 (1910): 471–4.

Lampe, David. "The Courtly Rhetoric of Chaucer's Advisory Poetry," *Reading Medieval Studies* 9 (1983): 70–83.

Lossing, Marian. "The Prologue of the *Legend of Good Women* and the 'Lai de Francise,'" *SP* (1942): 15–35.

Lowes, John Livingston. "The Prologue to the *Legend of Good Women* related to the French Marguerite Poems and to the *Filostrato*," PMLA 19 (1904): 593–683.

Mann, Jill. *Geoffrey Chaucer: Feminist Readings*. New York: Harvester Wheatsheaf, 1991.

Pearsall, Derek. *The Life of Geoffrey Chaucer: A Critical Biography*. London: Oxford University Press, 1992.

Quilligan, Maureen. *The Allegory of Female Authority: Christine de Pizan's Cité des Dames*. Cornel University Press: Ithaca, New York, 1991. Reisner, Thomas A. And Mary E. Reisner, "Lewis Clifford and the Kingdom of Navarre," *Modern Philology* 75 (1978): 385–90.

Reno, Christine M. "Christine de Pizan: 'At Best a Contradictory Figure'?" in *Politics, Gender, and Genre: The Political Thought of Christine de Pizan*, ed. Margaret Brabant. Boulder, Colorado: Westview Press, 1992, pp. 171–192.

Seymour, M. C. "Chaucer's Revision of the Prologue of the *Legend of Good Women*," *MLR* 92 (1997): 832–42.

Thundy, Zacharias P. "Matheolus, Chaucer and the Wife of Bath" in *Chaucerian Problems and Perspectives: Essays presented to Paul E. Beichner*, ed. Edward Vasta and Zacharias P. Thundy. Notre Dame, Indiana: Notre Dame Press, 1979, pp. 24–58.

Tyrwhitt, Thomas. *"The Canterbury Tales" of Chaucer* (1775), 2nd edition, Oxford: Clarendon Press, 1789, vol. 2, 51–52.

Walters, Lori. "Chivalry and the (En)Gendered Poetic Self: Petrarchan Models in the 'Cent Balades,'" in *The City of Scholars: New Approaches Approaches to Christine de Pizan*, ed. Margarete Zimmerman and Dina De Rentiis. Berlin: de Gruyter, 1994, pp. 43–66.

Willard, Charity Cannon. *Christine de Pizan: Her Life and Works*. New York: Persea Books, 1984.

Wimsatt, James I. *Chaucer and his French Contemporaries*. Toronto, Canada: University of Toronto Press, 1991.

3

Chaucer's Women and Their Logical Discourse

It is a commonplace still in modern as well as generally in medieval thought that logical discourse is the prerogative of males and does not come readily to women. This commonplace is notably confronted by Chaucer in a clever statement by the Wife of Bath which is both self refuting and typical of the logical abilities that Chaucer instills in his character of the Wife. The Wife shows herself a careful and consummate logician on a number of instances in both her prologue and her tale. In the midst of a lengthy discourse on gender differences which emphatically asserts her success in dominating all of her five husbands, an artfully crafted speech which clearly encourages all women to do as she has done, the Wife says to her fellow pilgrims:

> Oon of us two moste bowen, doutelees,
> And sith a man is moore reasonable
> Than womman is, ye moste been suffrable. (D 440–442)

This statement is only one of several in which the Wife of Bath uses the argument of paradox, a topic which I have discussed in another chapter of this book. In this statement, she argues that since it is well known women are not logical and men are more capable of logical behavior, men would do well to concede to women in arguments since a female is not logical enough to realize her inability to reason. Coming from a woman, and directed toward a male

audience (made up of such antifeminists as the Oxford Clerk) her logic is both an affront to them and irrefutable.

I cite this passage as an example of the widespread understanding of women's inferior logical abilities and I begin with the Wife of Bath because this Chaucerian example is most closely related to my topic. It would not be difficult to cite numerous medieval authorities on this topic of women's inferior logical abilities, but a few more samples would suffice. Certainly the most easily noted and perhaps most characteristic authorities summoned for these purposes are Saints Augustine and Thomas Aquinas. Aquinas is most complete in his discussion of the topic and, in several different places, makes thoroughgoing comparisons between the genders.

According to Aquinas, men are superior to women in both physical strength and in intellectual ability. Men are by nature created as the more reasonable and rational gender. It is notable that Thomas does not say women are "irrational," but rather that men are more rational. In this manner, women can be included under the general definition "Homo est animal rationalis." In this opinion, which he repeats in numerous places throughout his work, he is following a tradition which is seen early in Christian theology. St. Augustine undertakes a discussion of rationality in the two genders in his *De Trinitate*, Book XII and is cited by Aquinas to say that it is woman's place in the order of creation to be less reasonable; it is man's place to be more reasonable: "...ratio inferior locum mulieris, superior vero ratio locum viri" (*Questiones Disputate*, Qu. 7, art 3, 16). In accord with this inferior and superior ranking, as well, is the seriousness of the sin each commits, and so the male is more responsible. In his *Reportationes* (n. 3, cp. 11, vs 7) Aquinas carries on a sustained comparison between the genders. In the course of this discussion he explains the significance of women covering themselves with a veil (again from St. Augustine, *De Trinitate*, Book XII) and restates the natural superiority of men to women in both physical and intellectual capacities. Men are wiser and stronger than are women. He says, in very clear and simple Latin: "Nam viri sapientiores et fortiores sunt mulieribus." Scripture is the main basis for this

opinion. Woman was created from the side of man and so he is anterior to her and so more perfect than she: "*...haec igitur est ratio quare mulier producta est ex viro, quia perfectior est muliere.*" And in the *Summa Theologica,* part 1, ques. 92, ar.1, Aquinas says that women must be subject to men because of this inferiority. It must be so since men have the greater power of "rational discretion."

> From such a subjection naturally woman is subservient to man because naturally in man there is a greater abundance of rational discernment, nor is the inequality of men exempted at the time he was in a state of innocence.
>
> Sic ex tali subiectione naturaliter femina subiecta est viro quia naturaliter in homine magis abundat discretio rationis, nec inaequalitas hominum excluditur per innocentiae statum.

These are a few of the numerous passages in which Aquinas returns repeatedly to this topic.

An important aspect of Chaucer's presentation of logical discourse in his female characters is that in a culture whose mainstream is signaled by the stereotype of the illogical and irrational woman, he has chosen a number of accounts which undercut that commonplace. As in the prologue to the Wife of Bath's tale, where he has incorporated a series of anti-feminist anecdotes and proverbs and undercut their original antifeminist spirit by putting them in the mouth of the supreme feminine, so in the selection of narratives which are not particularly outstanding in their representation of female characters, he arranges a context of rational discourse in which he presents a series of remarkable female characters. Although there has been is no critical discussion which ties together these works to show that therein Chaucer is reversing the conventional stereotypes, a survey of the critical literature shows that Chaucer's sympathies for female characters is generally recognized. One need only see the entire context in which these stories are operative to understand the broad range of Chaucer's sympathies for female characters and his ability to understand and extricate himself from the bind of traditional stereotypes.

Any discussion of the intellectual character of Chaucer's female figures

must inevitably be tied to the central theme of the "Wife of Bath's Tale": domination in the male-female relationship. The Marriage Group is discussed in another chapter of this book but has an important bearing on the issue of logical discourse in the genders. In the context of that theory, the matter of female domination over males in relationships whether in marriage or not, is merely the matrix in which are embedded numerous other thematic strands. Chief among these thematic lines that will run through a good many of the tales, even though they are not part of the original four "Marriage Group," is the matter of the intellectual character that Chaucer instills into his female players. It is now generally acknowledged that the domination motif must be seen as extending beyond the central group of Wife of Bath, Clerk, Merchant and Franklin. It can, in fact, be seen even beyond the *Canterbury Tales* as a total work. And so, in my discussion, I will treat the motif of logical discourse in Chaucer's women as part of the domination theme and I will, accordingly, pursue it beyond the original Marriage Group and even beyond the *Tales* proper.

An important model for Chaucer in the submission of a man to the logical arguments of a female may be seen in the Boethian *Consolation of Philosophy* where, although Boethius' gender treatment may not have been intended literally, we see the confused persona of Boethius submitting to the logical arguments of the female embodiment of philosophy and logic. Chaucer may have seen this striking and widely represented relationship between the male philosopher and the female figure of unswerving philosophical wisdom as a relationship which can be transferred into a literal and real life male-female relationship. In any case, it is easy to see that throughout the numerous instances in his narratives where in a Chaucer narrative a male submits to the logic of a wiser female there is a very remarkable resemblance to that model.

Even in those cases where the male does not accept the superiority of the woman's logical argumentation, it is clear to the reader that the man is being irrational and is implicitly conceding to his female interlocutor by trying to evade the topic or resort to other issues. The Wife of Bath and Prudence clearly

bring the man to logical submission. The same is true in the "Knight's Tale" when the women persuade King Arthur to submit the matter to a jousting trial. In the tale of Chauntecleer, the rooster does not accept the wife's logical and scientific explanation, and the reader can clearly see his irrational behavior.

Particularly striking among all the tales which touch on this issue of Chaucer and the logical discourse in his female characters is the story told by the Second Nun, that is, a life of St. Cecilia. In the tale of St. Cecilia, the emperor resorts to violence, a clear sign of defeat in a logical confrontation. There has been considerable discussion among scholars about Chaucer's use of sources in the second half of the story and no satisfactory conclusion has been put forth about Chaucer's purpose for the changes he obviously injected. I believe, however, that when put in the context of the other examples of women engaged in logical discourse, the changes present a compelling pattern that suggest the changes are intended by Chaucer to present yet another such woman who confounds a male antagonist with her mental abilities.

The second nun, a traveling companion of the Prioress, tells a tale originally written by Chaucer as an independent piece and probably later reworked for a place in the *Canterbury Tales*. As an indication of what may be an incomplete reworking, we see that the original teller may have been a male since, in line 62, the speaker is referred to as an "unworthy sone of Eve," a detail which Chaucer apparently neglected to adjust when he fitted the tale for the Nun's recitation. The stanzaic form of the tale would also suggest composition before the time when Chaucer began the *Canterbury* collection, at a time when he was writing the *Troilus,* a work composed in the same stanzaic form. The Nun's narrative is drawn from the *Legenda Aurea* by Jacobus de Voragine. If Chaucer made few changes from his source, a work in which we see much the same treatment of the heroine, we must attach some meaning to his choice of a tale in which a heroine plays so important a role.

In the traditional story, St. Cecilia is an early Roman martyr and though she has sworn herself to chastity as a devout Christian, her family arranges a marriage with Valarian, a good young man, but a pagan. She is very eloquent

in explanation to him that yes, she will be his wife, but he must respect her chastity; he agrees to do so and even becomes himself a Christian, compelled by the appearance of an angel. Though not a part of the marriage group, this tale shares the thematic material of that group—it explores one other type of marriage relationship, one which in fact is alien to most modern ways of thinking about marriage. Cecilia and Valerian live together with a mutual agreement to remain chaste; notably Cecilia dominates in drawing up this agreement, and the arrangement seems to be for the satisfaction of both.

The high point of the tale comes in the confrontation between Cecilia and Almachius, the prefect who has summoned her to his court for enforcement of pagan worship. The battle between them is a confrontation of logic and intellect on the one side with coarse brutality and violence on the other, though the prefect imagines himself the intellectual superior. When summoned to the Almachius court, Cecilia is put on the stand:

> "I axe thee," quod he, "though it thee greeve,
> Of thy religioun and of thy beleeve." (G 426–427)

She replies like a logician:

> "Ye han bigonne youre questioun folily,"
> Quod she, "that wolden two answeres conclude
> In o demande; ye axed lewedly." (G 428–430)

Her reply is a rebuff on logical grounds, that he does not know how to phrase a question properly. He is being drawn into a debate the intellectual level of which he is hardly equipped to sustain. Dismayed by her reply, he threatens her—don't you take heed of my power? Your power is just a bag of wind, she says, which may be pierced with a needle. Of course it is the prick of her logic that deflates the man. But Almachius continues gamefully in his attempt to overwhelm her verbally. He again reminds her of his power:

> "Unsely wrecche,
> Ne woostow nat how fer my myght may strecche?

"Han noght oure myghty princes to me yiven,
Ye, bothe power and auctoritee
To maken folk to dyen or to lyven?
Why spekestow so proudly thanne to me?" (G 468–73)

But Cecilia is undaunted and replies in terms similar to those of Lady Philosophy in Boethius' *Consolation of Philosophy* when that consummate logician refutes the notion that wielding power can make one happy. Cecilia challenges any attempt on his part to be a philosopher in search of any truth and applies some devastating distinctions to his confused argument and reveals his basic error.

"Nat proudly, for I seye, as for my syde,
We haten deedly thilke vice of pryde.

"And if thou drede nat a sooth to heere,
Thanne wol I shewe al openly, by right,
That thou hast maad a ful gret lesyng heere.
Thou seyst thy princes han thee yeven myght
Bothe for to sleen and for to quyken a wight;
Thou, that ne mayst but oonly lyfe bireve,
Thou hast noon oother power ne no leve.

"But thou mayst seyn thy princes han thee maked
Ministre of deeth; for if thou speke of mo,
Thou lyest, for thy power is ful naked." (G 475–486)

Refuted once more, Almachius tries another round, in a last effort to save face for himself and not proceed with execution:

"Do wey thy booldnesse," Seyde Almachius tho,
"And sacrifice to oure goddes er thou go!
I recche nat what wrong that thou me profre,
For I kan suffre it as a philosophre;

But thilke wronges may I nat endure
That thou spekest of oure goddes heere," quod he. (G 487–492)

Cecilia answers that the gods of Almachius are mere stone; he can see that

for himself if he merely reach out his hand and touch them. Any one possessed of common sense knows that the true God is in heaven above. All men laugh at Almachius and scorn him for his foolishness to insist on the worship of stones. Unable to argue further, Almachius resorts to violence and has Cecilia tortured then beheaded. She clearly won the intellectual battle, but succumbed to a superior physical domination. The confrontation of Almachius and Cecilia is a scene of major importance in reading of Chaucer's treatment of women who have taken on the male prerogative of logical behavior and discourse.

Subsequent to these observations, especially with regard to the details of Cecilia's discourse which have to do with logical argumentation, I would like to suggest that Chaucer had intended that they be spoken for reasons of creating a logical woman. It may be part of his plan for her, and not something which he had adapted from some other version.

A search for Chaucer's implied intentions must begin with a look at his use of sources for the "Second Nun's Tale." There has been a considerable amount of speculation on Chaucer's use of sources in the "Second Nun's Tale" but several points appear clearly in Sherry Reames' summary of the major studies on the topic. Chaucer's version follows closely the Latin text of the *Legenda Aurea* until the final portion where we encounter considerable change.

> When one turns to the second half of the "Second Nun's Tale," one is confronted with another and more serious difficulty. The tale has faithfully followed the *Legenda* for over 250 lines, without significant additions or omissions, but now it skips over whole pages of the Latin and consistently omits details and short speeches. Most of the additions unique to Bosio's text are left out, but so are large sections of material found in all the published texts of the *Passio*—and some which are shared by the *Legenda* as well. One is left, then, with two possibilities. Either Chaucer drastically altered his approach to the translation when he shifted from one source to the other, or else his source for the latter part of the tale was much briefer than any which we have. (Reames 127)

It is generally agreed that Chaucer mostly depended on the life of St. Cecilia as found in the *Legenda Aurea* of Jacobus de Voragine, ed. by Gerould in *Sources and Analogues*. The last part of the tale, however, seems related to

a longer Latin life of the saint, but which is not completely known. Gerould was inclined to believe it is the *Passio* of Mombritius (which he printed in *Sources and Analogues*, pp. 677–84). Reames argues that the second half of the tale was based on some version of a Latin life close to that written by Antonio Bosio. Yet the question remains unanswered as to whether Chaucer combined this material from the *Legenda Aurea* or worked from a source in which the combination had already been made. I prefer to believe that Chaucer intended to highlight the logical discourse of Cecilia in these passages, even though he did find some of the phraseology already present in his sources.

"Ye han bigonne youre questioun folily,"
Quod she, "that wolden two answeres conclude
In o demande; ye axed lewedly." (G 428-430)

These lines represent a notable statement of logical criticism, an important idea that appears in two of the analogues as "Interrogatio tua stultum sumpit initium: que duas responsiones una putas inquisitione concludi" (*Sources and Analogues* p. 676). These lines were doubtless part of the common discourse between professor and student during the medieval university training in logical debate.

Cecilia's arguments have elicited several commentaries. Hirsh, for example, says that the changes from Chaucer's sources were made to emphasize the difference between the saint and her judge. Birney and others comment on the religious and theological context of the changes, but no one speaks to the significance of the logical terminology in a strictly philosophical sense, though Almachius does refer to himself as a philosopher—erroneously—as a stoic who can endure his discomfort. Since this is the earliest narrative in the chronology of Chaucer's works which makes use of logical discourse on the part of a woman, one must wonder how much of the exchange was suggested by his sources. The Latin text is replete with terms that apply to logical discourse, terms which are carried over into English by Chaucer, from whatever source he may have used. Almachius asks (interrogavit), she replies (Caecilia respondit); they accuse each other of errors (nisi cum verbum fallentibus irrogatur); si falso

locta sum;...Si enim malum esset hoc nomen: nos negaremus. dicit ei Almachius: Dic si quod nosti....Noli me ut dementem arguere: sed te ipsum increpa... Meas iniurias phylosophando comtempsi (*Sources and Analogues*, pp. 682–684). The context is clearly more related to the text of logic rather than of scripture and it is this spirit which Chaucer adopts into his account and, taken with his other accounts of women who use this kind of logical speech, we see a particular pattern of characterization emerge.

There has been considerable speculation about how and for what reasons, here as elsewhere, Chaucer manipulated his sources. Some commentators have said that in her defiance of Almachius as presented in lines 421 to 512, Cecilia resembles the *mulier fortis*, of *Prov.* 31.17 in terms of which St. Bernard praises the Virgin. Another inspiration for the scene may well be the speech of Christ before Pilate as recounted in *John* 18: 33–38; 19: 9–11. There are, however, some notable differences between her discourse and that of Christ's appeals to the prophets and of his role as redeemer. It is clear that Cecilia is drawing on logical models and makes her definitions and her criticisms of Almachius framed in terms of scholastic logic. Almachius is bested in this discourse. In this matter, we may look to the discussion of Sister Luecke who offers a feminist interpretation, and identifies Cecilia with the Second Nun as a strong-willed woman who utilizes virginity to effect freedom of action. Sister Janemarie Luecke's article is worth citing because, as most other recent writers working from a woman's point of view, she does not hesitate to accept the idea of Chaucer's sensitivity in the representation of female characters. But all of these interpretations cited above pass over what seems obvious, that Cecilia is behaving as a logician, a mode of behavior that is found elsewhere in Chaucer's women and found so often that we can hardly attribute it either to his sources nor to coincidence.

Chaucer's awareness of gender and his conception of the relationship between male and female in terms of intellectual domination is seen everywhere in his works of the middle to late periods. It is very clearly, and perhaps initially, enunciated in the prologue to the *Legend of Good Women* where he

shows himself as a persona being dominated by the figure of love who commands him to write well of women.

In the "Knight's Tale," we see that the King is overruled by the women who persuade him to behave in a more gentle manner and arrange a ritualized solution to the question of the two knights' dispute in their love. The discussion between Pertelote and Chauntecleer is certainly cast in terms of gender relations and some notable differences are established. We see that in the gender discussion, lines 2922–3157 do not come from the sources which Chaucer used for the rest of the tale. A number of studies on Chaucer's sources for this tale have been published, most in agreement with that by Kate Petersen from 1898. She placed the source in the beast epic tradition of the *Roman de Renart*. Petersen's detailed analysis shows that the tale was influenced by Marie de France's "Del cok e del gupil" and more recently Maveety has reasserted the influence of Marie which makes that association particularly interesting in terms of Chaucer's interst in female issues. The casting of the female character in the role of the logical, scientific and rational part should be recognized; it is a role consistent with other such roles which Chaucer has created for his female characters.

Very different from the Wife of Bath and St. Cecilia and yet especially significant in Chaucer's treatment of the female character is this depiction of the learned hen in the "Nun's Priest's Tale" about Chauntecleer and Pertelote. Chaucer makes considerable changes from his source to accommodate his thinking on the male-female relationship which is so important for him. He writes with a craft and intent that invite a close analysis and a detailed dissection of his narrative. As has been pointed out by scholars of Chaucer's sources, such as Kate Petersen and Robert Pratt, Chaucer made an insertion of considerable length to the basic and best known account of this story, *Le Roman de Renart* which is reprinted in *Sources and Analogues*, pp. 646–662. As Pratt points out, that insert comes from Robert Holcot's commentary on the *Book of Wisdom, Super Sapientiam Salomonis*. This commentary on Solomon, written in the middle of the 14th century by an English Dominican, was widely known

in Chaucer's time. Chaucer meaningfully adapts sections of Holcot's work (which Pratt characterizes as lively and entertaining in its style); in the debate he assigns the rational and scientific role to Pertelote and, in turn, the emotional, superstitious role to the husband, Chauntecleer. Such a reversal of roles is completely unrelated to the intention of Holcot's work but fits clearly and understandably into the pattern of logical discourse that Chaucer has designed for a number of his female characters.

Chauntecleer awakens from a dreadful dream and the frightened rooster recounts his vision of falling prey to a red creature with black tipped ears. The occasion allows Chaucer an opportunity to graft into his narrative a favorite medieval commonplace, a debate over the meaning of dreams. But the difference in the form of argument adopted by the husband and wife is of particular interest. Pertelote's argument is logical and scientific; Chauntecleer's reaction is impulsive and superstitious. She begins with an explanation based on medieval psychology—that dreams are caused by repletions, that is, by an excess of one or more of the four bodily humors. It is the nature of the bodily humor to influence the contents of dreams. Chauntecleer is choleric in personality, evidenced by his redness of face and neck, and this excess of sanguinary humor causes him to dream of red things. His personality is tinged with melancholy, so a small bit of black bile enters his dream and he envisions a red animal with black tipped ears. This explanation is in the best tradition of medieval dream learning. The solution to Chauntecleer's problem is to find herbs in the garden that will reduce the effect of his excessive humors, and then Pertelote enumerates herbs which he may pick and eat. But this rational and scientific explanation has no appeal for Chauntecleer and he prefers to believe that the dream is prophetic.

Recourse to such a superstitious interpretation of dreams is a reaction usually reserved—in literary accounts—for the female partner in these customary husband-wife discussions of a disturbing dream. Consider, for example, the way Caesar and his wife reacts to his dream in Shakespeare's play, and how frightened Calpurnia becomes at its prophetic possibilities. Chaucer

has reversed the roles in this tale, a matter of significance in a beast fable which portrays the Rooster or Cock as representative of the exceedingly virile or masculine (if somewhat dandy) man. The insertion of this scientific, rational explanation of dreams in the mouth of Pertelote is without parallel in any of the known analogues to Chaucer's tale and so must be seen as designed by Chaucer for a particular purpose. In the *Roman de Renart*, for example, Pinte sees the dream as a warning against attack from a fox. In *Reinhart Fuchs*, Pinte advises Scantecler to fly up into a thorn tree after he recites the dream account, and just in time too since at that moment Reinhart makes his appearance. The fact that in Chaucer's tale the fox does appear, and hence seems to reinforce the prophetic interpretation, does not reflect negatively on Pertelote's logic or scientific knowledge. It is merely the ending which Chaucer inherited from his sources. This contradiction within the tale was apparently negligible for him since he wanted to insert a new kind of Pertelote, one who has no parallel in other stories of the fox, the rooster and the rooster's wife.

The "Tale of Melibee," though written as many as five years before the creation of the Wife of Bath and the development of the "Wife of Bath's Tale," falls into the intellectual pattern established by that character and by her tale. The "Tale of Melibee" is a tale about domination and the subjection of the man to his wife in the marriage relationship. Though it is not part of the "Marriage Group," the "Tale of Melibee" fits very well into the thematic context established by the Wife's important statement of female superiority in any relationship of the two genders. And, as with the Wife of Bath, the superiority of the wife to the husband is established not through a prior advantage of money or power but by a clearly exhibited intellectual and moral capacity which unfolds through a series of logical arguments to which the man gradually consents. Paul Ruggiers has discussed the importance of the intellect in this argument but has not made a link to the gender issue.

Though it is not necessary to summarize the entire narrative of this lengthy prose tale, it should suffice to point out that here, as in other works, we have a wealthy and powerful man who is ready to resort to violence. As in others

stories, such as the "Knight's Tale," written at the same time or perhaps before this tale, and as in the "Wife of Bath's Tale," written after but related to it thematically, we have a woman who councils peaceful and rational behavior over impulsive and violent reactions on the part of the male. Melibee's wife, significantly named Prudence, early in her discourse takes the time to dispel misunderstandings about the nature of women. In order to move on to her argument, she wants to establish that women are not intrinsically evil.

> And, sire, that ther hath been many a good womman, may lightly be preved./ For certes, sire, oure Lord Jhesu Crist wolde nevere have descended to be born of a womman, if alle wommen hadden been wikke./ And after that, for the grete bountee that is in wommen, oure Lord Jhesu Crist, whan he was risen fro deeth to lyve, appeered rather to a womman than to his Apostles? (B2 2262–65)

We see that the argument, though logical, is based on scripture rather than philosophy. It is very soon after that Melibee accepts her arguments, though she has still much to reveal. Whan Melibee had heard the words of his wife Prudence, he spoke thus:

> "I se wel that the word of Salomon is sooth. He seith that 'words that been spoken discreetly by ordinaunce been honycombes, for they yeven swetnesse to the soule and hoolsomnesse to the body.'/ And, wife, by cause of thy sweete words, and eek for I have assayed and preved thy grete spaience and thy grete trouthe, I wol governe me by thy conseil in alle thyng."/ (B2 2302–03)

Then, in scholastic fashion, Prudence outlines the numbers and the ways in which Melibee has erred in his judgment. Eventually, Melibee concedes entirely:

> "Dame," quod Melibee, "dooth youre wil and youre likynge:/ for I putte me hoolly in youre disposicioun and ordinaunce" (B2 2913–14).

And he makes it clearer with this promise:

> ...his herte gan enclyne to the wil of his wif, considerynge hir trewe entente,/ and conformed hym anon and assented fully to werken after hir conseil,/ and thonked God, of whom procedeth al vertu and alle goodnesse, that hym sente a wyf of so greet discrecioun. (B2 360–63)

Jill Mann in her book on Chaucer and the treatment of female characters, speaks of the Melibee story (p. 122). In general, the Melibee story shows the submission of a man to the reason of a woman. Jill Mann says "it is an act of sober earnest, prompted by the claims of morality and reason." Her book *Geoffrey Chaucer*, part of the series "Feminist Readings," (revised and reissued in 2002 as *The Feminization of Chaucer*) has some very telling and useful observations. It is of particular interest to me that her work is not written in terms of modern critical theory but rather from a traditional critical approach. Though I have not borrowed much from her book I have found it of considerable help in discussion of gender issues. I must point out, however, that Professor Mann has entries in her index for "rape," "governaunce" "obeissaunce" "betrayal" and "authority" but none for "logic" or "reason" in either version of her book.

Another treatment of a female character in this regard may be seen in the *Troilus and Criseyde*. The *Troilus* is a long and complex work which demands and has received a great deal of critical attention. I would attempt, in some small way, to make an additional contribution to that body of criticism and address some ideas that will touch on major elements to which this chapter is addressed. The *Troilus* is a work which has often been misinterpreted, from Chaucer's time until our own. In the early part of previous century it was read much as a psychological novel, a story of tragic, but noble and beautiful love. Some scholars, most notably D. W. Robertson, have pointed out that the tragic but noble love interpretation is entirely inconsistent with the medieval way of understanding the moral issues of the poem. As many students in my generation at graduate school in the 1960's, I acknowledge myself to be much influenced by the Robertsonian reading the *Troilus*. In that work, Chaucer has brought about a sex role reversal by making Criseyde more logical and careful and by making Troilus more emotional and impulsive; he takes stock in dreams and he is irrational. Jill Mann has seen this as the creation of a "feminized" hero (p. 166). His unreserved surrender to the force of love is, for her (as she says it is for Chaucer) not a sign of weakness but of a generous nobility. He is feminized

not only in his reverence for woman but also in his vulnerability and sensitivity of feeling.

The poem, as Chaucer himself states, is a tragedy, and that tragic element consists of Troilus' total loss of self control. His emotional abandonment was in Chaucer's eyes reprehensible and Troilus' abdication of reason was more serious than Criseyde's desertion of his love. What is particularly striking about Chaucer's treatment of Criseyde is the complete reversal of the roles traditionally played by male and female characters in medieval literature. Troilus is the weakling; he faints when he declares his love; he is impulsive and irrational. That behavior may perhaps be seen in other courtly love accounts, notably in Chrétien's story of Lancelot. But Criseyde, on the other hand, receives a remarkable, perhaps a unique treatment. She is represented as a sensible, rational person, largely self controlled and realistic. Her response to the insistent pleas by Pandarus on behalf of Troilus is a model of rational self control. She ponders whether she should respond to Troilus' love or live without any love; she is free to love and he is noble, worthy of a good woman's love. When she first sets eye on Troilus, after his return from battle she swoons a bit; "Who yaf me drynke?" (II, 651) she asks, worried about losing rational control. But she recovers quickly, and goes over the reasons why she should respond:

> And gan to caste and rollen up and down
> Withinne hire thought his excellent prowesse,
> And his estat, and also his renown,
> His wit, his shap,and ek his gentilesse;
> But moost hire favour was, for his distresse
> Was al for hire, and thoughte it was a routhe
> To sleen swich oon, if that he mente trouthe. (II, 649-655)

This passage summarizes seven points in favor of the argument for love:

1. his excellent *prowesse*—physical skill at battle;
2. his *estat*—social standing;
3. his *wit*—intelligence;

4. his *shap*—physical beauty;
5. his *gentilessse*—special quality of personality characterized by agreeableness and consideration;
6. his distress was *for hire*—the reasons here comes close to home; and
7. it were *a routhe* to see such a man die.

This event and Criseyde's way of behaving are in contrast with the sudden infatuation of Troilus in the first book when upon seeing Criseyde for the first time, he becomes immediately and hopelessly love struck. The effect is immediate and then he spends most of his time in bed, lamenting his unhappiness, unable to help himself until Pandarus comes to serve as a go between.

There are several other locations in the poem where the role reversal is as strikingly evident. In book II after the lovers have spent the night together for the first time, the sun begins to rise and they know they must part. It is a moment traditionally recognized in a variety of love poetry, and medieval courtly poets have created a special genre for the occasion—the *aubade*, a poem recited by the male lover when he must leave the bed of his beloved at the time when the sun is about to rise after a night of love. He must leave her lest they be discovered together and face dire consequences. It is a poetic genre commonly found throughout the Middle Age and later; it is perhaps best recognized in Shakespeare's *Romeo and Juliet* when Romeo laments the coming of day and the dangers that would follow:

> It was the lark, the herald of the morn,
> No nightingale: look, love, what envious streaks
> Do lace the severing clouds in yonder east:
> Night's candles are burnt out, and jocund day
> Stands tiptoe on the misty mountain tops:
> I must be gone and live, or stay and die. (III, v. 6–11)

It is a genre as well satirized in John Donne's poem "Busy Old Fool Unruly Sun." Robert Kaske in a well known article points out that the *aubade* is traditionally recited by the male, but it is put by Chaucer in the mouth of the

female lover, Criseyde. This reversal fits well with Chaucer's general tendency to change occasionally the roles between the two sexes.

One problem many readers have had with Criseyde is her supposed betrayal of Troilus' great love for her. Chaucer does not try to excuse her behavior. She is trapped in an impossible situation—Troilus, like the Troy whose fate and name are echoic of his, is doomed. After she is exchanged for a prisoner of war, she is trapped on the other side of a hopeless war whose ending is a well known outcome for all Chaucer's readers. She must cope as well as she can and if she fall for Diomede, we must conclude that she is a vulnerable woman who is trying to survive. As Donaldson so well points out in the medieval French and Italian predecessors to Chaucer, the essential element in her character that is always transmitted is that she must betray her lover. Donaldson has made an insightful analysis of her career in English Literature. In a sense, Chaucer is limited by the material which he inherits. Yet if we compare his treatment with that of his source in Boccaccio we cannot but be impressed by the difference of his handling, by the greater sensitivity with which he treats Criseyde. Most notably, Chaucer is more concerned with what Troilus is doing to himself and with Troilus' eventual recognition of his own folly than he is with the punishment of Criseyde as the unfaithful woman. Chaucer has presented her as an intelligent, sensitive person with powerful emotions who was perhaps "slydying of courage." A major problem in the determination of Chaucer's attitude toward this heroine is the matter that between the author and us the readers there interposes the narrator whose attitude, it would be argued, is certainly not the same as that of the author. This is a topic that has been discussed at great length by Chaucerian critics from the earliest periods of published critical discussion and continues to be a topic of concern. While E. T. Donaldson may have written one of the most widely admired chapters on the topic in his *Speaking of Chaucer*, "The Ending of Troilus," pp. 84–101, the discussion began long before him and still continues. The discussions of the narrator in the Troilus have in fact spanned the previous century. Critical publications listed in my bibliography include Joseph Graydon (1929), Joseph

Beatty (1929), Robert Jordan (1958), Dorothy Bethurum (1959), Laila Gross (1968), Robert Reilly (1969), James Maybury (1983), Stephen Manning (1984), Anne Falke (1984), J. Asakawa (1984), Susan Bailey (1985), David Lawton (1985), Murray Evans (1986), Dieter Mehl (1988), and Derek Brewer (1990), who have all repeatedly brought this issue to the fore. I think that one risks the danger of overemphasizing the narrator's role, and the idea of a narrator "falling in love" with this heroine is going too far in the attempt to remove Chaucer from close contact with the poem or his responsibility for its treatment. One need not assume that Chaucer has entirely disapproved of Criseyde's behavior. His treatment of other female characters demonstrates a broad tolerance of what we might consider behavior unacceptable to the medieval audience or to the modern audience.

Other authors certainly have had a difficult time letting such a woman go free. In the great psychological novels about women who dared to break with the conventional morality of the 19th century, the heroine must pay for her sins by death at the end of the novel. Madam Bovary and Anna Karenina are striking examples that type. But that was not Chaucer's way.

From all we can determine in the extant evidence, it seems that many of Chaucer's earliest readers were not satisfied with his treatment of Criseyde. Robert Henryson wrote a sequel to the story in the 15th century in which Troilus does not die, but some years after his separation from Criseyde, he meets a group of lepers while he is riding on horseback. In pity, he throws them some coins and rides away, not knowing that Criseyde, among the lepers, herself afflicted, recognized him but remained silent and repentant. Donaldson's discussion of Criseyde is perhaps the most insightful but it is difficult for me to accept his uncritical acquiesence to Henryson's treatment of our Heroine. I suppose Henryson felt better after writing that sequel and setting things right. Even Shakespeare, whose treatment of both male and female characters is otherwise noted by its broad humanitarian understanding, describes Cressida as a common whore, any man's woman. In his play which is largely based on Chaucer's work, Shakespeare reduces considerably the

stature of his heroine whom he treats with much less sensitivity than does Chaucer, certainly with less interest in the many sided personality that we find in Chaucer's Criseyde. Shakespeare apparently chose the antifeminist tradition to embody in his work rather than come to terms with the complex problem of Criseyde's mixed motivation and complex feminine reaction to her dilemma. Shakespeare could have undertaken this theme, equal perhaps to the great themes of *Othello, Macbeth,* or *Hamlet,* one which would certainly have done him great justice had he decided to investigate with his powerful genius some problem of the female personality. But apparently he chose not to do so.

In the *Canterbury Tales* we may see a wide range of treatment accorded to female characters, yet there is a notable consistency in Chaucer's attitude. The particular manner of Chaucer's treatment is obvious if we match various works against the medieval traditions in which each work is found. The overwhelming picture that emerges, after such a reading is that Chaucer consistently veers toward a sympathetic treatment of his female characters, one relatively free from traditional bias and stereotyping.

Bibliography

Aquinas, St. Thomas. *Questiones Disputate de Veritate*, ed. R. M.Spiazzi Turin: 1949.

———.*Reportationes,Thomae Aquinatis Opera Omina cum hypertextib us in CD-ROM*, Milano, Editoia Elettronica, ed. 1992.

———. *Summa Theologica*, ed. P. Caramello Turin: Marietti, Turin 1934–

Asakawa, Junko. "Chaucer's Narrator and Criseyde." *Bulletin of Tsuru University* 21 (1984): 51–57.

Augustine of Hippo. *De Trinitate*, ed. and trans into French, Paris: Desclée de Brower, 1955.

Bailey, Susan E. "Controlled Partial Confusion: Concentrated Imagery in *Troilus and Criseyde,*" *Chaucer Review* 20 (1985): 83–89.

Beatty, Joseph M., Jr. "Mr. Graydon's Defense of Criseyde," *SP* 26 (1929): 470–81.

Bethurum, Dorothy. "Chaucer's Point of View as Narrator in the Love Poems," *PMLA* 74 (1959): 511–20.

Birney, Earle. "The Beginnings of Chaucer's Irony," *PMLA* 54 (1939): 637–55.

Brewer, Derek. The History of a Shady Character: The Narrator of Troius and Criseyde," in Reingard M. Nischik and Barbara Korte, eds. *A Model of Narrative: Approaches to American, Canadian, and British Fiction*. Konigshausen & Neumann, 1990, pp. 166–78.

Bryan, W. F. and Germaine Dempster. *Sources and Analogues of Chaucer's "Canterbury Tales."* Chicago: University of Chicago Press, 1941; reprinted 1958.

Chaucer, Geoffrey. *The Canterbury Tales*, ed. Larry D. Benson, based on *The Riverside Chaucer*. 3rd ed. New York: Houghton Mifflin Co, 2000.

———. *The Riverside Chaucer*, gen. ed. Larry D. Benson. 3rd ed. New York: Houghton Mifflin, 1987.

Donaldson, E. Talbot. "Briseis, Briseida, Criseyde, Cresseid, Cressid: Progress of a Heroine," in Edward Vasta and Zacharias P. Thundy, ed. *Chaucerian Problems and Perspectives: Essays Presented to Paul E. Beichner*. Notre Dame, Indiana: University of Notre Dame Press, 1979, 3–12.

———. *Speaking of Chaucer*. New York: Norton, 1970.

Evans, Murray J. "'Making Strange': The Narrator (?), the Ending (?), and Chaucer's 'Troilus,'" *NM* 87 (1986): 218–28.

Falke, Anne. "The Comic Function of the Narrator in *Troilus and Criseyde*," *Neophilologus* 68 (1984): 134–41.

Graydon, Joseph S. "Defense of Criseyde," *PMLA* 44 (1929): 141–77.

Gross, Laila. "Time and the Narrator in Chaucer's *Troilus and Criseyde*," *McNeese Review (McNeese State College, LA)*, 19 (1968): 16–26.

Hirsh, John C. "The Politics of Spirituality: The Second Nun and the Manciple,"*Chaucer Review* 12 (1977) 129–146.

Jacobus de Voragine. *Legenda Aurea*. ed. Gerould in Bryan and Dempster, *Sources and Analogues*, pp. 671–77.

Jordan, Robert. "The Narrator in Chaucer's Troilus," *ELH* 25 (1958): 237–257.

Kaske, R. E. "The Aube in Chaucer's *Troilus*," in Richard Schoeck and Jerome Taylor, eds., *Chaucer Criticism: Troilus and Criseyde and the Minor Poems*. Notre Dame, Indiana: Notre Dame University Press, 1961, pp. 167–179.

Lawton, David. *Chaucer's Narrators*. Cambridge, England: Cambridge University Press, 1985.

Loomis, Dorothy Bethurum. Chaucer and Shakespeare," in Arthur C. Cawley, ed. *Chaucer's Mind and Art*. Edinburgh and London: Oliver and Boyd, 1969; reprinted, New York: Barnes and Noble, 1970, pp. 166–90.

Luecke, Janemarie, O. S. B. "Three Faces of Cecilia: Chaucer's *Second Nun's Tale*." *American Benedictine Review* 33 (1982): 335–48.

Mann, Jill. *Geoffrey Chaucer*. Atlantic Heights, N. J.: Humanities Press International, 1991.

Manning, Stephen. *"Troilus,* Book V: Invention and the Poem as Process," *Chaucer Review* 18 (1984): 288–303.

Maveety, Stanley R. "An Approach to the Nun's Priest's Tale," *College Language Association Journal* 4 (1960): 132–37.

Maybury, James F. "The Character of the Narrator in *Troilus and Criseyde*," *Northern New England Review* 8(1983): 32–41.

Mehl, Dieter. "Chaucer's Narrator: *Troilus and Criseyde* and the *Canterbury Tales*," in Piero Boitani and Jill Mann, eds. *The Cambridge Chaucer Companion, Studies in the Age of Chaucer* 10 (1988): 213–26.

Mombritius. *Passio*. G. H. Gerould, in Bryan and Dempster, ed. *Sources and Analogues*, pp. 677–84.

Peterson, Kate Oelzner. *On the Sources of the Nonne Priestes Tale*. Radcliffe College, Mass: Radcliffe College Monograph 10, 1898; reprinted 1966.

Pratt, Robert. "Some Latin Sources of the Nonnes Preest on Dreams," *Speculum* 52 (1977): 538–70.

Reames Sherry. "The Sources of Chaucer's 'Second Nun's Tale,'" *Modern Philology* 76 (1978): 111–135.

Reilly, Robert. "The Narrator and His Audience: A Study of Chaucer's *Troilus*," *UportR* 21 (Spring, 1969): 23–36.

Robertson, D. W. *A Preface to Chaucer*. Princeton, N.J: Princeton University Press, 1963.

Rollins, Hyder E. "The Troilus-Criseyde Story from Chaucer to Shakespeare," *PMLA* 32 (1917): 383–429.

Ruggiers, Paul.G. "Serious Chaucer: The *Tale of Melibeus* and the Parson's Tale," in *Chaucerian problems and Perspectives: Essays Presented to Paul E. Beichner,* ed. Edward Vasta and Zacharias P. Thundy. Notre Dame: Notre Dame University Press, 1979, pp. 93–94

4

Money, Sex and Gender

In several of Chaucer's *Canterbury Tales* there is evidence that for him, and for many in his contemporary audience, there is an exchange of more or less equivalent values between the genders in terms of sexual availability and gratification with money as the exchange medium. The most obvious and basic level of this exchange—that is, prostitution—is referred to directly on rare occasions such as the wife of the prentice in the Cook's Tale:

> And hadde a wyf that heeld for contenance
> A shoppe, and swyved for hir sustenance. (A 4421–22)

Or at times, there is an indirect reference to prostitution, as the "stewes" or "baudes, wafereres":

> In Flaundres whilom was a compaignye
> Of yonge folk that haunteden folye,
> As riot, hasard, stywes, and tavernes,
> Where as with harpes, lutes, and gyternes,
> They daunce and pleyen at dees bothe day and nyght,
> And eten also and drynken over hir myght... (C 463–468)

> And right anon thanne comen tombesteres
> Fetys and smale, and yonge frustesteres,
> Syngeres with harpes, baudes, wafereres,
> Whiche been the verray develes officeres
> To kyndle and blowe the fyr of lecherye,
> That is annexed unto glotonye. (C 477–482)

As an example of a woman who gave comfort to men in exchange for

wealth we must obviously cite the Wife of Bath who accumulated some substantial assets by wedding wealthy older men and inheriting their money when they died—four times. In that same category we should add the young wife in the tale told by the Merchant about January, a man too old and unattractive to draw to himself a wife on sexual terms alone and in effect must buy her with his wealth. Again in the Shipman's tale we find a wealthy Merchant who supports a wife that has a complicated sexual/monetary relationship with her husband. In the same tale, there is an explicit exchange of cash for sex between the wife and the visiting monk. There may be other instances which may be cited but these examples should suffice to demonstrate some interesting aspects of Chaucer's writing and of his attitude on gender issues.

The "Merchant's Tale" about January and May reflects implicitly values of money in exchange for sexual favors which are explicit in other parts of the *Canterbury Tales*. Just as the aging Wife of Bath attracted her Jankin by offering the comforts of her affluent lifestyle, so January is able to take his choice of the young maidens by elevating a girl's standard of living and possibly even that of her family. In both cases the older party is purchasing more than sexual gratification. It is a transaction that involves a broad based relationship, but one which entails a companionship dependant on gender identity and gender differences. The fact that neither relationship works out to complete satisfaction does not entirely impugn its validity or desirability. Important in the transaction is the commitment to high stakes put up on both sides. The younger person surrenders almost all personal freedom as well as foregoing the normal gratifications of sexual relations that a young person may expect. The elder puts on the line his earthly wealth with the understanding that at his eventual demise, the younger partner will live on to enjoy that affluence and possibly share it with another partner.

In both cases, Chaucer allows the story to play out to the woman's advantage. The Wife, who has been on the receiving end of this bargain from four husbands, seems to have survived the fifth and younger partner and is

ready for another such arrangement ("Welcome the sixte, whan that evere he shal./ For sothe, I wol nat kepe me chaast in al." "Wife of Bath Prologue," D 45-46.) May, who will certainly survive her aged husband, seems to have made the bargain secure on her own behalf and yet is able to enjoy a few sexual comforts before her partner's demise and looks forward to some more.

In both cases, it would seem that the considerable material fortunes of the older partner are not sufficient to afford total sole possession of female sexual favors. It would seem, in fact, that in spite of an agreed upon bargain, the material payment is never quite enough to secure and hold fast and satisfactorily to the sexual good bargained for.

All of these instances appear in tales written during the last decade of Chaucer's writing career and are characteristic of his interests both in realism during that period as well as in the increased importance of money in his life and in his society generally. These examples also show, in the wider context of Chaucer's socio-economic environment, the increased importance of commerce in England and Europe, partly due to greater travel and exploration as a result of the crusades. The accumulation of individual wealth was also due to the Plague which destroyed perhaps one third or more of the population and thus left more of the material goods to the reduced population who survived it. As well this emphasis on money and the good which it can acquire for those who have money are indications of greater wealth among the rising middle class in the 14th century. Several participants in this new affluence are members of the aristocracy who have inherited and not earned by commerce the wealth which enables them to pay for their pleasures and comforts. But most of the participants in these exchanges are in fact among the *nouveaux riches* who are indulging their appetites as a prerogative of their expanding financial well being. (The complex socio-economic relationships that Chaucer lived in may be seen documented and explicated in numerous historical studies, but I was satisfied with material presented by R. S. Lopez in The *Commercial Revolution of the Middle Ages* and N. J. G. Pounds, *Economic History of Medieval Europe*.) Very little critical material has brought attention to Chaucer's writing

in the context of the Plague and its effects. One may cite Peter Beidler's "The Plague and Chaucer's Pardoner" as a singular exception.

The effects of the Plague show through Chaucer's work in a variety of ways. For the topic under discussion here, that is, the effect of the Plague on the economic life of England during the late 13th century, there is a variety of somewhat disputed data. The dominant trend among historians, however, and among the collectors of economic data during the medieval period is that the catastrophic reduction of population during the late 1300's had a considerable impact on the financial status of many individuals, one that is more marked in many ways during the following century, but there beyond the interests of this study.

John Hatcher, in his short but informative book *Plague, Population and the English Economy 1348–1530*, has compiled an array of statistics and illustrative graphs that show some dramatic changes in the interrelated trends of population size and consequent shifts in the distribution of wealth during the period of Chaucer's own lifetime. Although Chaucer could hardly have been aware of the larger dimensions of catastrophic change that the country was undergoing, still there was enough happening within the horizon of his personal experience that he could respond to it and reflect its results in his writing. Modern historians are certainly capable of collecting and tabulating statistics, however fragmentary and difficult to assess, from a range of population distributions throughout England that Chaucer and his contemporaries would have no means of accessing. Needless to say, Chaucer could hardly have been aware of how wide spread were the effects of the Plague in England. His experience was almost entirely local.

Nevertheless, that experience was profound and as a person who was closely connected with the economic life of his times, especially from the perspective of the royal expenditures and because of his work with the government office and in his personal need to make a living, he was more aware of what was happening demographically and economically than most of his contemporaries. It would seem that on the personal level great financial

achievement was not one of his interests or perhaps even one of his talents. Nevertheless, he heard of changes and doubtless could see in his own world a considerable amount of activity and change in the world of finance. It is an awareness that is reflected in the types of characters that populate the *Canterbury Tales*. Great or notable wealth seems to be a part of the life of more than few of his Canterbury Pilgrims, most notably the Wife of Bath, but also the physician who made some personal profit from the Plague:

> He kept that he wan in pestilence.
> For gold in phisik is a cordial,
> Therefore he lovede gold in special. (A 442–444)

We may see the same monetary interests in the Merchant, the Franklin, the Pardoner, the Prioress, the Monk and to a lesser extent, the Miller and the Reeve. In the *Tales* themselves, a notable preoccupation with money and its acquisition can be seen in Melibee, January, the characters of the "Friar's Tale" and in the "Pardoner's Tale."

The effects of the Plague reduced the population of England to such an extent that the economy was profoundly affected and altered for centuries. A decline in population resulted in an abundance of material goods for the survivors. As well, a high death rate affected wages which rose, inevitably in accord with the elementary rules of economic behavior. The loss of lives among the property owners enabled survivors to acquire more land. In his compilation of data, Hatcher looks at the Plague results and sees startling developments that have never been seen in the economies of modern times. Although the exact number of persons lost in the population decline cannot be known, the parameters outlined in Hatcher's book seem convincing and by any reasonable measure, must be noted as catastrophic. He presents the total population of the Island as somewhere between four and six million, very likely close to the higher number. Demographers whom he calls on for evidence have calculated variations in the population change according to social status of the individuals, the clergy, urban dwellers compared to rural populations and even in terms of gender (young men seem especially vulnerable). After a careful sifting of data

and the arguments of other historians, Hatcher offers a tentative range:

> A national death-rate of below 25 percent or above 55 percent would appear most unlikely. In addition to the data rehearsed above there are literally hundreds of mid-fourteenth records of manors, towns and other communities throughout the country which bear testimony, with a lack of precision but a compelling force, to a death-rate of at least 30 to 55 percent; yet when we look at England in the 1350's a death rate of more than a half would not appear to be compatible with the progress of the economy and the behavior of prices and wages. Until more evidence of rural death-rates is forthcoming great weight must be attached to a revised average death-rate of around 35 to 40 percent for the beneficed clergy. In fact it is fitting that it should provide the end-point of the most judicious estimate of the national death-rate in 1348-9 in the present state of knowledge: 30 to 45 percent. (p. 25)

The economic consequences of such a decline in population are enormous and well documented. In fact, it is the economic data that help demographers to calculate the death rate, so in this discussion and for our purposes, the analysis is moving in the opposite direction in order to determine causes from their effects. The result is an immediate rise in the finances of many individuals, though in the longer term and into the following century (beyond the scope of our discussion of Chaucer) the outcome is severely negative on the economy. Some of the obvious consequences of this shift in wealth are summarized by Hatcher:

> The subsequent reduction in population must have led to increased productivity restoring a more efficient balance between labour, land and capital. The reduction in population must also have led to a sharp increase in per capita wealth and consumption. In simple terms, the survivors inherited the property of those who had perished and, when presented with a sudden increase in wealth at a time of recurrent plague and considerable uncertainty, it is not surprising that they chose to spend on a greater scale than their predecessors. Demand was further stimulated by the increasing earnings of laborers and peasant. (p. 33)

Some sectors of the economy enjoyed a particularly bountiful income, as we may note in the textile industry, an area where it seems the Wife of Bath had some interests. Several historians (such as Helleiner and Duby, 309–310) have noted a trend of younger men to wed older women, though the reasons for this

trend is not clear (infanticide of female babies is a possible cause). But the trend certainly seems to bring to mind the marriage of the Wife of Bath with Jankin. The preponderance of Plague deaths among young males calls to mind the Pardoner's Tale where, in addition to the treachery of male companions over the discovery of gold coins (possibly left by one carried away by the Plague) the entire story is set in motion by an acute awareness of the death of one of their young comrades who succumbed to the Plague:

> Thise riotoures thre of whiche I telle,
> Longe erst er prime rong of any belle,
> Were set hem in a taverne for to drynke,
> And as they sat they herde a belle clynke
> Biforn a cors, was caried to his grave.
> That oon of hem gan callen to his knave;
> "Go bet," quod he, "and axe redily
> What cors is this that passeth heer forby;
> And looke that thou reporte his name weel."
> Sire," quod this boy, "it nedeth never-a-deel;
> It was me toold er ye cam heer two houres.
> He was, pardee, an old felawe of youres,
> And sodeynly he was yslayn to-nyght,
> Fordronke, as he sat on his bench upright.
> Ther cam a privee theef men clepeth Deeth,
> That in this contree al the peple sleeth,
> And with his spere he smoot his herte atwo,
> And wente his wey withouten wordes mo.
> He hath a thousand slayn this pestilence.
> (C 661–679)

Several observations are worth making with respect to the trading of money for sex. One regards gender and obviously we see the money move almost entirely in one direction, from male to female, unless the differential of age is introduced then the movement is from age to youth (which is usually included in the male → female move). Such is the case of the Wife of Bath who, over the age of forty, must "buy" her fifth husband. But that case, as we must note, is more complicated than mere money for sex, as we shall see when we return to the Wife of Bath's personality.

The second point we would make in Chaucer's repeated return to the sex for money theme is that money and sex imagery imbue those passages with similes, metaphors and extended comparisons to such an extent that we can claim for Chaucer a remarkable awareness of money, commerce and trade. It is an awareness expressed with poetic usages not equaled again until we see, in England, the plays of Shakespeare several centuries later when another and greater economic boom occurs in English society. Both of these elements, the gender issue and the use of money figures, are equally significant and intimately connected; they occur in a period of Chaucer's writing when he has thoroughly assimilated and is no longer dominated by the major literary influences in his earlier writing periods—first the French and then the Italian. His preoccupation with money as it functions in gender relations and in figures of speech is seen as creatively and literarily integrated in the *Roman de la Rose*, and the works of Dante, Petrarch or Boccaccio. Even Boccaccio whose style in the *Decameron* approaches the same realism that we see in Chaucer's later tales and who frequently tells tales of wealthy merchants and their wives, does not exhibit the same interest in gender issues nor, since he there writes in prose, show himself equally inventive in literary devices. Boccaccio's stories in their sexual escapades usually turn more on treachery and extra marital interest rather than on the purchase of sexual pleasure. The sexual adventures he recounts frequently involve trickery, extra marital allure or desire to humiliate others or avenge oneself. Seldom is money the motive for sexual activity.

We may begin the investigation of how Chaucer's creativity involves gender and money as well as figural language and monetary images in the "Shipman's Tale." The links between money and sex are explicit in many passages. The Merchant, who is apparently quite wealthy, is also a bit tight fisted. His wife, however, loves to spend and to indulge in revelry. They appear to be an ill-matched pair because of his sober intent on business and general lack of interest in sexual pleasures.

In the "Shipman's Tale," the issues of sex, money and gender come together in a way that is superseded only by the Wife of Bath's tale for their

interrelatedness and artistic integrity. If we are to take seriously the contention, which is made on good grounds, that the tale assigned by Chaucer to the Shipman was in fact originally conceived as part of the psychological make up of the Wife of Bath, we have a further opportunity of understanding her personality as Chaucer developed it. In effect, we may consider the tale about a merchant, monk and conniving wife as a first "Wife of Bath's Tale" which was superseded by another tale that contributed a greater complexity to her character.

That the "Shipman's Tale" was originally intended for the Wife of Bath is an idea now generally accepted. It is nowhere better stated than by Tatlock in 1907:

> ...the *Shipman's Tale* was certainly written not for the Shipman but for a woman...there cannot be the smallest doubt that the woman is the Wife of Bath.... The Shipman no doubt had his faults, but muliebrity was not one of them. Nor is the subject, drawn from trivial social life, appropriate to him. (p. 205)

Lawrence (p. 58) lists a number of other notable Chaucerians who agree with this assessment so I think we may be generally comfortable working with this assumption. If, then, we take the Shipman's tale as a preliminary characterization of the Wife, a Wife perhaps younger than the woman we see in the General Prologue, we may envision a woman who loved finery and was wed to a wealthy merchant for what we may assume were the material benefits of the union. We are reading about a woman who craved sensual satisfaction, with a craving so intense that she on occasion sought to satisfy it outside of marriage. All of these personality characteristics may be seen in the Wife's Prologue as well, which is a later composition. (For a discussion of the relationship between these two tales, one may see Arthur Moore, "The Pardoner's Interruption" and Robert A. Pratt in *Studies in Honor of Baugh*, pp. 45–79.)

The "second tale," that which became permanently assigned to the Wife, takes away none of these personality traits, reinforced as they are by her own self attribution in the lengthy Prologue. Her Prologue adds however an

intellectual dimension, one which I explore in another part of this study, in the chapter entitled "Boethius and the Wife of Bath."

One of the most integral and creative aspects of Chaucer's artistry in the *Canterbury Tales* is his development of complex relationships between the teller and the tale told. This relationship works in two directions; the character as described in the General Prologue lends meaning to the tale and, vice versa, the contents of the tale illuminate aspects of the personality which we read described in the General Prologue. Such is Chaucer's artistry that these relationships operate in various manners. At times the tale deepens the nature of the character described, as the Squire who is seen as a typical courtly lover in the Prologue and tells a tale in accord with the Courtly Love system. At times the relationship heightens the ambiguities we see in the Prologue, such as we may find in the portrait of the Prioress in the Prologue who appears as somewhat dubious in her religious life and who tells a pious tale which, however, is profoundly and unfeelingly racist. (We we may recognize this tale as version of the Blood Libel Legend—see the appropriate essay in Dundes.) In some cases, however, Chaucer does not seem to make any meaningful connection between teller and tale. Such is certainly the case with the Shipman.

The Shipman's tale then is not at all about a shipman. This is true even if we consider the Shipman a type of merchant, and there is no basis in his description as found in the General Prologue which correlates at all with the material in the tale. For purposes in this discussion, I consider the "Shipman's Tale" to be about the Wife of Bath and, consequently, in a major way about gender. It is about the correlative values of money and sex and how the socio-economic imbalances between the genders are somewhat leveled by their exchange of values between two individuals who strike a bargain. As a way of extending the gender theme, the poetry of the tale is thoroughly imbued with money/sex imagery in which the equivalence is reinforced and even woven into the text itself. Most significant in such a reading of the "Shipman's Tale" as a gender statement is that it conveys an emphatic message about the survival and domination of the woman. Not only does that message ring in consonance with

the "Wife of Bath's Tale," but contrasts sharply with any of the generally acknowledged analogues, those by Boccaccio and by Sercambi. This is a point made in an article from 1958 by William W. Lawrence. He neatly points out the suitableness of the tale to the character of the Wife of Bath:

> It looks, then, very much as if Chaucer deliberately altered his fabliau-like source to fit the Wife of Bath. (p. 58)

In both Boccaccio and Sercambi, the woman is humiliated as is frequently the case in Boccaccio's stories. In the *Decameron* version,

> Gulfardo departed and the woman left scorned, and he gave to her husband the dishonest price of her wickedness; so the wise lover enjoyed the greedy woman without paying for it.
>
> Gulfardo [the lover] partitosi e la donna rimasa scornata, diede al marito il disonesto prezzo della sua cattività, e così il sagace amante senza costo godì della sua avara donna.

In Sercambi:

> Madam Soffia, seeing that she had been thus tricked, thought that she would never again fall into such a situation with a person who would take back what he had given; and that is what I observe.
>
> Madonna Soffia, vedendosi così esser beffata, pensà di non cadere in tal fullo mai con persona che per quel modo riabia quello che dato l'avesse; e così oservò poi. (From Lawrence, p. 59; texts from W. F. Bryan and Germaine Dempster, *Sources and Analogue of Chaucer's Canterbury Tales,* here p. 441.)

Lawrence's conclusion on the issue is notable:

> But when we turn to Chaucer, what do we find? The story ends in very different fashion; the wife, with ready wit, tells her husband that she has spent the money on the adornment of her person, to his honor, and that she will readily discharge the debt – in bed. To this he assents. The whole closes, then, with the lady's triumph, not her discomfiture. (p. 59)

The exchange significance of sex and money is most creatively engaged

since Chaucer is always as much concerned with artistry on the level of figurative speech as with message. Though they seem to be good friends, the Monk and the Merchant are a sharply contrasting pair when we consider their behavior regarding money or sex. The Merchant is serious, retentive, cautious; the monk is jovial, without cares, generous and free ranging (though his duties involve responsibilities of oversight of monastic properties). The Merchant is little given to joviality; he is a serious man (sadly hym avyseth, 1. 76) but the monk is merry and is not above making off-color comments to the wife, on one occasion alluding to her supposed sexual activity the night before:

"I trowe, certes, that oure goode man
Hath yow laboured sith the nyght bigan.
That yow were nede to resten hastily."
And with that word he lough ful murily,
And of his owene thought he wax al reed. (B2 1297–1301)

In fact, the Merchant has not expended his energies on his wife but rather lavished his time on his business negotiations and on his account books. The neglected wife therefore meaningfully and to good purpose in her exchange with the monk introduces the first of the money/sex *double entendres:*

"Nay, cosyn myn, it stant nat so with me" (B2 1304)

"How things stand" is a metaphor which moves from sexual reference to financial standing to even the graphic image of bags of money erect on the counting table. She says to her husband, later, in her frustration:

"The devel have part on alle swiche rekenyngs!
Ye have ynough, pardee, of Goddes sonde;
Com down to-day, and lat youre bagges stonde." (B2 1408–1410)

This woman is not yet the mature Wife of Bath who takes such financial reckonings more seriously, but here perhaps we are dealing with a younger, more lustful Wife.

All three participants in this story are merchandizing in some manner,

though the product varies with each. The source of hard cash is from the Merchant who seems to deal in currencies. The exact nature of his profitable enterprise is not entirely clear but the details that are afforded us bear some historic interest. Thomas Hahn's nicely researched article on the financial backgrounds of 14th century merchandising observes:

> My argument, then, is that all the commercial details foisted upon us by the story affirm that this Merchant was a financial entrepreneur—not a money lender, not a banker, not a tradesman-merchant, but someone who derived a significant part of his income through the newly flourishing fourteenth century money market. (p. 238)

After he makes his sexual joke, the monk then engages the wife in a manner of counseling discourse to elicit the reason for her unhappy disposition. If the Wife of Bath needs to indulge in a confessional venting in the Prologue to her tale, this wife (a precursor to the Wife of Bath) responds with an explication of her problems. Her complaint may be reduced to a lack of generosity on her husband's part, both financially and sexually. In fact, she has a precise amount in mind at the moment: 100 franks (perhaps just over $1000 in current American dollars for the year 2003). She and the monk quickly reach an agreement and we see money and sex talk interchange repeatedly:

> "That whan youre housbonde is to Flaunders fare,
> I wol delyvere you out of this care" (B2 1389–1390)

"This care" is to be taken both financially and sexually. Instead of the more normal handshake in a gentleman's agreement, however, they agree with other gestures:

> And with that word he caughte hire by the flankes,
> And hire embraceth harde, and kiste hire ofte. (B2 1392–93)

When the wife interrupts her husband at the counting room, she chides him for too much attention devoted to his money bags ("lat youre bagges stonde"). He responds with a confession of his own and reveals an anxiety that certainly must worry all those who deal in the world of international finance. He must

cope with Flemish and Italian bankers and among colleagues in his trade, survival is not assured.

> "And by that lord that clepid is Seint Yve
> Scarsly amonges twelve tweye shul thryve
> Continually, lastynge unto oure age." (B2 1418–20)

At his age, only two out of twelve entrepreneurs survive and so his eventual profit does defeat these odds. Then, if his wife has challenged his money interests with the male sex image of the erect money bags, he expresses his fear of risk in a word already heavy with double meaning and which almost always refers to female genitalia:

> "And therfore have I greet necessitee
> Upon this queynte world t'avyse me,
> For everemoore we moote stonde in drede
> Of hap and fortune in oure chapmanhede." (B2 1425–28)

Of the several uses of "queynte" as female genitals, see the "Miller's Tale," 3276: "And prively he caughte hire by the queynte" or the Wife of Bath's Prologue "Ye shul have queynte right ynogh at eve" (D 332) and later by the Wife again: "Is it for ye wolde have my queynte allone?" (D 444)

Later in his farewell comments to the monk, the hardworking and very preoccupied Merchant offers to his friend anything that is in his power to give. The Merchant's intent would hardly have included his wife's sexual favors but he unwittingly does lend the monk money enough to serve as the means to those favors. So the monk has had two offers that day, obviously correlative, one sexual from the wife and the other monetary from her husband. The Merchant is able to make more money from existing cash. This seems to be a continually renewable resource which is a function of the newly developing financial market. The wife makes her offer from an equally renewable resource. It is up to the monk to convert one to the other and he does so. But unlike what we may only guess is his source (the fabliau Chaucer consulted resembles both the account by Boccaccio and Sercambi), the woman does not come out of the

narrative as the humiliated victim. If in the final analysis some character judgment must be made, it is the monk who emerges as a scoundrel. The husband's loss will be compensated by the same kind of exchange, this time expressed in accounting terms:

> "Ye han mo slakkere dettours than am I!
> For I wol paye yow well and redily
> Fro day to day, and if so I faille,
> I am youre wyf; score it upon my taille." (B2 1603–06)

So she seems to keep a running account with her husband; on one side of the ledger is her sex and on the other side is his cash. She invites him to keep the books. He may have been duped, but his loss is not great. The woman emerges as the most clever of the three—the monk is permanently self ejected out of this economy and whatever gratification he enjoys in the future must be sought elsewhere.

It should be observed that all three characters have some interest in both money and sex. When his energies are devoted to money, the Merchant's sexual energies are in abeyance; but the measure of his financial success emerges sexually. It is a recurring condition which the wife recognizes, though her sexual interests seem to remain at a more constant high. Financial success operates like a stimulant and an aphrodisiac on the Merchant:

> "His wyf ful redy mette hym atte gate,
> As she was wont of oold usage algate,
> And al that nyght in myrthe they bisette;
> For he was riche and cleerly out of dette.
> Whan it was day, this marchant gan embrace
> His wyf al newe, and kiste hire on hir face,
> And up he gooth and maketh it ful tough." (B2 1563–69)

His sexual interests, needs and abilities seem to vary with corresponding financial needs and vicissitudes. Her satisfactions are linked with his but do not always correspond precisely. The monk's financial and sexual needs are more irregular. Theirs are part of a matrimonial micro-economy and presumably the

tally sheet is balanced periodically. The monk, after all, has taken vows of chastity and poverty. His must be a gratification of opportunity and outside the system of any approved economy.

When one comes to discuss sex and money in the Wife of Bath's Prologue, critical caution is surely recommended. The sheer volume of literary commentary published on the Wife of Bath is certainly evidence enough of the complexity of her character and of the many interesting elements in Chaucer's artistry which may be found there and in her tale. As a mine for scholarly exploration, the 856 lines of the Prologue are matched only by the General Prologue to the *Tales* for richness of material—poetic, historical and psychological. With that caveat in mind, I would eschew theological, philosophical or other historical content of the Wife's Prologue to focus on the sex/money theme which, as I suggested earlier, first began in Chaucer's creative process with the "Shipman's Tale" and that was apparently put aside for this more complex portrait. As we move from the Prologue to the tale itself, we see how Chaucer's interest shifts from more sexual interests and goes to gender and the issue of domination, a condition which includes sex, perhaps money, but eventually, and most certainly, abides in the intellectual abilities he attributes to this woman for whom gender dominance was so important.

The most notable characteristics in the Wife's psychological make-up are fashioned by her intense involvement with the men to whom she was married. Four of these men were men of business of some manner, though we have much less information about their business transactions than was afforded us in the Shipman's Merchant. The final stamp on her personality, however, comes from her last husband, the Oxford scholar, who apparently left her with a new desire, once she had fulfilled to satisfaction her sex/money desires. This interest, of which we see only a glimmer in the Merchant's wife, is fully developed into clever logical discourse and a plethora of bookish citations—for example from Jerome, Ptolemy, Valerius Maximus, Theophrastus, Trotula with allusions to many others as well as to Scripture.

Nonetheless, the important stamp of Jankin's intellectuality on the Wife's

personality did not obliterate the accumulated characteristics of earlier relationships; she equates her own character to a scholar who has undergone studies in a curriculum of many disciplines, like a curriculum of the Liberal Arts, wherein a student of the seven disciplines, three of the trivium and four of the quadrivium, emerges as the completely prepared scholar. She herself is the product of a five tiered curriculum from which she feels she has emerged the completely competent gender specialist:

> Diverse scoles maken parfyt clerkes,
> And diverse practyk in many sondry werkes
> Maketh the werkman parfyt sekirly;
> Of fyve husbondes scoleiyng am I. (D 44c–44f)

Though this metaphor is inspired by her last husband's scholastic career, she had just expressed her interest in the sex/money complex in a clever, chiasmic figure that associated a man's body part with the container of cash and the cash bag with the man's physical virility:

> Of which I have pyked out the beste,
> Bothe of here nether purs and of here cheste. (D 44a–44b)

Here, as much as in the "Shipman's Tale," money and sex are seen as interchangeable commodities.

As her speech rolls on through logical argumentation, significant quotation and many layered expositions on gender, the Wife is interrupted at line 163. It is surely evidence of Chaucer's comical inventive genius that demonstrates how effectively he can use the subtle cutting edge of irony. The Wife's discourse is a threat to the males of the company and what with her forbidding demeanor, her sharp spurs—literal as well as figurative—and formidable experience, no one dares to interrupt. Even the Clerk, dismayed as he is by her parody of scholastic logic and by her heretical ideas on gender, expert in debate though he may have been at the University ("That unto logyk hadde longe ygo" A 286) needs the length of two intervening tales (the Friar and Summoner) as well as prompting from the Host before he can retort with the tale of Griselda. The

Host, who can interrupt even the author Chaucer himself and chide him for bad rhyme, and who severely reprimands the Pardoner for his religious fakery at the end of that tale, does not dare address her arguments. The Friar follows her account directly with his tale and begins with an obsequious acknowledgment of her scholastic abilities (of which supposedly he knows something) as he praises her:

> "Dame," quod he, "God yeve yow right good lyf!
> Ye han heer touched, also moot I thee,
> In scole-matere greet difficultee.
> Ye han seyd muche thyng right wel, I seye;
> But, dame, heere as we ryde by the weye,
> Us nedeth nat speken but of game,
> And lete auctoritees, on Goddes name,
> To prechyng and to scoles of clergye." (D 1270–77)

Apparently the intellectual density of her speech, although appreciated, is too much for the friar who has other fish to fry to as he begins an attack on the Summoner.

During her Prologue, there is a significant occurrence which needs some attention. (This interruption has not gone without notice, as we see in Moore and Silverstein.) Chaucer's genius, rather, brings an interruption, in order to alleviate the intellectual density in the Wife's discourse, from the Pardoner. He, of all the males in the group, has been ungendered and so, as it were, he flies in unhindered through the formidable gender barrier erected by the Wife of Bath. His comments are certainly comical, flattering from his point of view as a distinguished preacher himself, and couched in her kind of sex/money figures:

> "Ye been a noble prechour in this cas.
> I was aboute to wedde a wife; allas!
> What sholde I bye it on my flessh so deere?" (D 165–67)

The answer to his own question, of course, is in the General Prologue. He has already payed on his flesh as a castratophe is a "geldyng or a mare" (A 691). From the extensive description of his secondary sex characteristics, we

see that the Pardoner is gender undetermined, therefore gender neutral. He accordingly represents the polar opposite of the highly gendered Wife of Bath. It is a remarkable feature of Chaucer's gender awareness that he should pair these two opposites on the gender spectrum, the Wife of Bath at one end with her thoroughly gendered discourse and the Pardoner with his gender indeterminacy and his tale without any significant gender content.

The Wife's thought process, as seen in her lengthy autobiographical Prologue, is largely shaped by the contact she had with her fifth husband, the Oxford clerk, Jenkin. It is a mentality that is mostly preoccupied with theological issues and imbued with logical methodology and full of quotations from the ancients and the schoolmen. Underlying that level of discourse, however, is a clearly discernable thought process which comes from the mercantile world of accounts, paid receipts, trade and the importance of financial transactions. Her entire lifestyle is driven by her comfortable financial means which she earned by service to four husbands who brought to her their substantial material means. Though they were probably not at all close to Jankin's capacities at either sexual gratification or intellectual stimulation, they did leave their mark on the Wife's thinking. They apparently enjoyed some success in the world of finance. She first noted that they were men sexually and financially capable of satisfying her. So, she picked out the best "Bothe of here nether purs and of here cheste" (D 44b). About a hundred lines later, she recalls with an accounting metaphor her claims on her husband's sexual obligations to her:

> Myn housbande shal it have bothe eve and morwe,
> Whan that hym list come forth and paye his dette.
> An housbode I wol have—I wol nat lette—
> Which shal be bothe my dettour and my thral. (D 152–155)

This passage cleverly weaves together the Scriptural and the mercantile since, as has been pointed out, the Wife is alluding to Paul who also makes use of mercantile metaphor (*I Cor.* 7:3–4):

> A husband should pay his debt to his wife, and similarly should a wife pay to her husband. A woman does not have power over her own body but her husband does; similarly, a man does not have power over his body, but his wife does.
>
> Uxori vir debitum reddat similiter autem et uxor viro. Mulier sui corporis potestatem non habet sed vir similiter autem et vir sui corporis potestatem non habet sed mulier.

We note that the King James version translates this passage without reflecting the money language of debt: *debitum*—which is clearly in the Latin text:

> husband render unto the wife due benevolence: and likewise also the wife unto the husband. The wife hath not power of her own body, but the husband: and likewise also the husband hath not power of his own body, but the wife. (James Version of *I Cor.* 7:3–4)

The notion of slavery or thrall comes from the scripture and perhaps from Jerome's *Contra Jovinianum*, but the reference to debt and payment of debt is not as obvious in scripture. This is the kind of debt and payment which we see clearly illustrated in the "earlier" Wife of Bath's Tale, assigned to the Shipman.

Soon after the Pardoner's interruption, she returns to her early marital experiences and it is clear that in a description that includes both sex and money that three husbands at least were wealthy:

> The thre were goode men, and riche, and olde;
> Unnethe myghte they the statut holde
> In which that they were bounden unto me.
> Ye woot wel what I meene of this, pardee!
> As help me God, I laughe whan I thynke
> How pitously a-nyght I made hem swynke!
> And, by my fey, I tolde of it no stoor.
> They had me yeven hir lond and hir tresoor,
> Me neded nat do lenger diligence
> To wynne hir love, or doon hem reverence. (D 196–206)

Here sexual and financial images again intermingle as she calculates their sexual values ("I tolde of it no stoor") and though they had to work hard at night to satisfy her sexually, she is also making an unmistakable reference to

long hours at work to bring home adquate earnings. Again, this is a business observation of the husband which we see illustrated in the "Shipman's Tale." (On the marriage debt, see also Cotter and Harwood. In other *Tales* for the debt see Parson I 375, 940; *Mert T* E 2048. Much of this material may be found in Deschamps' *Miroir de marriage,* lines 1576–84.)

Here, as much as in the "Shipman's Tale," money and sex are seen as interchangeable commodities. Although the following passage is rich with material drawn from Deschamps and Jerome, the choice of mercantile imagery is consistent with the Wife's long assocation with men who dealt with money and trade:

> I sitte at hoom; I have no thirfty clooth (D 238)

> Thou seist to me it is a greet meschief
> To wedde a povre womman, for costage;
> And if that she be riche, of heigh parage,
> Thanne seistow that it is a tormentrie
> To soffre hire pride and hire maloncholie. (D 248–252)

Though these passages have been traced to Deschamps and to St. Jerome, the changes to suit the mercantile context are significant (See Deschamps 1625–48, Lowes and Pratt "Chaucer and Isidore.")
The assessment of potential wives is also compared to the assessment of livestock as well as other merchandise:

> Thou seist that oxen, asses, hors and houndes,
> They been assayed at diverse stoundes. (D 285–86)

The value of a woman fluctuates with time, as her beauty fades, just as values fluctuate with livestock. Now that she is old, her sexual value is reduced. If her value would hold, she could sell her sex at top price:

> For if I wolde selle my *bele chose,*
> I koude walke as fresh as is a rose. (D 447–8)

But now she laments the loss of those assets:

> The flour is goon; ther is namoor to telle;
> The bren, as I best kan, now moste I selle. (D 477–78)

(Note the meaning of "telle" is to tally up as well as to talk about.) Her discussion of her relationship with Jankin, the fifth husband, one with whom she suffered the most and at whose hand she became a battered wife, is filled with pathos. That husband is now dead, it seems (see D.S. Silvia). But her struggles with that husband culminate with her description in a telling statement. It is a statement listed as proverbial in B.J. Whiting (p. 368) but is better understood in a modern market economy as the law of supply and demand:

> Greet prees at market maketh deere ware,
> And to greet cheep is holde at litel prys;
> This knoweth every womman that is wys. (D 522–24)

Her marriage to Jankin, it seems, had some aspect of a bad bargain and though at the time of its telling the Wife is well enough pleased; it appears at first she payed too much for that marriage:

> And to hym yaf I al the land and fee
> That evere was me yeven therbifoore.
> But afterward repented me ful soore;
> He nolde suffre nothyng of my list. (630–33)

It was his youthful sexuality and his love of books that appealed to the Wife, but unfortunately that love of books was turned against her. When Jankin tried to curb her wandering ways he cited numerous antifeminist texts to show her how wicked women have traditionally been. Women must be tamed and all the best writers have shown it is the wisest policy of any sensible husband. She then makes a lament now famous from the works of later feminist writers:

> By God, if wommen hadde writen stories,
> As clerkes han withinne hire oratories,
> They wolde han writen of men moore wikkednesse

Than all the mark of Adam may redress. (D 693–96)

It is a plea by a woman who would have no arguments against her gender drawn from books because all the books (or at least almost all) were written by men. It is an argument nowhere better presented than in Jane Austen's *Persuasion* when Anne Elliot discusses with Captain Harville the sudden and surprising change in his friend Benwick. Harville speaks:

> "If I had such a memory as Benwick, I could bring you fifty quotations in a moment on my side the argument, and I do not think I ever opened a book in my life which had not something to say upon woman's inconstancy. Songs and proverbs, all talk of woman's fickleness. But perhaps you will say, these were all written by men."
> "Perhaps I shall—yes, if you please, no reference to examples in books. Men have had every advantage of us in telling their own story. Education has been theirs in so much higher a degree; the pen has been in their hands. I will not allow books to prove anything." (pp. 219–220)

The word "Education" is key in this passage because it almost certainly reflects Austen's source, Mary Wollstonecraft's book, foundation of modern feminism, *Vindication of the Rights of Women,* a work which focuses on women's right to an education.

The Wife's fight with Jankin over the book of wicked wives, from which she tore three leaves and cast them into the fire, ended with a ploy on her part to win back the title to her property. The two of them were, after a few more blows, able to settle accounts:

> But atte laste, with muchel care and wo,
> We fille accorded by us selven two.
> He yaf me al the bridel in myn hond,
> To han the governance of hous and land,
> And of his tonge, and of his hond also;
> And made hym brenne his book anon right tho. (D 811–816)

As a concluding comment on gender and money in Chaucer, it seems we should note above all the signs that Chaucer was well aware of gender issues involved. Unlike other writers of his time, and of the centuries to follow,

Chaucer refuses to fall into characterization along the steretyped gender depictions. It is not the case with his less gender conscious contemporaires who have allowd themselves to succumb to these traditional depictions, as we see in other English poets, the writer of *Gawain and the Green Knight,* as well as French poets and the Italian writers of the previous century (with the possible exception of Dante).

Bibliography

Adams, Robert. "The Concept of Debt in *The Shipman's Tale*," *Studies in the Age of Chaucer* 6 (1984): 85–102.

Austen, Jane. *Persuasion*. ed. with intro. and notes by Gillian Beer. London: Penguin Books, 1998.

Beidler, Peter G. "The Plague and Chaucer's Pardoner," *Chaucer Review* 16 (1982): 257–69.

Bryan, W.F. and Germaine Dempster, *Sources and Analogue of Chaucer's Canterbury Tales*. University of Chicago Press, Chicago, 1941.

Butterfield, Ardis. "Pastoral and the Politics of Plague in Machaut and Chaucer," *Studies in the Age of Chaucer* 16 (1994): 3–27.

Chaucer, Geoffrey. *The Canterbury Tales* ed. Larry D. Benson, based on *The Riverside Chaucer*. Boston and New York: Houghton Mifflin Co., 2000.

Cotter, James Finn. "The Wife of Bath and the Conjugal Debt," *MLN* 6 (1969): 169–72.

Crane, John Kenny. "An Honest Debtor?: A Note on Chaucer's Merchant, Line A276," *ELN* 4 (1966): 81–85.

Deschamps, Eustache. *Oeuvres, completes*, ed. Auguste H. E. Queux de Saint-Hilaire and Gaston Raynaud. Paris: SATF, 1878–1903, *Miroir de mariage*, vol. 9.

Duby, G. *Rural Economies and Country Life in the Medieval West*, trans. Cynthia Postan. University of Pennsylvania Press, 1998.

Dundes, Alan. *The Blood Libel Legend : a Casebook in Anti-Semitic Folklore*. Madison, Wisconsin: University of Wisconsin Press, 1991.

Hahn, Thomas. "Money, Sexuality, Wordplay and Context in the Shipman's Tale," in *Chaucer in the Eighties*, ed. Julian N. Wasserman and Robert Blanch. Syracuse, New York: Syracuse University Press, 1986, pp. 235–49.

Hatcher, John. *Plague, Population and the English Economy: 1348–1530*. London, England: Macmillan, 1977.

Helleiner, K. "The Population of Europe from the Black Death to the Even of the Vital Revolution," *Cambridge Economic History of Europe* 4 (1967): 69–71

Hornsby, Joseph Allen. *Chaucer and the Law*. Norman, Oklahoma: Pilgrim Books, 1988.

Johnson, Oscar E. "Was Chaucer's Merchant in Debt: A Study in Chaucer's Syntax and Rhetoric," *JEGP* 52 (1953): 50–7.

Lawrence, William W. "Chaucer's 'Shipman's Tale,'" *Speculum* 33 (1958): 56–68.

Lopez, R. S. *The Commercial Revolution of the Middle Ages*. Englewood Cliffs, N. J.: Prentice Hall, 1971.

Lopez, R. S. and I. W. Raymond. *Medieval Trade in the Mediterranean World* 3rd ed. New York, 1968.

Lowes John L., "Chaucer and the Miroir de Mariage," *MP* 8 (1910–1): 305–34.

Moore, Arthur K. "The Pardoner's Interruption of the Wife of Bath's Prologue," *MLQ* 10 (1949): 49–57.

Pounds, N. J. G. *Economic History of Medieval Europe.* 3rd edition London, England: Longman, 1980.

Pratt, Robert. "Chaucer's Shipman's Tale and Sercambi," *MLN* 55 (1940): 142–145.

———. "Chaucer and Isidore on why Men Marry," *MLN* 74 (1959): 293–4.

———."The Development of the Wife of Bath," in MacEdward Leach, ed. *Studies in Medieval Literature in Honor of Professor Albert Croll Baugh.* Philadelphia, University of Pennsylvania Press, 1961, pp. 45–79.

Shoaf, R. A. *Dante, Chaucer, and the Currency of the Word: Money, Images, and Reference in Late Medieval Poetry.* Norman, Oklahoma: Pilgrim Books, 1983.

Silverstein, Theodore. "Wife of Bath and the Rhetoric of Enchantment,"*MP* 58 (1961): 153–73.

Silvia, D. S. "The Wife of Bath's Marital State," *N&Q* 14 (1967): 8–10.

Stillwell, Gardner, "Chaucer's Merchant: No Debts?," *JEGP* 57 (1958):192–96.

Tatlock, J.S.P. *The Development and Chronology of Chaucer's Works.* London, England: Chaucer Society, Second Series, No. 37, 1907.

Whiting, B. J. *Chaucer's use of Proverbs.* Cambridge, Massachusetts: Harvard University Press, 1934.

5

The "Marriage Group" Revisited—Again

No essay of Chaucerian scholarship can outmatch George Lyman Kittredge's article on "Chaucer's Discussion of Marriage," perhaps the most enduring of all Chaucerian critical items, published in 1912 in *Modern Philology*. James Sledd, casting Kittredge in a Falstaffian mode, has cleverly remarked that the article is "both witty in itself and the cause of wit in other men." If we take Sledd's comment to indicate clever talk among a group of fellows, it could be discounted as meaningless and perhaps as living on the back of Kittredge's reputation. But if we take Sledd to mean that the "wit" is intelligent and insightful critical comment and "men" to include both genders, we certainly we must agree that Kittredge has inspired numerous responses which have extended and deepened his original observations. Most important of all the discussions of Kittredge (with the acknowledgment that there are some who do not accept his argument) are the studies which extend the discussion of marriage to other tales.

Kittredge's argument was undertaken not as a study in gender but as a structuralist approach to the *Tales*:

> Let us consider certain tales in their relation to Chaucer's structural plan. (p. 131 in Schoeck and Taylor)

He wished to emphasize that the tales are not to be seen singly but as part of a group of narratives which both reflect on the teller of each and interact among themselves. Not only do the personalities of pilgrims who tell tales

interrelate as parts of a group but their tales also interrelate thematically.

> Here one may appreciate the vital importance of considering the *Canterbury Tales* as a connected Human Comedy, of taking into account the Pilgrims in their relations to one another in the great drama which the several narratives are structurally incidental. (p. 133)

Kittredge's argument still works well for many readers, but in my application it will be transferred to operate more broadly on Chaucer's treatment of the gender issue. Obviously, a marriage debate is fundamentally a gender discussion since in Chaucer's England one must conceive of marriage as an arrangement between the genders. I will also shift the discussion to the point of the *Canterbury Tales* thematic center. That is, I believe that the Wife of Bath is the polar force which directs all the thematic material of the *Tales* and that all the other tales before and after hers are in some way a response either to her argument, her statements about her own experience, or even to her very presence in a largely male company.

In order to prepare the following discussion, I would like to present Kittredge's argument in its broad outlines and in doing so affirm its critical validity, a position generally accepted by Chaucerians at this time. Kittredge's argument begins with the Wife of Bath and as long as a reader accepts the sequence of tales as in Fragments III, IV, and V (or as in Group D, Group E and Group F) in the arrangement of the tales, the sequence has some logic to it. Kittredge would suggest that the Wife poses a question of domination in marriage which she herself answers emphatically should belong to the woman. Her argument elicits a response from the Clerk, a response which is not only explicitly directed to her but is also suited in several ways to the personality of the teller even though it was probably written earlier in some version perhaps before the scheme of the *Canterbury Tales* had even occurred to Chaucer (if we are to judge by the verse form that he favored in the early 1380's). The tale and the manner of its recitation are both eminently suited to the Clerk who is a representative of the doctrinaire teaching of the celibate clergy. It must be seen at its basis as essentially anti-feminist not only in spite of but especially because

of the somewhat cynical injunction to husbands not to put their wives to such a test and because of his advice to women not to attempt to become other Griseldas.

The "Merchant's Tale" represents a point view that is a "plague on both their houses" in response to the issue of which gender should take on the dominant role. It is not just a response to the Wife of Bath but to both the Wife and the Clerk. Speaking from his own experience of marriage, the Merchant begins his tale with a debate and ends with a fabliau. The debate flows from the traditional Catholic Church teaching on gender theory but, infused with the negativism of the Merchant, takes on a cynical ironic tone. It is, nonetheless, illustrative of some important issues in the debate.

With the "Franklin's Tale," fourth in the original group, Kittredge imagines that Chaucer has brought the discussion to a satisfactory conclusion and he would have us believe that this Breton Lay describes for us a perfect balance between the genders.

> For the marriage of Arveragus and Dorgin was a brilliant success....Thus the whole debate has been brought to a satisfactory conclusion and the Marriage Act of the Human Comedy ends with the conclusion of the Franklin's Tale.
>
> Those readers who are eager to know what Chaucer thought about marriage may feel reasonably content with the inference that may be drawn from this procedure. The Marriage Group of Tales begins with the Wife of Bath's Prologue and ends with the Franklin's Tale. There is no connection between the Wife's prologue and the group of stories that precedes it: there is no connection between the Franklin's Tale and the group that follows. Within the Marriage Group, on the contrary, there is a close connection throughout, that acts as a finished art. It begins and ends an elaborate debate. We need not hesitate, therefore, to accept the solution which the Franklin offers us as that which Geoffrey Chaucer the man accepted for his own part. Certainly it is a solution that does him infinite credit. A better has never been devised or imagined." (pp. 157–8)

Just a few years after Kittridge published his article, another Chaucerian, H. B. Hinkley, completely dismissed the idea that the "Marriage Group" was intended by Chaucer. Hinkley denied the existence of a "Marriage Group" and believed that the "Franklin's Tale,"—which Kittredge thought was a conclusion

to and a solution of the question of domination in Marriage—that "the Franklin's Tale is barely if at all co-ordinated with anything that precede the Squire" (p. 301). Today only a few critics take such an absolutely dismissive view of Kittredge's "Marriage Group."

We can thank Kittredge for leading us to see the debate and emphasizing the thematic interplay of stories and their tellers. But he is certainly wrong on two essential points and we can claim to have benefited from the intervening 90 years of critical introspection as well as from the new philosophical and psychological tools which we can bring to this work. The debate is not closed with the Franklin's tale and it does not represent the tidy solution to the gender issue that Kittredge may have ardently wished for. In fact, the issue is explicitly brought to the fore again in several other tales, such as the "Tale of Malibee" which reflects the same gender issues we see elsewhere: a woman prevails on her husband to be more logical and rational in his response to antagonism and the husband accepts her advice—and he is therefore dominated—advice that represents a morally superior mode of acting. If one goes beyond just the marriage issue and looks at gender as a broad topic, one sees the gender issues emerge in almost all of the tales, frequently in response to the teller's own gender awareness. It is perhaps weakest, though still present, in the young child's loving relation to the Blessed Virgin, whose virginity binds them across gender lines. The child is a martyr but also a virgin, as a young and unspoiled believer:

> O martir, sowded to virginitee,
> Now maystow syngen, folwynge evere in oon
> The white Lamb celestial—quod she—
> Of which the grete evaungelist, Seint John,
> In Pathmos wroot, which seith that they that goon
> Biforn this Lamb and synge a song al newe,
> That nevere, flesshly, wommen they ne knewe. (B2 1769–75)

The gender issue is notably absent in the "Pardoner's Tale," told by a person who is without gender, thanks to the ecclesiastical knife that deprived him and forced him to become an adult of dubious gender identity. He is,

therefore, the polar opposite from the Wife of Bath whose discourse is heavily gendered from beginning to end in accordance with her self recognized and repeated admitted gender awareness which springs from a strong, almost overwhelming libido:

> As help me God, I was a lusty oon,
> And faire, and riche, and yong, and wel bigon,
> And trewely, as myne housbondes tolde me,
> I hadde the beste *quoniam* myght be.
> For certes, I am al Venerien
> In feelynge, and myn herte is Marcien.
> Venus me yaf my lust, my likerousnesse,
> And Mars yaf me my sturdy hardynesse;
> Myn ascendent was Taur, and Mars therinne.
> Allas, allas! that evere love was synne!
> I folwed ay myn inclinacioun
> By vertu of my constellacioun,
> That made me I koude noght withdrawe
> My chambre of Venus from a good felawe. (D 605–618)

After failing (or perhaps refusing) to see the Marriage Group as the mainspring connected to many wheels, both smaller and larger, and then on to the entire machinery of the gender discussion in the other tales, Kittredge tries to keep the marriage discussion confined and neatly encapsulated in those four tales. That procedure doubtless allowed a reader some satisfactory understanding and a settled explanation of marriage and of the gender issue. Later critics, however, perhaps enlightened by the ensuing intellectual developments of the 20th century, could not rest contented with such easy answers. The coming and passing of philosophers who evolved a phenomenological approach that valued questions as much as or more than answers and wished to describe rather than solve problems have reshaped our thinking as we read this older literature. Or perhaps the coming and passing of philosophers who stressed the existential meaning of a problem rather than one solution which fits all have also helped us to devise a more nuanced and complex explanation of some literary works which subsequently would reveal

greater depth of meaning. It would seem, one may now argue, that Chaucer himself had not intended such easy answers, answers that are final and complete.

The second error in Kittredge's theory is more off the mark and, in a sense, somewhat distressing. In theory the arrangement of Arveragus and Dorigen not to claim domination one over the other is a noble one—but only in theory. In practice, it works much to Dorigen's disadvantage. One could hardly wish to model a marriage on this example.

He seeks the love of Dorigen fervently, following the canons of Courtly Love and succeeds in winning her love. The entire event is cast in the conventional terms of courtly lovers. But, unlike the most famous of such lovers (e.g. Lancelot or Tristan), he becomes her husband in lawful marriage.

> For she was oon the faireste under sonne,
> And eek therto comen of so heigh kynrede
> That wel unnethes dorste this knyght, for drede,
> Telle hire his wo, his peyne, and his distresse. (F 734–37)

Arveragus then, despite his "wo, his peyne, and his distresse," abruptly leaves Brittany and his wife for an unspecified task abroad (perhaps in England). Her subsequent suffering is very great and she is exceedingly depressed. The tale does not explain in detail that perhaps she suffers from a sense of betrayal after having been courted so intently. Her companions fear the worst, that in her depression she might commit suicide by leaping from the cliffs of Brittany's coast. In this vulnerable state of mind, she makes a rash promise to an unscrupulous plaintiff, Aurelius, a young man who seeks her love in an extra-marital relationship. In a pathetic gesture that expresses her desire for the legitimate love, the husband's safe return, she agrees to accept Aurelius if he could achieve the impossible—remove the dangerous rocks from the coast of Brittany. The eventual sham fulfillment of this task drives her already unstable mental state to the greatest imaginable agony. After reciting a series of stories about women who would rather slay themselves than commit a sin against chastity, she concludes:

> "What sholde I mo ensamples heereof sayn,
> Sith that so manye han hemselven slayn,
> Wel rather than they wolde defouled be?
> I wol conclude that it is bet for me
> To sleen myself than been defouled thus." (F 1419-23)

In the midst of this suicidal agony Arveragus returns and, she hopes, he will resolve all her distress. The modern reader would share her hopes, as I believe Chaucer would expect any reader to do, but the husband's response to her miserable retelling of the entire event is one of stunning insouciance:

> "Is ther oght elles, Dorigen, but this?" (F 1468)

He sees no problem in the dilemma she describes with respect to her own feelings about the matter; he will not object if she keeps to her word since one's "trouth" is sacred once given. But of a sudden he does begin to weep, not for her, but for his own reputation. Insensitive to her agony, he suddenly becomes aware of his own emotional pain and claims to suffer it bravely. Any reader would be taken aback by his self centered obtuse response. What could Professor Kittredge have been thinking when he read the lines in which Arveragus encouraged her to go to Aurelius, and gratify him but not reveal the extra marital sex, lest the husband himself exact the ultimate penalty from her:

> "I yow forbede, up payne of deeth,
> That nevere, whil thee lasteth lyf ne breeth,
> To no wight telle thou of this aventure—
> As I may best, I wol my wo endure—" (F 1481-84)

She is spared from death, a death administered either at his hand or her own, spared by Aurelius' withdrawal of his already unjustified claim, unjustified because of her unstable emotional condition and because its fulfillment was a hoax. By any law, canon law or secular law, such agreements made under fraudulent conditions are automatically null. Yet she is held to her promise by her husband and, initially, by a lover who finally seems to realize

that he could derive no satisfaction from a suicidal woman who (like Lucretia in the *Legend of Good Women*) would prefer death to dishonor. In an act of resignation, perhaps parallel to the "generosity" of the husband, seemingly selfless in not holding her to the promise, Aurelius releases her from the bond and imagines himself as good as a knight. The irony of these words needs hardly to be stressed:

> But every wyf be war of hire biheeste!
> On Dorigen remembreth, atte leeste.
> Thus kan a squier doon a gentil dede
> As wel as kan a knyght, withouten drede. (F 1541–44)

The teller ends his tale with a question to the reader: which of these characters, Dorigen, Aurelius, Arveragus or the Magician, was the most generous?

> Lordynges, this question thanne, wol I aske now,
> Which was the mooste fre, as thynketh yow?
> Now telleth me, er that ye ferther wende.
> I kan namoore; my tale is at an end. (F 1621–24)

The fact that the tale ends with a question should have suggested to Kittredge that the tale is not an answer to the question of the marriage relations nor to any other question. Indeed, this query is a clue that the story should be understood in the guise of a wide spread and widely recognized medieval genre —the debate. The debate as a genre did not represent an attempt to answer questions but an attempt to illuminate a variety of facets which may be discerned in a question. Chaucer has already provided examples of his interest in the debate and certainly we need not look far to other Middle English examples and indications of its popularity. The first half of the "Merchant's Tale" is clearly set up as a debate.

Among other debate poems in English which present a dilemma or otherwise not easily resolvable issue are poems on the debate between the flower and the leaf or between the body and the soul. The debate was the

method preferred by, and required from, students in the university where issues were explored by questioning opposite sides of a topic. Of the many medieval philosophers who wrote works about disputed questions *(quodlibita disputata)* are Thomas Aquinas, Henry of Ghent, John of Pecham, Petrus de Alvernia, Richardus Humbury, William of Balonia, Duns Scotus and Giles of Rome. The importance of the method is described in the *Cambridge History of Later Medieval Philosophy:*

> In the thirteenth century the principal duties of a Master in Theology were to lecture, to preach, and to dispute. The holding of academic disputationes many times in the year, perhaps even weekly, formed an integral part of the academic curriculum, less frequent, but no less important, than the giving of lecture courses. The records of these disputations, in the form of *Questiones disputatae*, constitute a valuable part of the output of many medieval philosophers and theologians. (p. 21)

This methodology finds its way into literature in various forms, no doubt the most famous of which is Hamlet's debate with himself over the worthwhileness of his life: "To be or not to be—that is the question" (3.1.57).

So, despite a structuralist's desire to see closure to the question of the marriage debate, it should be more revealing to look at the group as an open debate. The reader must decide for himself or herself what the answer may be. It would, therefore, be simplistic to seek an answer in Chaucer. Rather, we should look at this account as one in a series of examples of problems in marriage.

Nor should one look at the four stories of marriage as a distinct, discreet and closed group as Kittredge has imagined it. The Marriage Group is indeed a discreet and distinct group but it is not closed. It is rather the nucleus of a discussion which extends through almost all of the tales. The Wife has introduced the central topic in its most fundamental form, as a debate on marriage. Several other tales dealing as well with the marriage question, some explicitly, others less obviously, are by the Miller, Reeve, Man of law, Shipman, the character "Chaucer" on Melibeus, Nun's Priest, and the Manciple. Other tales deal with gender relations but not necessarily with marriage:

"Knight's Tale," "Monk's Tale," "Parson's Tale." Of the completed tales, that leaves the Prioress, Friar, Summoner, and Pardoner who provide little or no trace of any gender discussion.

We can never be sure of when and under what circumstances Chaucer first conceived of the character we call the Wife of Bath, given the name of Alyson, a name often assigned to women of lose morals. I would suggest that the conception of the Wife of Bath as a character and of her role in the *Canterbury Tales* may be linked with the discussion of heroic women in the *Legend of Good Women*. The writing of the final sections of the *Legend* may well have coincided with the writing of the Wife's prologue or at least fell within the same five year period. While the Wife's career does not follow the pattern of the women in the *Legend*, she does respond to the spirit which Chaucer invokes in the Prologue to the *Legend*—to remedy the assault on the integrity and goodness of women as perhaps seen in his earlier literary works. She is the eventual fulfillment of the obligation Chaucer undertook in the *Legend* to write about "good women." The meaning of "good women" which he initially took at face value, almost as "hagiographically good," seems to have become meaningless in that earlier work. The "good" women of the *Legend* were more victimized women than good women. So Chaucer shifted the meaning of "good woman" to a significance more akin to "strong woman" or "capable woman" or, in general, a woman who is not dominated and ruined by men, as most of the women in the *Legend* are. This more operative sense of "good woman" is also more realistic and meaningful.

The Wife may be imagined as responding to the need for a more positive reaction on the gender issue as it emerges in the Prologue to the *Legend*. It would seem that at some point between the writing of that Prologue and the time he finally decided to give up on the project with the unfinished life of Hypermnestra, Chaucer decided for some reason that the compilation of lives of victimized women was an inadequate response to the challenge he posed for himself in the words of Nature and the Goddess of Love:

Now wol I seyn what penance thou shalt do

> For thy trespas. Understonde yt here:
> Thow shalt, while that thou lyvest, yer by yere,
> The most partye of thy tyme spende
> In makyng of a glorious legende
> Of goode wymmen, maydenes and wyves,
> That weren trewe in lovyng al hire lyves;
> And telle of false men that hem bytraien,
> That al hir lyf ne don nat but assayen
> How many women they may doon a shame;
> For in youre world that is now holde a game.(F 479-489)

If the course taken in the subsequent lives led Chaucer to a dead end—probably because he was too closely tied to the example of Boccaccio's *De Claris Mulieribus*—he seems to have made an abrupt change of tactics with the Wife of Bath.

If we are to follow Kittredge's lead and make thematic connections between and among the tales, we would see that the most notable of the tales which are not directly part of the Marriage Group, but form the first ring around that group, are the fabliaux. The tales told by the Miller and Reeve form a special relationship to the marriage discussion and to the gender theme in ways that have a bearing not only to the question of domination in gender relations but as well on other gender issues, both marital, extra material and non-marital.

One may seriously question the proposition that Chaucer's conception of the *Canterbury Tales* began with the character of Alyson, but let us suppose for the sake of argument that such was the case. The fact that she does not begin the sequence of tales would indicate the plan on Chaucer's part to approach his topic gradually (as he does gradually approach the issue in the Prologue to the *Legend of Good Women*). Nonetheless by moving his reader (or listeners) through the tales told by the Knight and the two fabliaux from the Miller and Reeve, he is nonetheless preparing the gender discussion with several subtle but meaningful statements that will come into focus with the Wife's challenge on the issue of domination in marriage. One cannot avoid seeing how the will of the female charcters emerges from the opening tales and dominates the most important developments in the narrative. As he will bring out sharply in the

tales belonging more immediately and explicitly to the marriage discussion, women intervene in the "Knight's Tale" to perform gentler, kindlier acts and bring a man to behave in a more reasonable way. The women persuade Theseus to bury their forsaken menfolk who came to a violent end in battle and, more remarkably, to change his mind about the execution of Palamon and Arcite; he is persuaded to transform their conflict into a duel in which sharp and lethal weapons are prohibited. Instead of an execution, their hostility is transformed in a specially constructed stadium which houses places of worship not only to the god of battle (Mars) but also to the God of Love (Venus) and of Chastity (Diana) as well. What began as a violent response on the part of Theseus in the punishment of the escaped prisoners is transformed, at the behest of the women, into a contest to determine the more worthy lover.

The Wife of Bath represents the central figure around whom the discussion of the Marriage Group is arranged and around that Group the further extensions of the marriage question and beyond that of gender as a topic of paramount importance throughout the tales. Though her tale does not occur at the beginning of the sequence of *Canterbury* narratives, she is nonetheless its most important thematic engine. The tales which we read before she begins to speak are, in a sense, preparatory for her discourse and already contain in them several important elements of the issues she touches on. With her lengthy prologue and with her finely wrought tale, the gauntlet is thrown down. She provokes the discussion, just as a professor in the medieval university might provoke a debate, by introducing a question for discussion so that his students might show their skill and learning by taking various positions with regard to it. It could have been one of the *quaelibet questiones* (certain questions) that St. Thomas, in a volume he penned with that title, could have provided for students of scholastic logic.

The gauntlet is not picked up immediately, as it should have been by the Clerk, who would have recognized the scholastic frame of her logic and the nature of her challenge. Two fabliaux intervene before he responds. The fabliaux through most of the *Canterbury* sequence play a significant role in the

Marriage Discussion and we may note that Kittredge does not deal with them.

In the two fabliaux that follow the Knight's tale, those by the Miller and the Reeve, the wills of the several female characters clearly dominate. The young wife of the carpenter not only becomes the focus of intense interest on behalf of the three males, all of whom are thwarted in their hopes of gratification, but she is preserved from the violent humiliation which visits them, on two in a greater degree, on one to a lesser. The husband's arm is broken and he is publicly humiliated; Nicholas is badly burned; Absolon, given his particular sensitivities, is degraded and disgusted by both the other two young lovers. The same kind of gender specific distribution of punishment and humiliation is seen in the activities of the two women in the Miller's household, as told by the Reeve. Violence is visited on two of the men while the women have shown clearly that their sexual gratification was genuine if outside the bounds of normal morality.

Although Chaucer progressed well into the telling of the sequence of tales before he made more explicit his intention to focus on gender, a careful reading at to the opening portions of the *Tales* shows the gender theme appearing regularly and, particularly, it is stated in its most cosmic statement in the opening lines of the General Prologue:

> Whan that Aprill with his shoures soote
> The droghte of March hath perced to the roote,
> And bathed every veyne in swich licour
> Of which vertu engendred is the flour; (A.1–4)

If one were to interpret these lines in their cosmic context, the reader recognizes the mother earth (*mater terra*) from whom springs all living things. Life springs from the earth after she has been embraced and penetrated by father sky (*pater aether*) who penetrates her with his life giving juices. The masculine principle, also seen as the month of April, penetrates the dry infertility of the month of March and brings forth the flowers, the trees and the grasses ("every holt and heeth" A 6).

In these profoundly meaningful opening lines, Chaucer sees a vision of the

gender relations of humans projected into the cosmic forces which bring life to the earth and inspire, with deep thrusts, the lively birds and drive the humans to their religious expression to celebrate life. By singling out the Wife of Bath as the initiator of the marriage discussion, Kittredge has led us to the heart of what the *Canterbury Tales* is all about. He has shown us that the tales do not exist in isolation but in fact operate in a dynamic exchange and response with each other. It is a dynamism which in fact draws into its process even other works written earlier than the *Tales* and which even may be seen as preparatory to its thematic materials.

The importance of genre studies is made clear by recent critical works, such as that of John Hines, *The Fabliau in English*. Serious readers of Medieval and Renaissance literature understand the function of genre forms during those periods. Frequently a writer will depend on the reader's familiarity with the form and the significance of that writer's poetry draws upon an awareness of the traditional genre and the writer will play against the conventions of the form. This is clear in such poems as John Donne's "Busy Old Fool" which plays against the medieval form of the aubade; consequently a knowledge of that form's traditional manifestations make the poem more significant, not merely in terms of satirical representation but across a broader range of ideas not explicitly stated but which, either by the inversion or renewed emphasis bring new meaning to the form. The same may be noted in early Renaissance prose versions of the medieval romance where satire also gives way to a new type of narrative with added meaning, as we see in Cervantes' *Don Quixote*.

Of the various genres that Chaucer adapts and reinterprets, none is more significant with respect to gender issues, not even the romance, than is the fabliau. Chaucer's use of the fabliau is meaningful not only because he is the most important writer of fabliaux in England during the 14th century but also because, by depending on the reader's recognition of the form, he conveys what is clearly a new message in the genre.

The fabliau, as the name suggests, is an imported form. The English, as does any culture, produced a wealth of bawdy stories in its repertoire of folk

literature, but it is the French and the Italian writers who created most of the examples that Chaucer knew and against which he played his own variations. The French and Italian forms differ, as has been pointed out by several scholars who have written on the topic, but it is the Italian Boccaccio whose example bears the more important meaning for comparison with Chaucer. Although we can be sure that Chaucer drew on his own native English materials for later works, such as the tales told by Miller and Reeve, he is even then continually playing against the fabliau form as we might read it in Boccaccio; the differences between Chaucer and Boccaccio are telling and important. Boccaccio's work is a significant control model for our comparison not only because he is the most important single writer on the continent connected with the form but also because we know that Chaucer was directly familiar with many of his works. This is not to say that we can be sure he used any particular story as his model, but the general form and attitude that we see in Boccaccio's works must have been very clearly established in Chaucer's mind.

The fabliau as a genre is distinguished by several easily recognized features. It is a tale of life in the middle or lower social strata, usually is bawdy, mostly humorous in tone and one that depends as a source of humor on both anti-feminist and anti-clerical situations. The Italian tales tend to be more consistently anti-feminist than the French, as Hines reports. The most notable feature of Chaucer's adaptation of these tales is that he consistently avoids focusing the humor of the story on the humiliation of women. In other respects, however, Chaucer's fabliaux fit the familiar format and are remarkable for their naturalism and realistic representation of lower life in medieval England.

For all their conventional appearance, however, we must read Chaucer's fabliaux contextually to understand their full significance. Kittredge and others have taught us to see the tales in relation to each other and many useful observations emerge from the comments of John Hines and other critics who have looked either across the genre to see how Chaucer's works appear against the tradition of the genre or have seen his tales in the context of the larger discussion of issues in the whole of the *Tales* or even in the whole of his poetic

oeuvre. This point may be illustrated in the discussion over Alison's escape from any punishment in the "Miller's Tale."

Jeanette Richardson speculates on why Chaucer spares Alison any humiliation and according to her, Alison escapes any punishment in the tale because she acts purely in accordance with nature. If, however, we look at each fabliau, we see that Chaucer always spares his female characters. In the "Reeve's Tale," the two women even seem to enjoy their sexual escapades and are allowed to do so with impunity while the male participants receive some punishment or humiliation. In both the Merchant's tale and the Shipman's tale, the women are gratified and they frequently outsmart her husbands. When we see the manner in which women are treated in fabliaux written by others, Chaucer's singular treatment is seen as particularly meaningful in his consideration of gender. For examples of how Boccaccio uses women for the object lesson of the story, see the tenth story of the eighth day of the *Decameron* where the woman is defrauded and humiliated. One may also see this humiliation in the first story of the fourth day and in the *Il Corbaccione* by Boccaccio. Again the woman suffers in the 7th story of the 9th day. The 9th story of the ninth day represents an event that would be hard to imagine in one of Chaucer's *Tales*:

> Having laid his hands on a good stout stick of sapling oak, Joseph made his way to his wife's bedroom, to which she had retired, mumbling and muttering angrily to herself, from the supper-table. And grabbing her by the tresses, he flung her to the floor at his feet and began to belabor her cruelly. The woman first begin to shriek and then to threaten; but finding that Joseph was totally unmoved by all this, she began, bruised and battered from head to toe, to plead with him in God's name to spare her life, saying she would never again do anything to displease him. None of this had the slightest effect upon Joseph, who on the contrary tanned her hide with ever-increasing fury, dealing her hefty blows about the ribs, the haunches, and the shoulders until eventually he stopped from sheer exhaustion. And to cut a long story short, there was not a bone nor a muscle nor a sinew in the good woman's back that was not rent asunder. (from Giovanni Boccaccio, *The Decameron*, trans. G. H. McWilliam, pp. 693–694)

While Boccaccio presents a large range of stories in which male and female

characters may be either rewarded or punished, this is the kind of punishment Chaucer reserves only for his male characters.

After the paired tales of the Friar and Summoner have concluded, the sequence of narratives returns to the Marriage Group proper, that is, to the response from the Clerk and the subsequent telling of his tale. Kittredge's treatment of the Clerk's story about the Patient Griselda is, I think, still largely acceptable and has not been challenged by those who accept the theory of the Marriage Group as a whole. The Clerk is rather explicit in his response to the Wife of Bath:

> For which heere, for the Wyves love of Bathe—
> Whos lyf and al hire secte God mayntene
> In heigh maistrie, and elles were it scathe—
> I wol with lusty herte, fressh and grene,
> Seyn yow a song to glade yow, I wene; (E 1170-1174)

He is, however, non too aggressive in his response. Between her very forward and bold statements there intervene the fabliaux of the Friar and Summoner, two tales which could otherwise have distracted the whole company from her challenge. Furthermore, he does not break out in angered or even irritated response, as do others who have been insulted by a story, others such as the Reeve or the Summoner. The Clerk has been invoked by the Hooste that he should not remain silent and he had apparently been withdrawn into his own musings. He replies, as a good clerk should, out of obedience. But there is no doubt about the depth of his bitter feelings, a suppressed array of envy and resentment.

The Clerk's tale itself, however, and the envoy do bring up a more complex matter of interpretation for the reader. The story certainly comes from Italy, and is set in Italy. We recognize it as an analogue of the final story of Boccaccio's *Decameron*, though whether it comes directly or indirectly to Chaucer from Boccaccio has not been determined to the satisfaction of all critics. In Boccaccio it is very understandably seen as an antifeminist account which matches several other tales in that work and is certainly consistent with the

prevalent antifeminism of Boccaccio's later work, notably the *Corbaccio*. If one were to look for authorial intent, one might see this story in the *Decameron* as a rebuke of women in general upholding Griselda as an (impossible) example for all women to follow. This is an attitude on Boccaccio's part stated in the preface to the *De Claribus Mulieribus* whose purpose, he tells the reader, is to inspire female readers to be good women.

> I have also thought that at times I would include among these stories some pleasant exhortations to virtue and add inducements to avoid and detest wickedness, so that by adding pleasure to these stories their value would enter the mind by stealth. (trans. Guarino, p. xxxviii).
>
> Quandoque hystorias inserere nonulla lepida blandimenta virtutis et in fugam atque detestationem scelerum aculeos addere, et sic fiet ut immixta hystoriarum delectationi sacra mentes subintuabit utilitas....(p. 6)

Chaucer may have known the tale from Boccaccio or from Petrarch's Latin version the *De Obedientia ac Fide Uxoria Mythologia*. Both of these versions were widely known in the Middle Ages and doubtless were usually read as stories directed against inconstant or shrewish women. No strong feelings of appreciation for the other literary merits of these two Italian writers should deter us from seeing the story for what it is. It is not a happy story in favor of women and its intent appears to have been usually one of admonition for all women.

We cannot determine Chaucer's initial understanding of the story, but it is likely he understood it as did most of his contemporaries. It appears that he wrote the first version of his own adaptation at some time before he began to write the *Canterbury Tales*. The use of stanzaic rhymes in the narrative is characteristic of his pre-Canterbury period and that is the general opinion of scholars such as Severs and Dempster. (Yet there are still some scholars who would place it at a later date.)

It is reasonable to assume that if Chaucer wrote the story of Griselda five to ten years previous to composing the Wife of Bath's tale, that is, prior to the fashioning of a "Marriage Group." He may have read and understood the tale

in the same antifeminist spirit that we find in the original Italian authors. However, when he decided to adopt it as part of the Marriage Group, the tale takes on a clear function, one quite different from what we see in Boccaccio and Petrarch. The Clerk has been greatly offended by the Wife of Bath, both in her Prologue and in her Tale, for several reasons. As one who considers himself a master in logic (we are told that he "unto logyk hadde longe ygo" at Oxford, A 286) and who studied at the same place and perhaps under the same professors as Jenkin. They may have been classmates at Oxford. He doubtless took careful note when he heard the wife describe her last husband:

> My fifthe housbonde—God his soule blesse!—
> Which that I took for love, and no richesse,
> He som tyme was a clerk of Oxenford,
> And hadde left scole, and wente at hom to bord
> With my gossib, dwellynge in oure town; (D525–529)

We can imagine the roiling of antagonistic emotions when he heard of the humiliation that his former fellow scholar endured at the hands of this dominating and shrewish woman. The Clerk was doubtless much irked by her derisive, comical and satirical manipulation of texts he had studied seriously and which she doubtless learned about from Jankin (see chapter on Boethius and the Wife of Bath). She must have annoyed him greatly with her clear and clever manipulation of scholastic logical techniques such as the *nihil frustra* and the Aristotelian maxim *in medio stat virtus* which in her hands become tools for heresy; early on she even seems to sense his annoyance:

> Telle me also, to what conclusion
> Were members maad of generacion,
> And if so parfit wys a [wight] ywroght?
> Trusteth right wel, they were nat maad for noght,
> Glose whoso wole, and seye bothe up and doun
> That they were maked for purgacioun
> Of uryne, and oure bothe thynges smale
> Were eek to knowe a femele from a male,
> And for noon oother cause—say ye so?

The experience woot wel it is noght so.
So that the clerkes be nat with me wrothe,
I say this: that they maked ben for bothe; (D 115-126)

The Clerk may have been "wrothe" with her not only because she claimed a sexual as well as a purgative purpose for genitals which implies a dual requirement for their use, but also because her argument is so eminently scholastic. If a thing exists, it must exist for a purpose because God does not create in vain. This is the fundamental rule of *nihil frustra*. The Clerk may also have recognized a parody of Boethian logic in her tale which recounts the story of a wise female figure who confronts a suffering recumbent man and challenges his logic through a series of paradoxical arguments. Moreover, by adopting *both* "purgacioun" and sexual enjoyment, the Wife is able to claim, by implication, the familiar *in medio stat virtus* solution.

In this brief survey of the two stages through which the story of Griselda developed to become the Clerk's rebuttal to the Wife of Bath we see how Chaucer may have developed his thinking on the issue. In Boccaccio (or Petrarch) it was not a tale sympathetic to women; in Chaucer's early pre-Canterbury version it could have been similar to the Italian versions in intent. But by the time the tale is incorporated in the Marriage Group there is no doubt that both tale and teller have become placed entirely within the pale of doctrinal clerical antifeminist stereotypcasting.

In the sequence of tales which make up the Marriage Group, Kittredge selected those which are explicitly responses to the Wife's challenge about who should dominate in marriage. He ignored several other tales which intervene but which subsequent scholars have shown are relevant to the discussion even if they are not specifically replies to the Wife's issue. The two fabliaux mentioned earlier should be seen in that respect. The "Squire's Tale" is a third narrative which is encased within the sequence of the four "explicit" marriage tales but is not spoken as a response to the Wife. Its presence there has encouraged Professor Marie Neville, in her article of 1951, to see it as an integral part of the marriage discussion. Though not integral in the sense that it responds to the Wife's challenge of deciding which

partner should dominate, it does carry through the theme of marriage relations, certainly of gender relations. Her essay is an example of how Kittredge's article was able to inspire further critical insight. Although not particularly sensitive to the gender issues on the marriage topic or in the *Canterbury Tales* in general, Professor Neville advances the concept of the inter relationship of the tales as enunciated by Kittredge. She differs from Kittredge in that she considers the "Squire's Tale" as part of the marriage discussion because it touches on some of the requirements of the ideal marriage. In fact, it is not at all about marriage but it is indeed about gender and as such it fits well into Chaucer's gender discussion. Neville continues to break open the discussion of the Marriage Group and extends Chaucer's discussion to other than just the original four tales. She accepts Kittredge's thesis, however, that the "Franklin's Tale" is a solution. Where Kittredge saw the "Squire's Tale" as a pause in the discussion, Neville shows a convincing link between the Squire and the Knight, both in their personal relations (father and son) as well as in the content of their tales.

We can be certain that the discussion on the Marriage Group is not over and more publications in response to Kittredge's initial essay will follow. Like the Wife, Kittredge has provoked numerous replies on a vital topic and the discussion continues throughout the Chaucer readership. Unless some very significant textual discovery comes about to disrupt the sequence or until some scholar comes upon a better way to tie together the interchanges among these characters, it seems likely that the Marriage Group will endure farther into the present century as a viable interpretation. Insofar as it does continue as a reasonable interpretation, Kittredge's theory will contain the seeds of more gender discussion.

Bibliography

Benson Larry D. and T.M. Anderson. *The Literary Context of Chaucer's Fabliaux*, Texts and Translations. Indianapolis: Bobbes-Merrill Co., 1971.

Brewer, D. S. "The Fabliaux" in B. Rowland, ed.*Companion to Chaucer Studies*, Revised ed. Oxford England, Oxford University Press, 1979, pp. 196–325.

Brown, Carleton. "The Evolution of the Canterbury 'Marriage Group,'" *PMLA* 48 (1933): 1041–1059.

Giovanni Boccaccio. *The Decameron*, trans. G. H. McWilliam. London, England: Penguin Books, 1972.

———. *Concerning Famous Women*, trans. Guido A. Guarino. New Brunswick, New Jersey: Rutgers University Press, 1963.

———. *Famous Women*, (*De Mulieribus Illustris*) ed. and trans. Virginia Brown. Cambridge, Massachusetts: Harvard University Press, 2001.

———. *Forty-six lives trans. from Boccaccio's "De Claris Mulieribus"* by Henry Parker, Lord Morley, ed. with Latin text by Herbert G. Wright. Early English Text Society, orig. Ser. Vol 214. London: 1943.

Chaucer, Geoffrey. *The Canterbury Tales, Complete*, ed. Larry D. Benson, based on *The Riverside Chaucer*, Third Edition. Boston: Houghton Mifflin, 2000.

Dempster, Germaine. "Manly's Conception of the Early History of the *Canterbury Tales*," *PMLA* (1946): 379–415.

———. "A Period in the Development of the *Canterbury Tales* and of Blocks B2 and C," *PMLA* 68 (1953): 1142–59.

Hines, John. *The Fabliau in English*. London: Longman Publishing, 1993. Hinckley, H. B. "The Debate on Marriage in the *Canterbury Tales*," *PMLA* 32 (1917): 292–305.

Kittredge, George L. "Chaucer's Discussion of Marriage," *MP* 9 (1912): 435–67 reprinted in *Chaucer Criticism*, Vol. I edds. Richard Schoeck Schoeck and Jerome Taylor. Notre Dame Indiana: University Press, 1960, pp. 130–159.

Kretzmann, Norman, Anthony Kenny, John Pinboy, eds. *The Cambridge History of Later Medieval Philosophy*. Boston: Cambridge University Press, 1982.

Lawrence, William. "The Marriage Group in the Canterbury Tales," *MP* 11 (1913): 247–258.

Lyons, C. P. "The Marriage Debate in the *Canterbury Tales*," *ELH* 2 (1935): 252–62.

Neville, Marie. "The Function of the Squire's Tale in the Canterbury Scheme," *JEGP* 50 (1951): 167–179.

Pearcy, R. J. "The Genre of Chaucer's Fabliaux-Tales," in L. A. Arrathoon, ed. *Chaucer and the Craft of Fiction*. Rochester, Michigan: Solaris Press, 1986, pp. 329–84.

Pearsal, Derek. *Life of Chaucer*. Oxford, England: Blackwell Press, 1992.

Richardson, J. *Blameth Not me. A Study of Imagery in Chaucer's Fabliaux*. The Hague: Mouton, Studies in English Literature, 1970.

Rowland, B. "What Chaucer did to the Fabliau," *Studia Neophilologica* 51 (1979): 199–206.

Severs, J. Burke. "Did Chaucer Revise the *Clerk's Tale?*" *Speculum* 21 (1946): 295–302.
Sledd, James H. "The Clerk's Tale: The Monsters and the Critics," *MP*, 51 (1953): 73–82.
Stilwell, L. G."The language of Love in Chaucer's Miller's and Reeve's Tales and in the Old French Fabliaux," *JEGP* 54 (1955): 693–9.

6

Boethius and the Wife of Bath

As I had hoped to demonstrate in the previous chapter, the ability to think and speak logically has been seen throughout the Middle Ages, and right into Modern Times, as a male prerogative. Philosophical discourse as well as logic, was a male attribute and may, among other evidence, be seen clearly illustrated in the all-male student bodies of the medieval university. In the Medieval Period, and beyond, university students were not only exclusively male, but clerical students as well, aspirants to the priesthood. They were committed to a celibacy which excluded intimacy with women. The Wife of Bath, then, stands in sharp contrast to the assumptions in this practice of education in the more abstract and learned disciplines. Contrary to the expectations of many readers of medieval literature, the most philosophical mind among all of Chaucer's characters in the *Canterbury Tales* belongs, I would claim, not to a cleric, but to the Wife of Bath. In the Wife of Bath, Chaucer has created a personality which, among all the characters of Medieval English Literature, is certainly one of the most complex that any reader will encounter. By examining her intensively self analytic prologue, we may see that she understands and explains how well she knows her own mind and personality. She tells us that she is rough and lecherous, and on that account she has been much castigated in her own time and to an even greater extent by modern critics. She also gives considerable evidence of an intense intellectual interest, one certainly as great as that of any male on that pilgrimage. Her intellectual abilities have not gone unnoticed entirely and Patrick Gallacher not only called attention to her mental powers but even traced some of her logical discourse to Aristotle. Gallacher's citations, including Aristotle, Plato, Aquinas,

copious notes of his article and testify to the wide range of intellectual background that Chaucer wished to infuse into her discourse. Mary Carruthers has explored the Wife's use of St. Jerome's writings, a knowledge which can be plausibly assigned to the Wife's intimacy with the bookish Jankyn, her last (and probably late) husband. Neither of these scholars, however, has made mention of either Boethius or of the technique of logical paradox which seems to infuse the Wife's speech and logic.

Her claim to have been schooled by five husbands is a clever reference not only to marital and sexual learning,

> For she koude of that art the old daunce, (A 476)

but is also an allusion to a liberal arts curriculum wherein she particularly excelled in logic and rhetoric. Her best teacher was the blonde, curly haired ex-cleric, Jankyn, who instructed her not only in hard knocks, but also in the love of learning and of books. This fifth husband was an endless source of fascination for her, not only because he was young, virile and attractive, and because he was schooled in literature and philosophy. It was he, doubtless, who taught her how to cite title and author as support and example in arguments. Unfortunately, however, that learning was also directed by him against her as a woman and so their relationship was clouded with conflict.

Nevertheless, her association with the Oxford cleric had a considerable influence on her way of thought. It is obvious that she was not "trained" in any formal sense as he was. But the scholastic bent of her thought, derived in some way from discourse with Jankyn, is evident from the opening of her prologue where she arranges her arguments in true scholastic fashion. As she prepares an argument to support her right to wed more than once, she follows a logic familiar to university students of her time. The position *contra* her argument is presented first, then answered and followed by arguments in support of her opinion. An appeal is made in turn to authority (Old Testament, New Testament as well as the ancients) and to logic. She seems to have modeled this argument as a *sed contra* attack, and the best and perhaps best known example of this

argumentation is found in the works of Thomas Aquinas and may be found throughout his works. One may point out as a particular example, in the *Summa Theologica*, the Question of the External Causes of Sin, Question L XXIX: Whether God is a cause of sin?

It seems that God is in fact a cause of sin, for the Apostle says of certain people (*Rom*.i.28) "God delivered them up to a reprobate sense, to do those things which are not right." He also cites *Wisdom*, xiv.II and *Isiah,* xlv.7. But, he says, On the Contrary, It is written (*Wis.* xi.25): "Thou...hatest none of the things which Thou hast made." Now God hates sin, according to *Wis.* xiv.9: "To God the wicked and his wickedness are hateful." Therefore God cannot be a cause of sin. Aquinas then replies with quotations from *Ezech.* iii.28 and from St. Augustine, *De Gratia et Libero Arbitrio*, XXI, and so demonstrates that God cannot be a cause of sin. (See *Basic Writings of Saint Thomas Aquinas*, Vol. II, edited and annotated, with an Introduction by Anton C. Pegis, pp. 651-653.)

There is, however, one particular aspect of her logical method on which I would like to focus attention. In many instances, her method of argumentation advances in the form of contrasting opposites; it is a logical process which may be observed with particular clarity and masterly effectiveness in Boethius' *Consolation of Philosophy*, a work which, as all Chaucerians know, was singularly important in almost everything Chaucer wrote during the middle period of his career. This argument of the Wife of Bath from apparent contradiction appears elsewhere in medieval thought, but since it is such an integral part of the *Consolation,* and since Chaucer's interest in that work is of far reaching significance, I should like to train my focus primarily on the *Consolation* and Chaucer's use of it.

Peter Elbow, in his book *Oppositions in Chaucer*, addressed himself to this paradoxical form of argumentation in both Chaucer and Boethius. We note that his approach, though, differs considerably from the logical methodology which I outline here and, though both the terms "dialectic" and "paradox" are found in his discussion, he does not make use of the same phrase which I have adapted

for this essay—The Dialectic of Paradox. Professor Elbow has taken a more literary understanding of paradox and opposition while I am concerned with a procedure based rather on assumptions of logical discourse. Moreover, Elbow does not address the identical passages in Boethius, i.e. the arguments against power, wealth, pleasure or fame as avenues to happiness. Curiously enough, although his discussion of *Troilus* and the "Knight's Tale" are of great interest, Elbow does not refer at all to the "Wife of Bath's Tale." Nonetheless, I look upon this chapter as an extension of the work of Professor Elbow, carried out with the same understanding of a technique close to the center of the thought process in the minds of both Chaucer and Boethius.

Beyond Professor Elbow's work Boethius' influence on medieval thought is well evidenced by other regularly published new studies which hardly seem to exhaust our discovering the full extent of his penetration into much of the literature of the Middle Ages. Boethius' commentaries on Aristotle as well as his translations of Greek works on arithmetic and music supplied the text books for and the structure of the liberal arts curriculum in the medieval universities. The training of students in the curriculum of the liberal arts guided them toward philosophical studies, which were considered the culmination of the arts program. The Boethian *Consolation* summarizes in a particularly integral fashion the study of the arts, both in terms of their ethical preoccupations and their logical development. (I have collected and published a book of essays which I believe in part will justify this claim and demonstrate the importance of the liberal arts treatises written by Boethius and used for liberal arts studies throughout the Middle Ages.)

The *Consolation of Philosophy* is important not only for its philosophical content, but also for its logical process. Those who are familiar with the total corpus of Boethius' writing are aware that, considering the totality of his work, he must be considered primarily a logician. A list of Boethius' works includes two commentaries on the *Isagoge* of Porphyry, one on the translation by Marius Victorinus, another on a new translation by Boethius; a translation of Aristotle's *Perihermeneias* (*De Interpretatione*), with two commentaries, one

Boethius and the Wife of Bath

for beginners, another one for advanced readers; a translation of Aristotle's *Prior Analytics, Posterior Analytics, Sophistic Arguments* and *Topics*. In addition to these logical works, Boethius wrote a *De Arithmetica*, a *De Musica*, and a *De Geometria* (this last now extant only in fragments). Finally, there is *The Consolation of Philosophy* (the work known best to modern readers), and several short theological treatises: *De Sancta Trinitate, Utrum Pater et Filius et Spiritus Sanctus de Divinitate Substantialiter Praedicentur, De Persona et Duabus Naturis in Christo, Quomodo Substantiae, in eo quod sint, bonae sint cum non sint substantialia bona* (also called the *De Hebdomadibus)*. Gilson, in his *History of Philosophy in the Middle Ages*, has provided a useful and comprehensive survey of these works on pp. 603–606.

Boethius' translations and commentaries on the logical works of Aristotle were only the beginning of a much more ambitious program to translate and comment on all the works of the Stagerite. But as it is, he has left us mostly with logical treatises. The Boethian preoccupation with logic is evident in the *Consolation* and a particular method of proceeding by paradox is especially worthy of mention. It is not a method which he discusses in his logical writings, but method it is nonetheless. I have chosen to call this method the Dialectic of Paradox, for reasons which I will explain shortly.

Any attempt to trace the logic of paradox to its sources must eventually arrive at the works of Zeno of Elea in the 5th century B.C. Zeno is especially recognized, now as in ancient times, for his arguments against plurality and against motion. In his demonstrations on these topics he used the argument of paradox with considerable skill and with results which still challenge philosophers. His most famous example is about Achilles and the tortoise. If Achilles and a tortoise were to run a race on the course A–Z but the tortoise were to begin slightly ahead of Achilles at B, Achilles would never win the race. This must be, since the distance from A to B, from Achilles to the tortoise, is able to be divided into an infinite number of parts. But it would take an infinite amount of time to traverse an infinite number of spaces. Therefore Achilles will never pass the tortoise. This argument places the result of logic

and the intellectual process over the evidence of the senses, evidence which Zeno mistrusted.

It is not possible to do justice to the subtle and complex possibilities that have been attributed to the ideas of Zeno. His arguments have received considerable attention in modern times, notwithstanding Aristotle's well known attempts to refute them. Scholars such as Kurt von Friz, H. Frankel, G. Vlastos and Wesley C. Salmon have shown that his ideas are to be taken seriously and these same writers, in works cited in my bibliography, have provided ample discussion for modern readers to consider on behalf of Zeno. Yet, his ideas are known largely through Aristotle's citations wherein Zeno is being refuted. One may read this material in Aristotle's *Physics*, VI. 9, 239b. Zeno's role cannot be stressed too strongly. According to William A. Reese (*Dictionary of Philosophy and Religion*, p. 174), when he defines the term "Dialectic": "The procedure brings to light contradictions, and other types of opposition not sensed before. The origin of the dialectic may be appropriately attributed to Zeno, Socrates and Plato. The role of dialectic, the interpretation of its nature, and the estimate of its importance alter widely in the course of the history of philosophy." Professor Reese cites examples from Aristotle, Abelard, Kant, Marx and others but does not mention Boethius.

Zeno directed his arguments to epistemological problems since he was concerned with the validity of the evidence derived from sense perception, and after that perhaps showed some interest in metaphysical applications. Boethius doubtless read of Zeno's proofs in Aristotle's *Physics* where the Stagerite undertook their refutation. Boethius, however, when writing the *Consolation* was less interested in epistemology or metaphysics and much more concerned with ethical demonstration. Whether he directly adapted the arguments of Zeno cannot be determined, but in contrast we may see that the demonstrations of Boethius in the *Consolation* are concerned with neither epistemology nor metaphysics but ethics; Boethius has raised the argument of Zeno to the level of moral paradox. It is this process in the Boethian ethical argument which I have chosen to call the Dialectic of Paradox. This logical process may be

simply explained: the effect one will achieve by a given action or decision is not the effect that he truly desires, but in fact will prove to be an effect directly opposite to his desire. This process of proceeding by contraries is used by Boethius to prepare the way for acceptance of the *Summum Bonum* or the highest good in which there is no illusion of opposites or any frustration of legitimate desire.

Discourse in the *Consolation of Philosophy* takes the form of alternating exposition and plentiful example (as in the Wife of Bath's Prologue). Lady Philosophy undertakes, in the first book, to console the victim of evil fortune—one who is rather the victim of his own misunderstanding of the nature of fortune—by disposing of illusory happiness. Men have striven after happiness, she explains, by endeavoring to acquire material possessions, power, honor, or fame. In Books II and III, Lady Philosophy patiently demonstrates that the acquisition of these illusory goods does not bring happiness at all. On the contrary, acquiring them achieves an effect precisely the opposite to that desired by those who aspire to their possession. To achieve wealth, power, honor or fame is, in reality, to achieve a state which is worse than remaining without them. Neither Croesus or Nero, for all their riches, died happy men. The possession of wealth creates insecurity, fears of theft, and ignorance about the identity of one's true friends.

> So the situation has been reversed. Wealth which was thought to make a man self-sufficient in fact makes him dependent on outside help. In which case, what is the way in which riches remove want? (Book III, prose iii; p. 53)

> In contrarium igitur relapsa res est; nam quae sufficientes sibi facere putabantur opes, alieno potius praesidio faciunt indigentes. Quis autem modus est quo pellatur divitiis indigentia?

Nor can power give real happiness. Regulus, Roman consul during the first Punic War, had bound many of his African captives in chains; but before long he was himself chained by his captors.

> What sort of power is it, then, that strikes fear into those who possess it, confers no

> safety on you if you want it, and which cannot be avoided when you want to renounce it? There is no support, either, in friends you acquire because of your good fortune rather than your personal qualities. The friend that success brings you becomes your foe in time of misfortune. And there is no evil more able to do you injury than a friend turned foe. (III, prose 5; p. 57)

> Quae est igitur ista potentia quam pertimescunt habentes, quam ne cum habere velis tutus sis et cum deponere cupias vitare non possis? An praesidio sunt amici quos non virtus sed fortuna conciliat? Sed quem felicitas amicum fecit, infortunium faciet inimicum. Quae vero pestis efficacior ad nocendum quam familiaris inimicus?

The same may be seen with those who desire fame and honor.

The underlying reason for the failure of these attractive earthly means to happiness is that they are given to man by fortune. Therefore they are transitory, empty, and unpredictable. Their coming and their passing is without the control of those who desire them or possess them. Their loss or acquisition is at the whim of *Fortuna* whose only constant, only necessary, attribute is continual change. To rely on Fortune for happiness is to rely on an inconstant woman, on a prostitute:

> So now you have committed yourself to the rule of Fortune, you must acquiesce in her ways. If you are trying to stop her wheel from turning, you are of all men the most obtuse. For if it once begins to stop, it will no longer be the wheel of chance. (Book II, prose l; p. 23–24)

> Fortunae te regendum dedisti; dominae moribus oportet obtemperes. Tu vero volventis rotae impetum retinere conaris? At, omnium mortalium stolidissime, si manere incipit, fors esse desistit.

After she has logically demonstrated the inherent failure of transitory happiness, Lady Philosophy continues to develop her argument through the Dialectic of Paradox. By means of an elaborate discourse based on apparent contradiction, she moves from the discussion of transitory good to the definition of the unchanging good. This transition proceeds by an examination of the external or apparent success of evil in a world created and ruled by a good God. In such a world, one must believe firmly that good men in reality do prosper.

If one is misled by the evil that men do and think that these vile men are successful, one then deceives himself about the nature of good and evil, particularly if he believes in the sovereignty of a good God. The evil men whom you see around you do not exist, since evil cannot be said to have true existence. Boethius here appeals to a type of moral existentialism in which existence depends on the good and in which evil, the lack of existence, renders an evil person as "non-existent." Lady Philosophy concludes the discussion of illusory existence by relegating evil men to the same position as the illusory happiness previously disposed of in an earlier book and ends in a statement closely woven with paradox.

> To the objection that evil men do have power, I would say that this power of theirs comes from weakness rather than strength. For they would not have the power to do the evil they can if they could have retained the power of doing good. This power only makes it more clear that they can do nothing, for if, as we concluded a short time ago, evil is nothing, it is clear that since they can only do evil, the wicked can do nothing. (Book IV, Prose ii; p. 91).

> "Sed possunt," inquies, "mali." Ne ego quidem negaverim, sed haec eorum potentia non a viribus sed ab imbecillitate descendit. Possunt enim mala quae minime valerent, si in bonorum efficientia manere potuissent. Quae possibilitas eos evidentius nihil posse demonstrat. Nam si, uti paulo ante collegimus, malum nihil est, cum mala tantummodo possint, nihil posset improbos liquet.

The concluding portions of the *Consolation* take up the problems of chance in God's providence and, especially, free will and God's foreknowledge. Paradox rests at the bases of these questions as well, but the Boethian Paradox works expertly to demonstrate the co-existence of free will with God's knowledge which does not at the same time effect what it knows. God's infinite knowledge includes in it as part of a master plan for the universe, saved by necessity for the sanctions of good and evil, the free will of men who make their decisions in the context of an overarching providence.

Among those who knew and read seriously in the works of Boethius were Jean de Meun and Geoffrey Chaucer. Both translated the *Consolation* into their native vernaculars and Chaucer made it one of his youthful tasks to translate

Jean de Meun's *Roman de la Rose* into English. Jean de Meun, as well as the portion of the *Roman* written by Guillaume de Lorris, held a life long fascination for Chaucer. The *Consolation* and the *Roman* may be considered the warp and woof of his intellectual fabric. Chaucer read and used ideas from both Boethius and de Meun, and de Meun's thought was itself thoroughly imbued with Boethian ideas.

Both Chaucer and Jean de Meun assimilated Boethius for his own particular literary purposes. Yet, interestingly enough, though each read Boethius seriously, each could make clever and humorous (perhaps even satirical) adaptations of what in the *Consolation* is rather straight-faced philosophical discourse. One might say that each "medievalized" the late Roman Boethius in his own way. I would not at this point attempt a full-scale analysis of what could be considered Boethian paradox in the *Roman de la Rose*, but its apparent existence there is worthy of note. For example, paradox plays an important part in the catalogue of contrarious passions in the lover where love is defined cumulatively through a recitation of its paradoxes.

> Love is a troubled peace, an amorous war—
> A treasonous loyalty, disloyal faith—
> A fear that's full of hope, a desperate trust—
> A madman's logic, reasoned foolishness—
> A pleasant peril on which one may drown—
> A heavy burden that is light to bear—
> Charybdis gracious, threatening overthrow—
> A healthy sickness and most languorous health—
> A famine swallowed up in gluttony—
> A miserly sufficiency of gold—
> A drunken thirst, a thirsty drunkenness—
> A sadness gay, a frolicsomeness sad—
> Contentment that is full of vain complaints—
> A soft malignity, softness malign—
> A bitter sweetness, a sweet-tasting gall—
> A sinful pardon, and a pardoned sin—
> A joyful pain—a pious felony—
> A game of hazard, ne'er dependable—
> A state at once too movable, too firm—

An infirm strength, a mighty feebleness—
Which in its struggles moves the very world—
A foolish wisdom, a wise foolishness;
$$\text{etc. (4293-4324)}$$

Amour ce est pais haïneuse,
Amour c'est haïne amoureuse;
C'est leiautez la desleiaus
C'est la desleiautez leiaus;
C'est peeur toute asseüree,
Esperance desesperee;
C'est raison toute forsenable,
C'est forsenerie raisnable;
C'est douz periz a sei neier;
Griés fais legiers a paumeier;
C'est Caribdis la perilleuse,
Desagreable e gracieuse;
C'est langeuer toute santeïve,

C'est santé toute maladive;
C'est fain saoule en abondance;
C'est couveiteuse soufisance;
C'est la seif qui toujourz est ivre
Ivrece qui de seif s'enivre;
C'est faus deliz, c'est tristeur liee,
C'est leece la courrouciee;
Douz maus, douceur malicieuse,
Douce saveur mal savoureuse;
Entechiez de pardon pechiez,
De pechié pardons entechiez;
C'est peine qui trop est joieuse,
C'est felonie la piteuse,
C'est li jeus qui n'est point estables,
Estaz trop fers e trop muables,
Force enforme, enfermeté forz,
Qui tout esmeut par ses efforz;
Prosperité triste e jolie; (Langlois ed., pp. 212-214)

The catalogue of a lover's contrarious passions lived an independent life of its own in courtly literature. We hear it from the love-stricken hero in the first book of Chaucer's *Troilus* and see it later in Thomas Wyatt's sonnet:

> I find no peace and all my war is done.
> I fear and hope, I burn and freeze like ice.
> I fly above the wind yet can I not arise.
> And naught I have and all the world I seize on.
> That looseth nor locketh, holdeth me in prison
> And holdeth me not, yet can I scape no wise;
> Nor letteth me live nor die at my device
> And yet of death it giveth me occasion.
> Without eyen I see and without tongue I plain.
> I desire to perish and yet I ask health.
> I love another and thus I hate myself.
> I feed me in sorrow and laugh in all my pain.
> Likewise displeaseth me both death and life,
> And my delight is causer of this strife.
>
> (Rebholz, ed. p. 80, no. XVII)

(The description of the contrarious passions comes to Wyatt from the poems of Petrarch, of which this sonnet translates No. 134.)

The Dialectic of Paradox, however, is a particular application of paradox to a mode of argumentation; in the Wife of Bath's Prologue and Tale it takes on a carefully shaped literary function. It is, first of all, interesting that a form of schoolman's logic appear on the Wife's behalf. Never before had clerical logic been used for such an exuberant affirmation of sexual vitality. It is particularly appropriate on the Wife's behalf because in the marriage debate the Cleric is beaten at his own game: his own logic, into whose study he had gone long ago, is used with mastery against male domination and against male rules for celibacy while at the same time allowing for the higher value of virginity, granted to it by scriptural authority. The Friar recognizes the Wife's incursion into clerical territory after her tale, but is hardly in a position to rebut her. Instead, he pursues a course of bitter satirical diatribe directed against the Summoner who seems to bother him more than these arguments about the nature of marriage.

The Wife's discourse continues in her own manner, which is laced with concessions to the clerical establishment, but persistently irreverent and self

serving. So, while she is a wooden vessel in the master's house, and does not envy the golden vessels of celibacy, the Wife will grant that:

> Virginitee is greet perfeccion
> And continence eek with devocion. (WB Pro D 105–6)

But her argument is structured to give the victory to marriage (by which she clearly means sexual indulgence) and set up the dart for virginity. Indeed, not only is marriage not second to virginity but in fact is superior to it and virginity is dependent on it. This paradox is implicit in the compact argument stated:

> And certes, if ther were no seed ysowe,
> Virginitee, thanne wherof sholde it growe? (WB Pro. D 71–72)

That is, if a given man and woman, a potential couple, were to content themselves with a vow of chastity, the world would have but two more virgins. Should they, however, wed and bear, say, four children, two of whom would marry and two remain celibate, and should this process continue for three or four generations, three or four times as many virgins would result. Thus, paradoxically, does marriage produce more virgins, and thus is virginity dependent on marriage, and thus is marriage superior to it. As has been recognized, this concept is adapted, satirically, from St. Jerome's "Epistola xxii ad Eustochium" (Migne, xxii, 406): Laudo nuptias...sed quia mihi virgines generant.

The argument from paradox appears again in the Wife's Prologue in lines D 440–443 where she appeals to the stereotyped idea that women are not as rational as men. If this is so, men should, since they are more reasonable, make concessions to women since they are not able to understand rational concessions. The paradox of course comes from the fact that a woman is making this argument.

> Oon of us two moste bowen, doutelees;
> And sith a man is moore resonable
> Than womman is, ye moste been suffrable.

> What eyleth yow to grucche thus and grone?

The Dialectic of Paradox is used with mastery in the Wife's tale, where it is adapted fittingly to theme and character. The Wife has set out to demonstrate that female domination in marriage is, in her opinion, ideal in a marriage relationship and that she had the superiority of personality and intellect to achieve it with five husbands. Strangely enough, a certain measure of acceptance is in evidence on behalf of the dominated males in her relationships. If acceptance is not always clear in her life, it is so in the tale.

Her tale begins, paradoxically enough considering the theme, with rape, which is a physical assertion of masculine sexual domination. By the end of the tale one wonders which way this irony has cut. Before long the reader's sympathies are shifted to the young rapist who must, in a year and a day, discover what women desire most of all. It should be noted that this task is imposed by King Arthur's wife, whose will supersedes her husband's original (and unimaginative) command of beheading. The tale thereby illustrates the theme of domination by the wife over the husband. Her interference also gives the knight a clue to the answer but he does not recognize it.

At the end of the tale, Boethian paradox comes into full play. The foul old woman assumes a relationship to the wretched knight that is reminiscent of the opening scene from the *Consolation*. There Lady Philosophy appears to a disconsolate Boethius who reclines on his prison bed. The teacher-pupil relationship is clear in both Boethius and Chaucer. In the tale, the forlorn knight (who appears as a mild satire on the Boethian model) himself inarticulate, agrees with the wife about the nature of his unhappiness: he is wed to a woman who is ugly, old, poor, and of low degree. He desires a wife who is beautiful, young and noble. Within the following 130 lines the old wife undertakes a demonstration, by force of logic and example, to prove that such a desirable, young, beautiful, and noble wife is by no means superior to what he has in her.

> Now ther ye seye that I am foul and old,
> Than drede you noght to been a cokewold;
> For filthe and eelde, also moot I thee,

Been grete wardeyns upon chastitee. (WB Tale. D 1213-16)

In fact, such a seemingly desirable woman may be of less worth and the cause of even greater unhappiness. True *gentilesse* comes not of high birth but of gentle deeds. To understand that, she tells the knight, he should read Seneca and Boethius. Nor is it preferable to be wealthy, because poverty is freedom; it allows a man to know God and himself. Poverty is a seeing-glass in which a man may perceive his true friends. But the knight is especially fortunate that his wife is foul and old because ugliness and age are the wardens of chastity. To have a wife young and beautiful, the old wife makes clear, is to invite cuckoldry—and that would be a greater sorrow to bear in the wife than age and ugliness.

At that point Chaucer's narrative departs from the pattern of consolation into which he had moved the tale. The wife's narrative, after all, is not meant for consolation; it must demonstrate that man be submissive to his wife. Accordingly, the old woman winds up her argument and poses the alternatives, after carefully structuring the case to render the knight impotent of a decision:

"Chese now," quod she,"oon of thise thynges tweye:
To han me foul and old til that I deye,
And be to yow a trewe, humble wyfe,
And nevere yow displese in al my lyf;
Or elles ye wol han me yong and fair,
And take youre aventure of the repair
That shal be to youre hous by cause of me,
Or in som oother place, may wel be. (WB Tale, D 1219-1226)

The husband submits; the paradox is not for him to reconcile. The old woman has brought to this reformed rapist a knowledge to save him from the king's sword. The knight considers it best that she keep the mastery of him and that she resolves the dilemma as it suits her. The old woman then announces that she will be both fair and true. She not only has the knowledge to save the knight but is a shape shifter who is able to make herself young and beautiful. She has already made operative her knowledge in saving the knight's life, and

then she makes it operative in their own marriage—women want most to have domination over their husbands, for the husband's good. The knight turns to find beside him a beautiful young creature whom he takes into his arms as his lawful wife, and "His herte bathed in a bath of blisse" (D 1253). The lascivious knight has received what he wanted, and the wife has attained the mastery. As the reader moves away from this closing scene of happiness one knows that abstract logic and a thoroughly palpable sensuality have achieved that higher synthesis which is so characteristically the Wife of Bath's from the very opening of her Prologue.

Bibliography

Aquinas, Thomas. *Basic Writings of Thomas Aquinas*, trans. Anton Pegis, New York: Random House, 1945.

Aristotle. *Physics,* trans. R. P. Hardie and R. K. Gaye in *The Basic Works of Aristotle*, ed. Richard McKeon. New York: Modern Library, 1941; 2001, pp. 2218–394.

Boethius. *Consolation of Philosophy*, trans. Richard Green. New York: Bobbs Merrill and Co., 1962.

———. *The Consolation of Philosophy*, trans. Victor Watts, revised edition. London, England: Penguin Books, 1999.

———. *Consolatio Philosophiae*, ed. L. Bieler, in *Corpus Christianorum*, Ser. Lat.XCIV, Turnhout, 1957.

Carruthers, Mary. "The Wife of Bath and the Painting of Lions," *PMLA* 94 (1979): 209–222.

Chaucer, Geoffrey. *The Canterbury Tales*, ed. Larry D. Benson, based on *The Riverside Chaucer,* 3rd ed. New York: Houghton Mifflin Co, 2000.

Elbow, Peter. *Oppositions in Chaucer*. Middletown, Connecticut: Wesleyan University Press, 1973.

Everett, Dorothy. *Essays on Middle English Literature*. Oxford, England: Oxford University Press, 1955.

Frankel, H. "Zeno of Elea's Attacks on Plurality," *American Journal of Philology* 63 (1942): 1–25; 193–206.

Gallacher, Patrick. "Dame Alice and the Nobility of Pleasure," *Viator* 13 (1982): 275–293.

Gilson, Etienne. *History of Christian Philosophy in the Middle Ages*. New York: Random House, 1955.

Gordon, Ida. *The Double Sorrow of Troilus: A Study of Ambiguities in Troilus and Criseyde.* Oxford, England: Oxford University Press, 1970.

Grunbaum, Adolf. "A Consistent Conception of the Extended Linear Continuum as an Aggregate of Unextended Elements," in *Philosophy of Science* 19 (1952): 288–305.

Guillaume de Lorris and Jean de Meun. *Le Roman de la Rose,* ed. Ernest Langlois. Paris: Librairie de Firmin-Didot, 1920.

———. *The Romance of the Rose,* trans. Harry W. Robbins and Charles W. Dunn. New York: E. P. Dutton, 1962.

Masi, Michael, ed. *Boethius and the Liberal Arts*. Berne, Switzerland: Peter Lang, 1983.

Muscatine, Charles. *Chaucer and the French Tradition*. Berkeley, California: University of California Press, 1957.

Payne, Robert. "Chaucer and the Art of Rhetoric," in *Companion to Chaucer Studies*, ed. Beryl Rowland. Toronto, Canada: University of Toronto Press, 1968.

Reese, William A. *Dictionary of Philosophy and Religion*. New Jersey: Humanity Books, 1998.

Salmon, Wesley C., ed. *Zeno's Paradoxes*. Middleton, Connecticut: Hackett Publishing Co., 1967; reprinted 2001.

Vlastos, G. "Zeno's Race Course," *Journal of the History of Philosophy*, 4 (1966): 95–108.

Von Fritz, Kurt. *Dictionary of Scientific Biography*. New York: Charles Scribner's Sons, 1976, Vol. XIV, pp. 607–612.

Wyatt, Sir Thomas. *The Complete Poems of Sir Thomas Wyatt*, ed. R.A. Rebholz. New Haven, Connecticut: Yale University Press, 1981.

7

Chaucer and the Incubus

The character of the incubus has a prominent place in the literature and the imagination of the Middle Ages. As a supernatural demonic personality which is invoked as a threat to women in the vulnerability of their sleep, alone in their own beds, the incubus becomes a significant factor in the assessment of gender issues in the literature of the Middle Ages.

The literature of the Middle Ages is rife with accounts of demons, both male and female (the female known as the *succuba*), who have sexual relations with humans. There are numerous stories in many languages of both benign and hostile incubi. That is, there is the friendly incubus which appears in the likeness of attractive young man who seduces women in their sleep or in the privacy of their isolation, and there is the hostile rapist whom women feared as the dark unknown stranger who attacked them in the night. (In terms of modern psychology, the incubus can perhaps be seen as the symbol of feared and repressed sexuality as well as pervasive fear of attack by an unknown stranger in the night.) Sometimes the incubus was invoked as an excuse for an otherwise unexplained pregnancy or blamed for a deformed birth. Of the many medieval accounts of the benign incubus perhaps the best known is the character who appears in the account of the nun who recalls her impregnation and birth of Merlin. The story is widely known through Malory's account. His source, Layamon's *Brut*, is particularly notable in its presentation of the benign type:

þa faereste þing at wes iborn

Swulc hit weore a muchel cniht. Al of gold idiht (7839–7840)

The often reproduced illustration in the French manuscript in the Bibliothèque Nationale Ms Fr. 95, fol. 113v shows the demon as hairy and horned but pleasant in face as he copulates with the nun under bed clothes. The woman who became Merlin's mother was apparently naive as to the character and intent of her companion that night who acts to beget a son upon that innocent virgin. In what seems to be a reversal and mockery of the Virgin Mary's impregnation by the Holy spirit to beget the Son of God, Malory represents the devil who wishes to procreate a half human son in his own image. In his attempt to beget a son who has his mother's humanity and his father's deviltry, however, the incubus is thwarted.

The child to emerge from this union has his mother's goodness and some of his father's superhuman abilities. What seems to have happened, in the devil's miscalculation, is that a larger force, perhaps identified with the *felix culpa*, has determined the outcome of the devil's actions. This is the same force which had determined the outcome of King Uther Pendragon who impregnates Igraine, the Duke of Tintagil's wife and which results in the birth of Arthur. This is a greater good coming from an evil deed, or as Lancelot's sin with Elaine with whom he copulates thinking he is with Guinevere, an act which results in a greater good, that of Sir Galahad's birth. So Merlin arises from the devil's misdeed to thwart the devil's own plans. It is a force which seems to operate consistently not only in Malory but in many of the Arthurian stories that bring the major events to a more favorable outcome, a series of adjustments for the better that eventually culminates in the discovery of the Holy Grail.

The Arthurian stories also relate accounts of succubae who have a variety of successes with the Knights of the Round Table. In the "Tale of the Sankgreal," by Malory, Sir Percival encounters a "jantill woman of grete beauty" who even brings him to her bed. At the last moment, Sir Perceval looks on his sword which reminds him of the crucifix and he makes the sign of the cross. At that, Lucifer makes known his true identity in the beautiful woman

and disappears in a puff of black smoke. Morgan La Fay, however, achieves a striking success. As temptress she is impregnated by Arthur who fathers Mordred on her, the instrument of the father's final undoing.

In the works of Chaucer, there are at least three allusions to the incubus and perhaps one to a succuba. The details of how these instances are devised by Chaucer and the particular way in which they are changed from their sources casts some light on Chaucer's attitude on gender issues. The one most explicit reference occurs in the Wife of Bath's tale where the incubus is mentioned perhaps as a representative of the benign type in her satirical reference to the presence of friars in the land who have now chased away all evil spirits and merely replaced the incubus but can do no more harm than make a woman pregnant. For the Wife, the comparison with the incubus is to "limiters and other hooly freres" (D 866). This distinction is missed by Kiessling whose chapter on the topic is entitled "Monks and Incubi in Chaucer." For the Wife of Bath, the subsequent sexual dishonor seems benign enough:

> In every bussh or under every tree
> Ther is noon oother incubus but he,
> And he ne wol doon hem but dishonour (D 879–81)

Nicolas Kiessling's book *Incubi in English Literature* presents us a good survey of how the medieval theory of the incubi developed up to Chaucer's time. Elements from pagan belief in supernatural spirits and their relations with humans along with biblical accounts of demons and the sexual interaction between humans and non-human creatures combined and coalesced in the high Middle Ages. Many of the authors who discuss the doctrine of the incubus and who recount anecdotal evidence of their activities were authors well known to Chaucer, such authors as St. Augustine, St. Jerome, Isidore of Seville, Dante and Boccaccio. In Chaucer's case, Richard Rolle, his near contemporary in England, and Boccaccio, in Italy, seem particularly relevant. Kiessling notes both the explicit reference to incubi in the Wife of Bath's tale (D 880–81) and also alludes to the reference made by the Miller's wife but does not mention Lucretia's fear that she may be confronted by an incubus in the *Legend of Good*

Women.

Of the various cultural influences on English Literature in the late Middle Ages, the classical and the biblical from the Mediterranean traditions and the Germanic and Celtic from the North all had a variety of elements to contribute to what we know refer to univocally and perhaps simplistically as an "incubus." In Celtic mythology, particularly, the supernatural characters who came to interfere in the sexual lives of humans were referred to as elves or fairies and, perhaps under the influence of the Mediterranean demonic tradition, some of these became associated with the devil. One such fairyland incubus, adjusted for comic effect, is seen when Tatiana engages with the monstrously deformed Bottom and his donkey's head in Shakespeare's *A Midsummer Night's Dream.* The Celtic sources most probably account for the deformed child in Chaucer's "Man of Law's Tale." In that account, we see a plot by the wicked Donegild "The kynges mooder, ful of tirannye" (696). She seeks to discredit Custance and writes a letter to her absent son, Custance's husband, that his wife was delivered of a monster son and thus she must have been some form of devil. In the "Man of Law's Tale," there is an allusion to a succuba, or an elf, on whom was blamed the birth of a deformed child:

> The lettre spak the queen delivered was
> Of so horrible a feendly creature
> That in the castel noon so hardy was
> That any while dorste ther endure.
> The mooder was an elf, by aventure
> Ycomen, by charmes or by sorcerie,
> And every wight hateth hir compaignye (B 750–56)

The most significant of Chaucer's references to incubi appears in the *Legend of Good Women* and, meaningfully later, in the "Reeve's Tale." The "Legend of Lucrece" represents perhaps one of the most wronged and clearly most pathetic of the female victims in Chaucer's anthology of stories about wronged women. While some of Chaucer's other women in the *Legend* may have betrayed family, father or homeland, Lucrece was always loyal and indeed remarkable for her wifely virtues. She is raped and in despair takes her own life.

Her despair and suicide must be seen in pagan Roman and not Christian terms in which they would indeed seem reprehensible—a point which St. Augustine drives home in some laborious detail when he comments on an early account of the tale.

The story of Lucretia was popular in the late classical and medieval period and served various writers to a variety of ends. She is cited by Titus Livius, St. Augustine, Tertullian, and Alanus de Insulis, among others. For Tertullian (*Ad Martyres*, Cap. IV) and Alanus (*Liber de Planctu Naturae*) she is an example of the extremely high value of chastity. For Titus Livius, the significance of her experience was largely political. For Augustine, the event as recounted in I, 19 of the *De Civitate Dei* serves a clearly defined moral purpose. The two chapters immediately preceding her story in Augustine deal with the issue of chastity and its real meaning. According to Augustine, true chastity is a virtue of the soul and is not lost merely through a physical violation. Augustine eventually emerges with a reprimand for Lucretia since suicide cannot be a proper means in protecting her virtue. Of course, within the teaching of Christian doctrine, Augustine is unarguably correct though he grants no sympathy to Lucretia—blame the victim if you will.

> I affirm, therefore, that in case of violent rape and of an unshaken intention not to yield unchaste consent, the crime is attributable only to the ravisher and not at all to the ravished. To my cogent argument to this effect, some may venture to take exception. Against these I maintain the truth that not only the souls of Christian women who have been forcibly violated during their captivity but also their bodies remain holy. (p. 53)

> An forte hui perspicuae rationi, qua dicimus corpore oppresso nequaquam proposito castitatis ulla in malum consensione mutato illius tantum esse flagitium, qui opprimens concubuerit, non illius, quae oppressa concumbenti nulla voluntate consenserit, contradicere audebut hi, contra quos feminarum Christianarum in captivitate oppressarum non tantum mentes, verum etiam corpora sancta defendimus? (p. 31)

In this opinion, Augustine differs from Chaucer and Ovid as well as from Livy. For Chaucer, whose mind on the matter is closer to Ovid's, Lucretia is deliberately placed outside the realm of Christian dogma (as are all the women in the *Legend*). Chaucer, unlike Boccaccio in his *De Claris Mulieribus*, is

careful to select women who lived before the Christian era. Their goodness comes then not from compliance with Christian dogma but rather consists in what Chaucer would have us see as a "religion neutral" environment where virtue is defined in terms of gender relations. Chaucer's focus is entirely on their tragedies in which woman as a woman becomes a victim. Augustine does attempt to enter the complex psychological dimensions of Lucretia's suicide, but in the end Augustine must hold her guilty and so he transitions from a discussion of chastity to a condemnation of suicide. Augustine is more concerned with moral issues than with the psychological aspects of a woman who sees herself completely dishonored and who subsequently has lost all sense of self worth.

We may look to Livy and, to a lesser extent, to Ovid for the story of Lucretia used to serve to political ends. The outcry against Tarquinius brought about the end of the tyrant's reign. In Chaucer, the purpose of the story changes and is more focused on the woman's victimization. Even though the disposal of the tyrant is mentioned by Chaucer, his context gives the story a different significance. After hearing Colatyn boast of her virtues, the libidinal curiosity of Tarquinius is ignited. When he actually comes to see her beauty, he determines on a sexual conquest. As he stalks her in the night, he steals into the home of Colatyn who had earlier foolishly shown him the access, and he creeps upon Lucrece in her sleep. As he sits on her bed, apparently he thinks that merely his status as the king's son would be adequate to seduce her virtue. (The reference to his father is also a remnant of the story's original political purpose.) But should she not accede to his desires, he prepares a knife to take her under the threat of death. As he approaches to sit on her bed, the motion awakes her and, apparenlty she briefly considers that it may be an incubus come to attack her. Then she quickly dismisses the idea because an evil spirit would not press so heavily on her bed:

> Were it by wyndow or by other gyn,
> With swerd ydrawe shortly he com in
> There as she lay, this noble wif Lucresse.
> And as she wok hire bed she felte presse.

"What beste is that," quod she "that weyeth thus?"
"I am the kynges sone, Tarquinius,"
Quod he "but, and thow crye or noyse make,
Or if there any creature awake,
By thilke God that formed man alyve,
This swerd thourghout thyn herte shal I ryve." (1784–93)

Chaucer's allusion to the incubus at this point is telling. It would seem to indicate that the victim knows her assailant to be human yet the question "What beste is that" would suggest her awareness of his diabolic intent.

Ovid's *Fasti* bears an interesting resemblance to Chaucer's *Legend of Good Women* in several ways, perhaps not entirely coincidental. Both authors are primarily motived, at least with regard to the story of Lucretia, by gender issues. The *Fasti* is also structured according to the Calendar of Roman Feasts. Each book of the *Fasti* was designed to correspond to the period of one month. The material Ovid covers touches on myth, Roman heroes, history and other topics. Although Chaucer's *Legend* is not directly tied to the liturgy or the calendar, the use of the word "legend" in the title is evocative of a liturgical use. The word "legend" comes from the customary term for a collection of saints lives, such as the *Legenda Aurea*, designed to present an hagiographical account of the saint whose feast is celebrated on a given calendar day. As Ovid's *Fasti* was designed to explain the occasion for a calendar feast, so was the usual collection of saints lives. For the Christian calendar each day had at least one and often more than one saint assigned for veneration on that date. Also, incidentally like the *Legend of Good Women*, the *Fasti* is not complete but it ends with the month of June.

In Ovid the approach to Lucrece is quite different. There is no mention of a beast nor allusion to an incubus:

He got up and freed his sword from its gilded scabbard,
And came, modest wife, to your chamber.
As he got on the bed, the king's son spoke: 'Lucretia,
I've got my sword. It's Tarquin speaking.'
No reply. She'd lost her voice, the strength to speak
Was gone and with it all composure;

She was like a poor lamb under attack from a wolf.

> Surgit et aurata vagina deripit ensem
> et venit in thalamos, nupta pudias, tuos
> utque torum pressit, "ferrum, Lucretia, mecum est!"
> Natus ait regis "Tarquiniusque Loquor."
> Illa nihil, neque enim vocem viresque loquendi
> aut aliquid toto pectore mentis habet
> sed tremit, ut quondam stabulis deprensa relictis
> parva sub infesto cum iacet agna lupo. (793–98)

John Gower, Chaucer's contemporary poet and personal friend, also makes use of the Lucretia story in the *Confessio Amantis*. A comparison with Chaucer's version and with the classical accounts brings out a salient aspect of how Chaucer uses the story. We note that Gower's account is written in the London English of Chaucer's time, not like Gower's other works in French and Latin. In Gower, the differences between his story and his source, Ovid, we find an account that is more like Ovid than like Chaucer in one important respect; Gower does not have Lucretia speak of or even hint at the thought of an incubus:

> And thanne upon himself he caste
> A mantell, and his swerd al naked
> He tok in honde; and sche unwaked
> Abedde lay, but what sche mette,
> God wot; for he the dore unschette
> So previly that non it herde,
> The softe pas forth he ferde
> Unto the bed wher that she slepte,
> Al sodeinliche and in he crepte
> And hire in bothe his Armes tok
> With that this worthi wif awoik,
> Which thurgh tendresse of wommanhiede
> Hire vois hath lost for pure drede
> That o word speke sche ne dar:
> And ek he bad hir to be war,
> For if sche made noise or cry,
> He seide, his swrd lay faste by
> To slen hire and hire folk aboute. (4964–4981)

It cannot be determined how much Chaucer know of Gower and whether he might have read this passage.

In his brief note on Lucretia, Marvin J. LaHood endeavors to show how Chaucer Christianized the story of Lucretia. There are minor changes which could support LaHood's argument but the introduction of an incubus is the most salient Christian element that Chaucer has added to Ovid's account so the incubus seems to serve several purposes in Chaucer's use of it.

The significance of Livy's version of the Lucretia story contrasts strongly with Chaucer's very different use of the account. Chaucer makes clear that his main inspiration in the Lucretia story is Ovid and Ovid stands with Chaucer in his interest. It is generally obvious in most of his works that he is more concerned with gender than he is with political history. Although Chaucer does cite Livy, the contrast between his account and the historian's version is significant because the literary functions of the two differ so fundamentally. The difference between the Chaucer/Ovid version of the Lucretia story as seen in Livy is parallel to the Chaucer/Ovid contrast with Virgil in the Dido story. In Livy, the rape and death of Lucretia result in the overthrow of Tarquinius' father, the tyrant, King Lucius Tarquinius Superbus. As the result of the public outcry over Lucretia's dishonor and death, the tyrant and his family were banished. That banishment ended the rule of kings in Rome.

> When the news of these events reached the camp, the king, in alarm at the unexpected danger, set out for Rome to put down the revolt. Brutus, who had perceived the king's approach, made a circuit to avoid meeting him, and at almost the same moment, though by different roads, Brutus reached Ardea and Tarquinius Rome. Against Tarquinius the gates were closed and exile was pronounced. The liberator of the city was received with rejoicing in the camp, and the sons of the king were driven out of it. Two of them followed the father, and went into exile at Caere, in Etruria. Sextus Tarquinius departed for Gabii, as though it had been his own kingdom, and there the revengers of old quarrels, which he had brought upon himself by murder and rapine, slew him.
>
> Lucius Tarquinius Superbus ruled for five and twenty years. The rule of the kings at Rome, from its foundation to its liberation, lasted two hundred and forty-four yeas. Two consuls were then chosen in the centuriate comitia, under the presidency of the prefect of the City, in accordance with the commentarius of Servius Tullius. These were

Lucius Junius Brutus and Lucius Tarquinius Collatinus.

> Harum rerum nuntiis in castra perlatis cum re nova trepidus rex pergeret Romam ad comprimendos motus, flexit viam Brutus—senserat enim adventum—ne obvius fieret; eodemque fere tempore diversis itineribus Brutus Ardeam, Tarquinius Romam venerunt. Tarquinio clausae portae exsiliumque indictum: liberatorem urbis laeta castra accepere, exactique inde liberi regis. Duo patrem secuti sunt, qui exsultatum Caere in Etruscos ierunt. Sex. Tarquinius Gabios tamquam in suum regnum profectus ab ultoribus veterum simultatium, quas sibi ipse caedibus rapinisque concierat, est interfectus.
> L. Tarquinius Superbus regnavit annos quinque et viginti. Regnatum Romae ab condita urbe ad liberatuam annos ducentos quadraginta quattuor. Duo consules inde comitiis centuriatis a praefecto urbis ex commentariis Ser. Tulli creati sunt, L. Iunius Brutus et L. Tarquinius Collatinus. (Citations from Livy, *Ab Urbe Condita*, pp. 208–209.)

The banishment of Tarquinius Superbus, according to Livy, led to the reign of the first consuls, Lucius Junius Brutus and Lucius Tarquinius Collatinus. In Chaucer and in Ovid, the focus is on Lucretia's dishonor and victimhood. In Chaucer, the banishment of the tyrant is managed in three lines:

> Of hir had al the toun of Rome routhe,
> And Brutus by hir chaste blood hath swore
> That Tarquin shulde ybanysshed be therfore,
> And al hys kyn; and let the people calle,
> And openly the tale he tolde hem alle,
> And openly let cary her on a bere
> Thurgh al the toun, that men may see and here
> The horryble dede of hir oppressyaun,
> Ne never was ther kyng in Rome toun
> Syn thilke day; and she was holden there
> A seynt, and ever hir day yhalwed dere
> As in hir lawe; and thus endeth Lucresse,
> The noble wyf, as Tytus bereth witnesse. (1861–73)

In these lines Chaucer condenses the political import of her mishap:

> Ne never was ther kyng in Rome toun
> Syn thilke day.

The enormity of the event politically may certainly have been in his mind since he refers to Titus Livius, but his emphasis on her personal tragedy is clear since he omits the political consequences and, more significantly, contextualizes her story in the *Legend of Good Women*.

In Ovid, the political results are clearly the source for Chaucer's brief treatment:

> With a shout, Brutus roused the Romans
> and reported the king's unspeakable acts.
> Tarquin fled with his sons. The consuls began their year-long term.
> That was the monarchy's final hour. (II, 849–852)
> (Ovid's *Fasti: Roman Holidays*. Trans. by Betty Rose Nagle)

> Brutus clamore Quirites
> concitat et regis facta defanda refert.
> Tarquinius cum prole fugit: capit annua consul
> iura: dies regnis illa suprema fuit.

Though written much later, it is instructive to read Shakespeare's account of Lucretia's story to whom he devoted a long poem in stanza form. As we might expect, he prolongs greatly the encounter which leads to the rape and so deepens its psychological dimensions. Notably, we may see indications of the demonic, as in Chaucer, and perhaps under his influence.

> Imagine her as one indeed of night
> From forth dull sleep by dreadful fancy waking,
> That thinks she hath beheld some ghastly sprite,
> Whose grim aspect sets every joint a-shaking;
> What terror 'tis! But she, heedfully doth view
> The sight which makes supposed terror true. (449–55)

Nothing in the "Wife of Bath's Tale" seems to pick up the ideas suggested in her reference to the incubus, but Chaucer makes complex use of the incubus myth in the "Reeve's Tale" from approximately the same period of his writing when he penned the "Wife of Bath's Tale." In this equally complex mixture of humor, satire and multilayered analysis of gender, however, he devises quite

another function of the incubus story. In the Reeve's tale, the psychology of the female victim, as one might expect some ten or more years in Chaucer's career after the *Legend of Good Women*, is far more nuanced and complex. In a few lines, a rapid development takes place that illustrates not only Chaucer's ability to turn the gender tables and also to keep sympathy with the female side.

In "The Reeve's Tale," the "victim" survives and prevails and the several male invaders are punished for their transgressions. Two Cambridge students have been duped, had their grain stolen and are forced to spend the night in the Miller's lodging with his family. The final and fateful scene is played out at the end of a previously quiet but not uneventful evening. Allen has successfully entered the bed of the Miller's daughter and not entirely to her displeasure. John, in a similar but more clever move has bedded the Miller's wife but all the while, we are to suppose, he makes her think she is with her own husband (whom he probably resembles physically with his "swyne's-heed"). When Allen creeps triumphantly but with serious repercussions into bed with the Miller, thinking he is with his schoolmate, he begins his male boast:

> He seyde, "Thou John, thou swynes-heed, awak,
> For Cristes saule, and heer a noble game.
> For by that lord that called is Seint Jame,
> As I have threis in this shorte nyght
> Swyved the milleres doghter bolt upright
> Whil thow hast, as a coward been agast." (A.4262–67)

As the two men, the student and the burly Miller, struggle in the ensuing altercation, they fall back on the Miller's wife, now asleep after what has presumably been a thoroughly satisfactory and sleep enducing sexual experience. On feeling the two bodies upon her own, she is shocked out of a profound slumber and awakes startled and afraid. In terror she cries to her savior for help, invoking the Holy Cross of Bromeholm. Then she calls to what she thinks is her husband next to her and fears the incubus himself has attacked her:

> The fiend is on me falle (A.4288)

In a few moments—the lines do not indicate how much time passes in this event—she comes to the erroneous conclusion that it is the two students who have begun to brawl and then she begins aggressively to take up a staff herself and beats upon one of them—who turns out to be her husband:

> For she was falle aslepe a lite wight
> With John the clerk, that waked hadde al nyght,
> And with the fal out of her sleep she breyde
> "Help! Hooly croys of Bromeholm," she seyde,
> "In manus tuas! Lord, to thee I calle!
> Awak, Symond! The feend is on me falle.
> Myn herte is broken; help! I nam but deed!
> Ther lyth oon upon my wombe and on myn heed.
> Help, Symkyn, for the false clerks fight!" (A. 4283–91)

In this late period of his writing career, Chaucer will have no more accounts of the female victim as he did in the *Legend of Good Women*. The incubus has been exorcized in the Wife of Bath period and now the victim becomes the aggressor. The Miller's wife mistakenly strikes down the husband, who has already shattered the face of the student who has dishonored the Miller's daughter. But during the brief moment when, half awake, the wife of the miller fears the presence of the incubus, she instinctively invokes the Holy Cross of Bromholm.

The cry of the Miller's wife to the Holy Cross of Bromholm, in Norfolk, would have evoked a marked response from Chaucer's audience since that relic, which had been venerated already for several centuries, was reaching the peak of its renown. Pilgrims traveled from all over England to visit the site of its display and indeed, it could have rivaled Canterbury as a pilgrimage center. Just a few years after the writing of the "Reeve's Tale," on August 29th, 1401, a very high indulgence was granted by Pope Boniface IX for pilgrims to that holy relic (Warmold 37). While there is no evidence that Chaucer visited the Cluniac Priory of Bromholm where the cross was enshrined, he would certainly have heard of its fame. Chaucer's pilgrims tell their tales en route to Canterbury and his choice of pilgrimage places may have been determined by the fact that he

passed through Canterbury several times on his various trips to the mainland, doubtless taking the regular route to the coast through Rochester, from Canterbury to Dover where he would embark by ship across the Channel. It would not be far fetched to suggest that had he traveled to Norfolk with any regularity, he may have written a series of "Bromholm Pilgrimage Tales" instead.

Part of the reason for the Cross' fame was the relic's special power as protector against the devil. There are several pieces of evidence that indicate its power was invoked against Satan, as would be appropriate in the "Reeve's Tale" if the Miller's wife thought that she was be accosted by an incubus. Among various indications to this effect is the hymn found in a fourteenth century psalter from Bromholm (now Ashmole MS 1523 in the Bodleian Library, Oxford). The hymn begins with the usual song of praise to the cross of Christ, but concludes with the lines:

Defend me from sin,
from a desperate situation,
from a machination driven by the enemy

Me defendas de peccato
Et de facto desperato
Hoste truso machinato (Warmold p. 33)

There is evidence that the cross was frequently invoked in cases where the diabolic presence was feared, and the woman's cry is a further clue that the wife feared the presence of an incubus. The invocation of this Cross was perhaps a triggered response on her part as a fear frequently ready in her mind. The wife's reference to the Holy Cross of Bromholm is therefore particularly instructive. In a moment of fear when she suspects that she is being attacked by an incubus, though she is a resident of Trumptington, not far from Cambridge, she calls upon a relic from the Norfolk Cluniac priory of Bromholm, some 70 or 80 miles north of Trumptington, close to the famous shrine of Our Lady of Walsingham from Cambridge. The Cross drew on a wide area of veneration not only in Norfolk and around Cambridge, but of all of England and indeed from

the continent as well (Wormald 31). It is also cited by Langland (who is from the West of England) in the B text when Coveitise is rehearsing the sins of avarice committed by his wife and himself and he swears to repent and make a pilgrimage to a holy shrine. He seems to conflate Walsingham with the nearby Bromholm, perhaps because they are in an area of England that Langland did not know:

> "Ac I swere now (so thee Ik!) That synne wol I lete,
> And nevere widdedly weye ne wikke chaffare use,
> But wenden to Walsyngham, and my wif als,
> And bidde the Roode of Bromholm brynge me out of dette."
> (Lines 224–27)

Since Chaucer was a resident of London most of his life, his citation of the Cross in the "Reeve's Tale" would indicate it was well known in all parts of England since both southern and western Englishmen seem to have heard of it. The Miller's wife called upon a cross, then, well known south and west as well as in Norfolk for its efficacy against attacks from the devil. Two texts edited by Wormald are particularly relevant in this connection. Two early 13th century chronicles have described the transferral of the relic in the cross and told of its powers against demons. In the year 1223, Roger of Wendover says of its powers that it can cure leprosy, blindness and that "obsessi a daemonibus liberantur" (p. 44) . (Those who are possessed by demons are liberated.) More telling yet is Ralph of Coggshill, who ends his description of the relic with an assurance of its power against the devil:

> [This cross] is certainly a true defense against invisible enemies, and through it the strength of the enemies is weakened, their power is taken away, their presence is put to flight and present danger is frequently turned aside. (my trans)

> "Validum certe contra hostes invisibiles propugnaculum, per quod eorum virtus enervatur, potestas infirmatur, presentia fugatur, atque imminens periculum saepe devitatur." (p.45)

This brief survey of the incubus in the works of Chaucer, though focused

on a previously unnoticed use of a traditional and frequently seen medieval actor in the medieval gender arena, should indicate several significant aspects of the way in which Chaucer thinks about and treats gender. It is, in his later period particularly, a manner distinct from that of his contemporaries and, indeed, of most writers for centuries after. He not only avoids the usual stereotyped gender descriptions but seems to delve into those areas where motivation and behavior are driven by distinct gender awareness, an awareness which sometimes plays against the stereotypes. In other writers, the incubus seldom functions to the service or the flattery of women. It serves either the exploitation of a woman's fear or a dark indicator of how some female fantasies may operate. Chaucer uses the term itself but one time and that is in jest, in the mouth of a woman whose reversal of traditional literary treatments of woman has been amply discussed in another part of this book. In the other two instances, in the tale told by the Reeve and in the story of Lucretia, though neither the word "incubus" or any synonym for it occurs, the function of the mythological creature is clearly present for anyone who can contextualize the proper literary references. In the Reeve's tale, a frightened woman momentarily feels herself under sexual attack from the fiend. She and her daughter have enjoyed the pleasure of the two young rascals and perhaps now she fears retribution. In any case, Chaucer's sensitivity to her sexual quandary is significant. In the case of Lucretia, her assault by Tarquinius seems hardly worse than that from a demon. In Lucretia's case, her fear is well founded and her pitiful condition is not substantially differentiated from being attacked by the devil. Augustine and others have not granted her much sympathy, but the poets, such as Chaucer, and after him, Shakespeare, and certainly since then many other writers and painters as well as religious devotees have given her due reverence.

Bibliography

Augustine of Hippo. *City of God*. Trans. Gerald Walsh, Demetrius Zena, Grace Monohan and Daniel Horan, Image Books, Doubleday, 1958.

———. *De Civitate Dei*, ed. Barnadus Dombart and Alfonsus Kalb, Teubner editions, Stuttgart, Germany: 1928; reprinted 1981.

Giovanni Boccaccio, *Famous Women*, (*De Mulieribus Illustris*) ed. and trans. Virginia Brown. Cambridge, Mass: Harvard University Press, 2001.

Chaucer, Geoffrey. *The Legend of Good Women*, ed. by Janet Cowen and George Kane. Lansing, Michigan: Colleagues Press, Medieval Texts and Studies, vol. 16 1995.

Chaucer, Geoffrey. *The Canterbury Tales*, ed. Larry D. Benson. New York: Houghton Mifflin, 2000.

John Gower, *Confessio Amantis*, ed. Russell A. Peck. Toronto, Canada: University of Toronto Press, 1980.

Kiessling, Nicolas. *The Incubus in English Literature*. Washington State: Washington State University Press, 1977.

LaHood, Marvin J. "Chaucer's The Legend of Lucrece," *PQ* 43 (1964): 274–76.

Langland, William. *Piers Plowman: The B Versions*, ed. George Kane and E. Talbot Donaldson. California: University of California Press, 1988.

Livius, Publius Titus, *Opera*, Books I and II, ed. and trans. B. O. Foster, London: William Heinemann, 1919.

Layamon, *Brut*, ed. W. R. J. Barron and S. C. Weinberg. New York: Longman, 1995.

Ovid, Publius Ovidius Naso. *Fasti*, ed. Franz Bömer, Carl Winter. Heidelberg: Universitätsverlag, 1957.

———. Ovid's *Fasti: Roman Holidays*. Trans. with notes by Berry RoseNagle. Bloomington, Indiana: Indiana University Press, 1995.

Shakespeare, William. *The Riverside Shakespeare*, ed. G. Blakemore Evans. New York: Houghton Mifflin Co, 1974.

Simpson, W. Sparrow. "On the Pilgrimage to Bromholm in Norfolk," *Journal of the British Archeological Association*, 30 (1874), 52–59.

Seymour, M. C. "Chaucer's Revision of the Prologue of *The Legend of Good Women*," *Modern Language Review*, 92 (1997): 832–42.

Tertullian. *Ad Martyres*. Biblioteca Augustana Oehler, Leipzig: 1853. http://www.tertullian.org/latin/ad_martyres.htm

Titus Livius. *Ab Urbe Condita*. Latin text and English translation by B. O. Foster. Boston: Harvard University Press, Loeb Classical Editions, 1961.

Weiher, Carol. "Chaucer's and Gower's Stories of Lucretia and Virginia." *ELN* 14:1 (1976): 7–9.

Wormald, Francis. "The Rood of Bromholm," *Journal of the Warburg and Courtland Institute*. I (1937): 35–45.

Index

Adam, 3, 5, 15, 27, 99
Aeneas, 50
Alanus de Insulis, 149; *Liber de Planctu Naturae*, 149
Albertus Magnus, 14
Albrecasis, 17
analogues, 62–65, 67, 87
Aphrodisiac, 23, 91
Arab, 10, 16–20
Aretealus of Cappadocia, 17
Aristotle, 10–17, 21, 26, 35, 127, 130–132; *De Animalibus,* 13, 17; *De Interpretatione*, 130; *Posterior analytics*, 131; *Prior Analytics*, 131; *Sophistic Arguments*, 131; *Topics*, 131; *Physics*, 132
Austen, Jane *Persuasion*, 99
Blood Libel 86
Boccaccio, 32, 72, 84, 87, 90, 117–122, 147; *Il Corbaccione*, 118, 120, 121; *Decameron*, 84, 118–120; *De Claris Mulieribus*, 113, 149
Boethius, 32, 34, 35, 39, 58, 61, 86, 121, 122, 127–144; *Consolation of Philosophy,* 34, 39, 59, 62, 129–144; *De Musica*, 131; *De Arithmetica,* 131; *De Sancta Trinitate,* 131; *De Interpretatione,* 130; *De Hebdomadibus*, 131; *De Persona*, 131; *De Geometria*, 131; *Utrum Pater*, 131;
Boniface IX, 157
Book of Wisdom, 65
Brittany, 108
Bromholm, 157–159
Cambridge, 156, 158
Catherine of Siena, 26
celibacy, 7, 18, 104, 127, 138, 139
Cervantes, *Don Quixote* 116
Chaucer, Geoffrey
 Works:
 Book of the Duchess, 47
 Canterbury Tales, 16, 22, 35, 44, 46, 47, 58, 59, 74, 77, 78, 81, 86, 87, 92, 97, 103, 104, 112–118, 120, 123, 127; "Clerk's Tale," 20, 58, 93, 104, 105, 114, 119, 121, 122; "Franklin's Tale," 58, 81, 105, 106, 123; "Knight's Tale,"59, 65, 68, 112–115, 123, 130; "Man of Law's Tale," 111, 148; "Merchant's Tale," 16, 21, 58, 78, 81, 105, 110, 118; "Pardoner's Tale," 2, 21, 80, 81, 83, 85, 94–96, 106, 112; "Prioress' Tale," 59, 81, 86, 112; "Second Nun's Tale," 59, 62, 64; "Shipman's Tale," 78, 84–86, 92, 93, 96, 97, 111, 118; "Squire's Tale," 86, 106, 122, 123; "Summoner's Tale," 93, 94, 112, 119, 138; "Tale of Melibee," 67–69, 81; "Wife of Bath's Prologue and Tale," 20–24, 40, 55–58, 65–68, 77–79, 81–91, 92–99, 104, 105, 107, 111–114, 116, 119–123, 127–142, 147, 155, 157
 Hous of Fame, 47
 Legend of Good Women, 32, 33, 41, 46, 48, 49, 64, 110, 112, 113, 147–149, 151, 155–157
 Troilus and Criseyde, 48, 49, 59, 69–73,130, 137
Chrétien de Troyes, 26
Christine de Pizan, 10, 15, 26, 31–51; *La cité des dames*, 26, 36, 38; *Livre de la cité* 33, 38, 42
Col, Gontier & Pierre, 38, 42
Constantinus, 14, 16–25; *De Coitu*, 16–23; *De Genitalibus Membris*, 22
Costa Ben Luca, 17
courtly love 8, 26, 35, 70, 86, 108, 137
Dante, 8, 32, 35, 84, 100, 147
Deschamps, Eustache, 31–33, 35–38, 40, 43–47, 49, 97; *Miroir de Mariage*, 43, 44, 97; "Ballade" 43–46, 49–51
devil, 77, 88, 146, 148, 158–160
dialectic, 129–132, 134, 138, 140
Diana, 114
Donne, John, 71, 116
dream 34, 39, 66, 67, 69
Duke of Tintagil, 146
Duns Scotus, 111, 127
Durand, William, 17
economics, 24, 79–82, 84, 86, 91, 92, 98
education 10, 99, 127
Eleanor of Aquitaine, 26

England, 17, 24, 31, 35, 45, 46, 51, 79–82, 84, 104, 108, 116, 117, 147, 157–159
Esculapius, 16
Eve, 3, 7, 15, 26, 27, 59
evil, 4, 5, 42, 68, 133–135, 146, 147, 150
fabliau, 87, 90, 105, 113–119, 122
Flemish Bankers 90
France, 43, 45, 49
Froissart, 31, 32
Galen 17–19, 25
Gavin Douglas, 48
Genesis, 3–5, 7, 9
genitals, 22, 90, 122
Gilbertus Anglicus, 16, 23, 25; *Compendium Medicinae*, 23
Giles of Rome, 111
Gower, John, 152, 153; *Confessio Amantis*, 152
Guillaume de Lorris, 31, 32, 136; *Roman de la Rose*, 21, 25, 26, 35, 37, 38, 41–46, 51, 84, 136
Haly Abbas, 17
Henry IV, 32
Henry VIII, 24
Henry of Ghent, 111
Henryson, 73
Hildegard, 7, 14, 15
Hippocrates, 17–19, 25
Hippocrene, 45, 51
Holcot, Robert, *Super Sapientiam* 65, 66
Holy Grail, 146
Isaac, 17
Isabeau of Bavaria, 42
Isidore of Seville, 97, 147
Italian Bankers 90
Italy, 18, 37, 119, 147
Jacobus de Voragine, *Legenda Aurea* 59, 62, 63
Jean de la Montreuil 38, 42
Jean de Meun 25, 31, 32, 38, 135, 136
Jean Gerson, 37, 38, 42
Jean (son of Christine) 31, 32
Jean Le Fèvre, 38–40
Joan of Arc, 26
John of Gaddesden, 16, 23–26; *Rosa Anglica*, 23
John of Pecham, 111
King Arthur, 59, 140, 146, 147
King James, 96

King Uther Pendragon, 146
Lady of Walsingham 158, 159
Lancelot, 26, 70, 108, 146
Latin, 4, 10, 18, 24, 38, 39, 41, 56, 62, 63, 96, 120, 152
law 9, 10, 48, 98, 108, 109, 142, 154; canon law, 109
Layamon's *Brut*, 145
Lewis Clifford, 45, 46
Liberal Arts, 93, 128, 130
Machaut, 31, 32, 48; *Le Jugement* 48
Malory, 145, 146
Marie de France, 26; *Del cok e del gupil* 65
Marius Victorinus 130
Mars, 107, 114
Mary Magdalene, 6
Matheolus, 35, 36, 38–41; *Lamentationes*, 39
Merlin, 145, 146
Merton College, Oxford, 17
Monte Casino, 18, 20
Mordred, 147
Morgan La Fey, 147
New Testament, 6, 7, 128
Norfolk, 157
Old Testament, 6, 128
Ovid, 21, 32, 36, 37, 44, 51, 149–155; *Fasti*, 149, 151
Oxford, University of, 17, 56, 92, 95, 121, 128, 158
Paris, 31, 39, 42, 45, 46
Paul of Aegina, 17
Peter of Spain, 14
Petrarch, 32, 35, 36, 84, 120–122, 138; *De Obedientia*, 120
Petrus de Alvernia, 111
philosophy, 1, 2, 11, 16, 18, 25, 34, 39, 42, 44, 50, 51, 58, 61, 63, 68, 92, 106, 107, 111, 127, 128, 130–136, 140
Plague, 42, 79, 80–83, 105
Plato, 8–10, 14, 35, 127, 132; *Laws*, 9; *Republic*, 10; *Symposium*, 8, 9
prophets, 64, 66, 67
prostitution, 77, 134
psychology, 1, 7, 12, 14, 66, 69, 73, 85, 92, 106, 145, 150, 155, 156
Ptolemy, 92
Punic War, 133

Index

queer studies, 2
Ralph of Coggshill, 159
rape, 69, 140, 148, 149, 153, 155
Razis, 16
Regulus, 133
Reinhart Fuchs, 67
Richard Rolle, 147
Richard II, 32
Richardus Humbury, 111
Rochester, 158
Roger of Wendover, 159
role 6, 9, 11, 34, 40, 59, 64–67, 69–73, 105, 112, 114, 132
Roman de Renart, 65, 67
Ruffus of Ephesus, 18
Salisbury, Earl of, 31, 32
Satan, 7, 158
Seneca, 44, 51, 141
Sercambi, 87, 90
Shakespeare, William, 66, 73, 74, 84, 155, 160; *Romeo and Juliet*, 71; *Othello*, 74; *Hamlet*, 74, 111; *Macbeth*, 74; *A Midsummer Night's Dream*, 148
Sir Galahad, 146
Sir Gawain, 26, 27, 100
slave, 14, 96
Spain, 18
St. Augustine, 21, 56, 147, 149, 150, 160; *De Gratia*, 129; *De Civitate Dei De Trinitate* 56, 149
St. Jerome, 40, 92, 96, 97, 128, 139, 147; *Contra Jovinianum*, 96
St. Bernard, 64
St. Cecilia, 59–65
St. Paul, 6, 40, 95
St. Thomas Aquinas, 16, 21, 56, 111, 129; *Questiones Disputate;* 56, 111; *Summa Theologica*, 24, 57, 129
St. John, 64, 106
stoic, 39, 63
succuba, 145–148
Taddeo Alderatti, 19
Tertullian, 149; *Ad Martyres*, 149.
Theophrastus, 92
Titus Livius, 149, 155
Tristram, 108
Trotula, 26, 92
Troy, 72
university, 63, 93, 111, 114, 127, 128

University of Paris, 37, 42
Valerius Maximus, 92
Venus, 107, 114
violence, 59, 60, 62, 67, 68, 114, 115, 149
Virgin Mary, 64, 106, 146
virginity, 7, 64, 106, 138, 139, 146
Wollstonecraft, Mary, *Vindication of the Rights of Women*, 99
William of Conches, 14, 15
William of Balonia, 111
Wyatt, Thomas, 137
Zeno of Elea, 131, 132
Zeus, 8